THE INVISIBLE PRESENT

THE INVISIBLE PRESENT

African Art & Literature

DENNIS DUERDEN

ICON EDITIONS
HARPER & ROW, PUBLISHERS
NEW YORK, EVANSTON, SAN FRANCISCO, LONDON

Grateful acknowledgment is made for permission to reprint the following:

Excerpts from *Kongi's Harvest* and *Collected Plays* (Vol. II) by Wole Soyinka. Reprinted by permission of the Oxford University Press, Oxford.

Excerpts from *Labyrinths with Path of Thunder* by Christopher Okigbo. Copyright © 1971 Legal Personal Representatives of Christopher Okigbo. Published 1971 by African Publishing Company.

Excerpts from *The Myth of the Bagre* edited by J. R. Goody. © Oxford University Press, 1972. Reprinted by permission of the Oxford University Press, Oxford.

FIRST EDITION

Designed by Gloria Adelson

Library of Congress Cataloging in Publication Data

Duerden, Dennis.
 The invisible present.

 (Icon editions)
 Bibliography: p.
 Includes index.
 1. Arts, African. I. Title.
NX587.D83 1975 709'.01'1 74–25153
ISBN 0–06–432000–6

75 76 77 78 79 10 9 8 7 6 5 4 3 2 1

To my wife, Rhoda,
who made perceptive and
incisive comments at all times

Contents

Introduction and Acknowledgements

This book presents my observations of the art and literature of several African societies, undertaken in an attempt to understand their nature. My purpose in doing so is not because I have a naturalist's curiosity but because I believe that coming to terms with our past misunderstanding of these societies can help us to understand our own Western societies.

It will help us, for example, to understand that the distinctions we ourselves make are artificial ones, such as the distinction between visual art and literature made by all books on African art. The art of Africa cannot be understood if it is examined separately from the literature, any more than the literature can be understood separately from the art. It may sound as if, in talking about literature, I am thinking only of oral literature; in fact, what I say applies to the modern literature published in books or written in English and French as well. Just as the nonindustrial African societies do not regard their visual art as something to be considered separately from their poetry, music and dancing, so it is impossible to consider the work of modern African writers without some knowledge of all the other arts which form a background to their work.

I deliberately use the term "nonindustrial" African art. This phrase carries a pejorative association, as if we were denigrating the older kind of African society, which is still very much in existence, every time we say that it did not have industries in the sense that we

now understand them. In fact, it is impossible to think of a phrase used to describe these societies in our language which does not carry some kind of pejorative association. "Traditional African societies," which is a more common and some think more acceptable expression, is to my mind an extremely misleading phrase and one which distorts the truth almost as much as "tribal African society." "Traditional African society" implies that African societies somehow handed down traditions from kin group to kin group, village to village, clan to clan, for thousands of years, and it gives an impression of an art which consists of static symbols—symbols that have remained the same since the beginning of time. We find this concept exaggerated in Mircea Eliade's *Myth of the Eternal Return*[1] and in Griaule's translations of the testimony of Ogotommêli, the Dogon sage.[2] I need not point out what an appalling solecism is committed when the phrase "primitive art" is used when talking of African art. Sociologists and ethnologists have been at great pains to justify their use of the word "primitive" when referring to "primitive societies." They have explained that they need a word to describe societies without centralised institutions, acephalous societies, before they were changed by our own centralised institutions. However, for the art historian the word "primitive" must carry a pejorative association. It is a word which sums up a particular phase in modern art and might be given a referential date to help us understand its significance in "modern art," the date when Picasso exposed *Les Demoiselles d'Avignon* to his friends for the first time (1907). Goldwater has explained to us in his *Primitivism in Modern Art* how the primitive meant

something "simple" and basic which, because of its very fundamentality and simplicity, would be more emotionally compelling than the superficial variation of the surface [and] that the further one goes back historically, psychologically, or aesthetically the simpler things become.[3]

That is, in fact, what it means for art historians, signifying a myth which was originated and perpetuated by the Romantic movement, the myth of evolutionary development in the visual arts, begun perhaps by the Nazarenes in the early nineteenth century, continued by the Pre-Raphaelites and applied for the first time to quattrocento Italian painting and coming only at the end of the nineteenth century

1. Eliade, 1954 and 1957.
2. Griaule, 1965.
3. Goldwater, 1966, page 251.

to mean African art, Oceanic art, Mexican art, Pre-Columbian art, aboriginal art, etc., but in particular African art. We have already forgotten the connection between Italian primitivism and "primitive art," but we have only to turn to James Barry's remarks concerning Cimabue's Rucellai Madonna in his lectures in the eighteenth century to be reminded of it:

The imitations of early art are exactly like those of children . . . the people then, of those ages, only saw so much and admired it because they knew no more.[4]

Belonging to a time when people "knew no more"—that is what the word "primitive" meant for artists and art history throughout the nineteenth century, and that is what it still means for them today, only today they are aware of the fear that it was a romantic illusion that there ever was such a time in any meaningful sense for art history (despite Gombrich's contortions to inform us that there was).[5]

What word can we use, then? Some people have suggested "non-metropolitan art," but that includes a great deal of art affected by the Industrial Revolution as we know it, and the characteristic of the African art that I am describing is that it has been gradually eroded by the Industrial Revolution until it is only a travesty of its former self. "Preliterate art" will not do because in any case we talk of "oral literature," and this art did not precede its oral literature. Nor can it be said to have existed without the use of writing, because it has existed side by side with writing in Africa for a thousand years, although it may be that, like the Yugoslav poets recorded by Lord in his researches on Homer,[6] the African sculptor, like the epic poet, forgets this art as soon as he learns to read and write. However, this reading and writing are products of the Industrial Revolution, and so we come down to the term "nonindustrial" because the African art we describe is destroyed by the Industrial Revolution. There is a clear division in Africa between the modern African artist educated in a technical college, art school or university art department and the kind of artist I am describing, just as there is a clear division between modern African literature produced and published in English and oral literature. It is not, however, necessary for the modern African artist to go to an art school for the division to take place. Ulli Beier's

4. Barry, 1809, vol. 1, page 521.
5. Gombrich, 1960. See Duerden, 1974, page 28.
6. Lord, 1953.

Oshogbo artists in Nigeria, for example, were distinguished by the fact that they "dropped out" after one or two years at art school.[7]

I have spent rather a long time discussing how to find an appropriate term for nonindustrial African art not only because of my embarrassment at not having a word to describe it but because the discussion about what word to use for it is instructive as an introduction to the linguistic difficulties that generally inhibit our understanding of African art, literature and society. These difficulties affect not only those whose original tongue is English but also the African writers themselves when trying to describe in English their own art and society.

A few years ago Robert Armstrong, in *African Notes*, published by the University of Ibadan Institute of African Studies, in Nigeria, listed a number of ways in which the Idoma speakers of Nigeria use their word for "god." It can be used for "to drill," "interpretation," "muslim prayers," a person's character, "rain," "god above," "guardian spirit" and for two kinds of tree—the kapok and the wild fig.[8] It appears, then, that there is no equivalent for the English word "god" in Idoma, that when we translate any word in Idoma as if it meant god we are using a word which has many implications in English which it does not have in Idoma. When we take a word such as the Idoma word ɔwɔ and translate it as "god" we are using a word which has many implications in Idoma which are missing in English.

There have been a number of discussions about whether there is such a thing as a high god in African religions. A report of a symposium which took place a few years ago concerning that subject can be found in the pages of *Odu*, the African Studies journal of the University of Ibadan (Ife).[9] In *Conch*, a journal of Ibo studies, Donatus Nwoga has written a perceptive criticism of English-speaking scholars who translate the word *chi* as meaning "god" and suggests it should be translated as "the central force."[10] Tauxier, writing on Bambara religion, said much the same thing over forty years ago about the meaning of Xo for the Bambara of the Ivory Coast and Mali.[11] I wonder, however, whether these discussions about the meaning of words or concepts in African societies will lead us any-

7. Beier, 1968, page 109.
8. Armstrong, 1960, page 12.
9. Verger, 1966.
10. Nwoga, 1971.
11. Tauxier, 1927.

THE INVISIBLE PRESENT

the societies I describe and that these symbols together constitute a language which can be used elliptically to discuss actual states of affairs which it is prudent not to refer to by precise locations or as precise events. In terms of the phrase used in the title of this book, they keep the present invisible. I have suggested that this ideographic language is actually opposed to any permanent code of symbolism in the art of each society and that, therefore, there is no similarity between that art and Western Medieval art, as many historians have suggested. I also suggest that it is this aversion to permanently and universally translatable symbols for the structure of the present, for what exists now and which is expressed in the ideographic language, that accounts for African societies' aversion to the use of writing, to symbols becoming recorded signs.

We shall also refer to dramatic performances in which the names of animals are adopted by performers to conceal the fact that they are playing the roles of living people known to all the participants. The particular roles played by each animal are consistent in many widely separated African societies.

I would like to acknowledge the help and encouragement I have received over the past twelve years while trying to reach the approach to African art outlined in this book from Ernest Gellner, who first commented on my tentative suggestions and was always available with proposals for comparison; from Kofi Awoonor and Wole Soyinka, whose confidence in what I was trying to say prevented me from abandoning the idea; and from William Abraham, who first led me to believe that my clouded perception of African society was worth submitting for consideration. I would also like to thank the following for the assistance they gave me in finding the material and for their discussions with me about its possible significance: Peter Baker, Julian Beinart, Lazarus Ekueme, Robert Gardner, Jack Goody, Mazisi Kunene, Godfrey Lienhardt, Christopher Middleton, Peter Morton-Williams, Hans and Gianna Panofsky, Victor Pasmore, Charles and Dorothy Patterson, "Burg" and Joyce Turner, and Frank Willett. Finally, I wish to thank Maxine McGregor for her unfailing patience in making a manuscript out of the first draft.

DENNIS DUERDEN

where except to show up the imperfections of the terms we are forced to use. What we have to do is to think ourselves into an African society and consider what it is like to live in it, what it is like to see the world from the point of view of an individual in that society. That is why writers of modern African literature are helpful in understanding African art and why African art is helpful in understanding African literature.

Sometimes social anthropology is useful, but at the present time it always seems to begin with structuralist assumptions, and nonindustrial societies cannot be understood in terms of the "either/or" of modern structuralism.

Having said all this, I must admit that I am forced to use words like "god" or "spirit" or "destiny" or "creative principle" when describing the beliefs of nonindustrial society. And the African writers in English—Chinua Achebe, Wole Soyinka, Kofi Awoonor, Elechi Amadi, Robert Serumaga and others whose work I discuss in this book —are all forced to use these imperfect terms when describing their own societies. However, by describing the way people think and behave in these societies, they somehow reveal to us some sense of the words that are actually being used by the people in their own language. It may appear that I am claiming that there is a unity in the cosmologies and psychologies of African societies south of the Sahara that does not exist. It is more fashionable these days to point to the difference in these societies than to attempt to discover unifying principles like those outlined in Father Tempels' *Bantu Philosophy*,[12] Jahnheinz Jahn's *Muntu*[13] or William Abraham's *The Mind of Africa*.[14] However, there are some striking similarities between the cosmologies of many African societies south of the Sahara, and there can be no argument that much of the visual art of Africa is unique compared with any other art in the rest of the world. It is, for example, true that it is very rare to find a society in this area which is interested in our own form of architectural display. There are very cogent reasons why this is so, and I have tried to suggest some of them in this book. The reasons are revealed by what I call an ideographic language of the symbols which are universal in these societies. In speaking of an ideographic language of the symbols I mean that the symbols have a well-understood significance which is common to all

12. Tempels, trans. King, 1959.
13. Jahn, 1961.
14. Abraham, 1962.

1 Time and African Art

Visual art in the West[1] is what we go to see in museums, galleries and exhibitions. It is constantly on display. An artist is someone who usually exhibits his work, and African art is what we see "exhibited." But the African art we see in Occidental museums is that which is comparatively invisible when we go to Africa. In Africa itself sculpture is not on display, although there are infrequent instances of its being shown. For example, when travelling through a Yoruba town in western Nigeria it is sometimes possible to see carved posts or carved doors. The doorways of the tall palaces of the Bamileke in Cameroon have elaborate façades, although the palaces are not easy to find or to approach. (It is said also that the Bamileke palaces catch fire every ten years.[2]) Generally, the European observer has to ask to see the carvings and masks which are so well known in Europe, and they are produced only if he is explicit on exactly what it is he wants to see. Some carved figures can be seen only in dark shrines. Some hang from smoke-filled rafters and are swathed in protective covering which may be unwrapped with great reluctance.

At present there are museums, such as the one in Lagos, which house vast collections, and there are traders who sometimes sell origi-

1. Although Africa is not "East" I use the word "West" to describe European and American identical cultures because that is the term writers and scholars use when characterising themselves and their own specific features.
2. Hurault, 1962, page 61.

nal works—that is, works which are not fakes or copies—and bring them to your door. To see some of the best sculpture in its own environment, however, it may be necessary to make a long and uncomfortable journey, and when the traveller arrives he may have difficulty in persuading the owners to bring out what he wants to see. When they are persuaded they themselves may have to go to considerable trouble to produce the work from the places where they have kept it hidden.

There is no similar problem facing us when we want to look at art in the West. There, art is always present for the artist or the art critic and the connoisseur. Apart from the continuous display inside and outside public buildings, examples, both good and indifferent, exist on the walls of practically every building we go into. Obviously European and African art exist for quite different purposes. It does not help to make the sweeping generalisation collectors often make— that all African art has a religious function and is brought out only on religious occasions. Even in the case of Occidental religious art there is a constant display, whereas it is the nature of African religions which causes African art to be hidden. It appears as well that the West not only displays its art, but what it cannot display it keeps as a permanent record, because we have a great faith in classified and recorded memory. The more our society has recorded its memories, the more pleased we are, and we do not feel happy until they are safely stored in a computer bank, in the way in which 110,000 items of African art in the ethnographic collection of UCLA were all computerised. The modern theory of evolution and the gene is essentially one in which everything is remembered. Given the code, we hope to trace back our history as far as the creation of the first amine in primeval chaos. The taxonomy of Cytochrome C is our guide to each evolutionary stage. In doing so, however, we are demonstrating that it is only a linear memory that makes us feel secure. Society is seen as a number of individuals who exist as discrete units each of which has a continuous linkage with the past. The fact that each of these units has a relationship with each of the other units in the present which is itself unique and distinct from the relationship between any previously existing set of units is ignored because each of us is conditioned to our preservation as separate individuals and to outlasting our contemporaries if possible. This produces the paradox that we devote considerable time and attention to the collection of antiques but very little time and attention to the preservation of marriages,

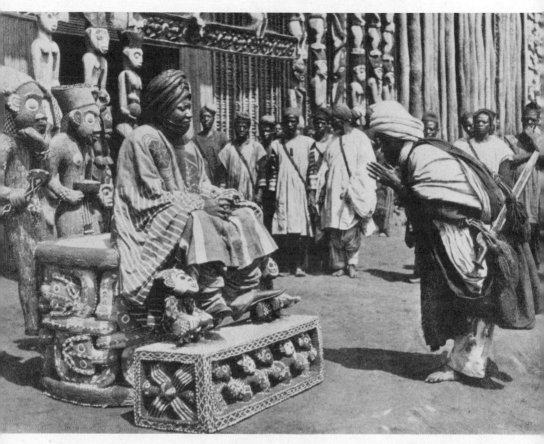

PLATE 1. A Bamileke king, with his feet raised from the ground, which they must never touch, sits in front of an elaborate palace, which may soon be burnt and rebuilt. All the ideographic representations are those of kingship, for example, the snake and the leopard. (Cameroon) *Division of Photography, Field Museum of Natural History*

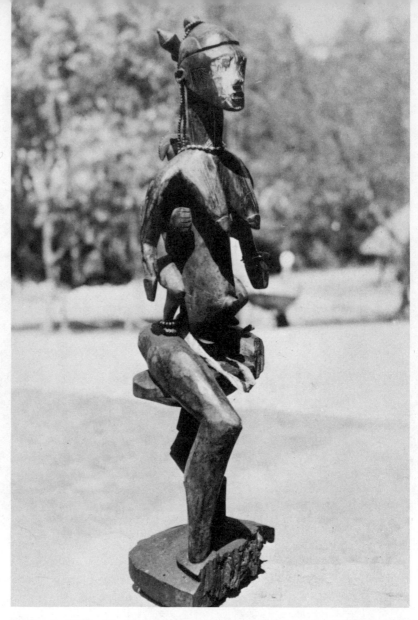

PLATE 2. This Afo figure was discovered by the author when it was taken out on a woman's head to dance at a "festival of the images," a fertility ceremony at the beginning of the new year in Nigeria, north of the Benue. It was being used by Gwandara people who had bought it from their neighbours, the Afo. Wrapping it to the waist, a cloth disguised the fact that it was slowly being destroyed by ants, but it was preserved each year until a new one was required.

to clubs for adolescents or to the care of the old and infirm. Spouses, children, parents, grandparents can be discarded, but old objects, books and information are lovingly preserved.

There is, therefore, no sense of an individual's development from birth through adulthood to old age and death, and old age and subsequent death is not welcomed in our society as the reward for a life lived successfully as its proper end;[3] they are resisted and, if possible, denied. At the same time, all our monuments are erected to the longevity of our culture. Thus we can see that our demand for computerised records and the preservation in archives of copies of every scrap of printed and written paper is the product of a compulsive demand for linearity, because a nonlinear sense of our history, a discontinuity in the past, creates in us too strong a sense of our own mortality; and it is death that we fear, whereas nonindustrial African societies welcomed it. A man's life was regarded according to the analogy of the seasons as an organic growing and dying, not as a link in an iron chain stretching back into the past and forward to the future.

For traditional African society the conscious and determined preservation of stored memories is a sacrilege. Perhaps the best modern description of the sacrilegious nature of printed memory is that given by the modern Ugandan poet Okot p'Bitek in his "The Song of Lawino." An uneducated African village woman laments the fact that she has lost her husband, Achol, to an educated African woman and that he lives on a hill in an iron-roofed house full of books:

> My husband's house
> Is a mighty forest of books,
> Dark it is and very damp,
> The steam rising from the ground
> Hot thick and poisonous
> Mingles with the corrosive dew
> And the rain drops
> That have collected in the leaves.
>
> If you stay
> In my husband's house long,
> The ghosts of the dead men
> That people this dark forest,

3. "The peaceful demise of an old chief with numerous progeny is as much an occasion for rejoicing in his life's achievement as for sorrow."—Bradbury, writing about the Edo in the midwestern state of Nigeria. Bradbury, 1973, page 213.

> The ghosts of the many white men
> And white women
> That scream whenever you touch any book,
> The deadly vengeance ghosts
> Of the writers
> Will capture your head,
> And like my husband
> You will become
> A walking corpse.[4]

Lawino tells us that "the ghosts of the many white men and white women . . . scream whenever you touch any book" in her husband's house. As we shall see, these images should be kept in ancestral shrines where they belong and should be kept hidden. They are the private property of the descendants of the ancestors.

Consequently, it often seems to members of old African societies as if Occidentals choose the African art which is not displayed in Africa and with great perversity display just that kind of art in their own countries, as if they wish to remember those things which African societies prefer to keep hidden. At Jos museum in northern Nigeria this was regarded as a ridiculous custom by local inhabitants, who went into the museum to laugh at the white man's habit of storing dead images, images which had been forgotten when they had been removed from the societies which used them and which the spirits themselves had no use for once the images were no longer stored in a shrine and used in a ceremony. It is important to remember that the spirits were not supposed to exist in the carvings, as is sometimes erroneously suggested. They were merely supposed to be present when the ceremonies required their presence and could inhabit the images of the men or the musical instruments or any other material vehicle which happened to be present.

We might logically conclude, therefore, that African sculpture is hidden precisely to prevent it from becoming a stored memory. In many cases it is regarded as destructible. It is better that it should be eaten by ants or decay to be replaced by the most contemporaneous expressions of what the society thinks, that it should slowly disappear instead of existing as evidence of what the society was like historically. In the same way old men are encouraged to take their memories with them to the ancestors. They may not impose them on their heirs who wish to be free to fulfill their own destinies.

4. Okot p'Bitek, 1966.

African sculpture is often made of very soft and therefore impermanent wood, but in one location—in Oron in eastern Nigeria—the ancestral figures were made of very hard wood, and they were thrown into the bush and abandoned; the white ants were left to do their worst. The wood used for these figures expressed the indestructibility of the old men of whom the figures were real-life portraits, but the act of casting them into the bush expressed the wish that they would join the forgotten ancestors and not hang around with their memories in human society.[5]

Therefore, the ambivalence of the living to the dead elders was implicit in the carving and the use made of the ancestor figures at Oron in the Rivers State of Nigeria. It is recognised in such a society that the ancestors cannot be forgotten suddenly, that they should not be buried and ignored and that important institutions exist for ensuring that the remembering of a dead elder should last until the vacation of his position in the group has taken place in a properly slow and ritual manner. Many of the people of West Africa make it obligatory upon a son to give his father a second burial. An Edo son in a village in Benin may not be able to afford his father's second burial for twenty years. The ghost of a father who has not yet had his second burial might make his sons and their wives and children sick or bring them other misfortunes, even to the extent of trying to get them to join him in the bush of ghosts by causing their deaths.[6] It is clearly understood in such a society that the influence of the elders does not terminate when they die and that it must be slowly phased out of the society.

An elder who has been successful while he was alive will behave well as a ghost if he is given the burial he deserves. Eventually he must be forgotten, but this cannot be done abruptly. (In fact, the ancestors are constantly urged to come back to the world in another's body.) Some old·men who do not have children or who have not left their children the wherewithal to give them proper burials become hostile spirits. Those men who acquire ancestral status are those who have benefited their families and their societies while they have been alive, and those who become hostile spirits are those who have made no contribution. However, the latter may not be held to blame for

5. As we shall see in the Edo funeral ceremonies described by Bradbury, one part of a man goes back to the bush, but another is "planted" in the house where he dies. See also page 62.

6. Bradbury, 1973, page 233.

their behaviour while alive, for it may be that they had ill luck as a result of their arranged destiny. When they become spirits they must be avoided, if possible; if not, placated.

There is an important psychological assumption which is fundamental to this belief and is at variance with the nineteenth-century psychology of the individual, whose assumptions are built into our Western assumption about the place in the world of our society. This principle is that the ego is not found in the separate human body but exists in the group in which a man lives.

A man's ego cannot exist on its own. It is this principle which explains why the present is never visible. What is happening to me now is not just happening to me. It is happening to the whole group in relation to its environment, but the properties of the group are vague and shadowy. Its boundaries fade away to a distant horizon, extending from the family to the lineage, from the lineage to the clan, from the clan to the linguistic and territorial grouping. However, each man somehow constructs his own universe of such wider relationships, and this is what is meant by his personal destiny.

We must avoid using the word "symbol" to describe the part played by the Oron ancestor figures. They are temporary adjuncts of the ancestor's soul, but they do not symbolise the ancestor. Western writers often describe the concrete forms or words used in African visual and oral art respectively as if they were regarded as symbols by the people who use them, whereas it is extremely important for an understanding of these societies to get away from the sense of the word "symbol" used to describe identifiable objects existing in modern European art. A society which takes care that the ego is not distinguishable from the group and which regards the boundaries of any group as indefinite is one which avoids the use of representations of objects as if they were symbols. There is an understanding that symbols may become manipulable in the same way as things. Symbols are objects which may get out of hand, like the broom and the buckets in The Sorcerer's Apprentice, and words which become symbols may get out of hand in the same way.

This applies in particular to the individual's ego in the group. A man who looks at himself as an object, as a thing apart, is using himself as a tool and may himself become manipulable. Therefore, there is no way in which his ego can be spoken of as a discrete unit and given a label. There is no way in which it can be symbolised. Describing my ego in the group is not something which can be done

by using symbols, and attempts to frame a symbolism are merely like interposing a machine between the group and its environment. No work of art, no figures or masks, no poem, no dance must be allowed that kind of rigidity. Looking for a personal symbolism is also to make the Platonic mistake of trying to pin the flux down to some remembered forms which are alleged to reassure man about his immortality. As we have seen, this immortality is disputed by an African psychology and would cause great harm to the individual in the group. Therefore, it is necessary to devise a method of disposing of the ancestors by telescoping the genealogical depth and to invent elaborate methods of forgetting.

Nevertheless, it is obviously impossible for any society to avoid using a language involving symbolism; we all communicate complicated emotions and vague apprehensions about them to one another by representing them with symbols. A distinguishing feature of man is his use of symbols. It appears, however, that the artist in nonindustrial African society, be he poet, painter or storyteller, wishes to avoid making his symbols permanent, wishes somehow to prevent them from becoming universally accepted symbols. It follows that when describing the uses of art in African society we should make it plain that it appears as if generally accepted symbols are being used unintentionally and not state affirmatively that it is the intention of the artists to use such symbols. A form may become a symbol in this society in our sense when it has a static permanent existence, but at that point it may be found necessary to destroy it, to "pull it down."[7]

A society cannot entirely dispense with a common symbolism. It cannot dispense with some constants. Consequently, the act of destroying permanent symbols does produce its own symbolism in this society, a meta-language for the society's symbolic cosmology, which remains more or less permanent and seems to be universal in Africa.[8] For example, the opposition between sky and earth, expressing the idea that anything which rises too far into the air must be pulled down before it becomes dangerous (not an Icarus myth, because it applies to gods as well), seems to underlie all thinking about the

7. Richard Adams has suggested that the same symbols can be used in different ways at different times by the same society, depending on which group holds power (Adams, 1972). It is obviously true, however, that those members of the society who manipulate symbols—e.g., diviners—may regard them as having a different meaning to that which is given them by the other members of that society.
8. See pages xiii and xiv.

nature of man in society in the African societies we shall be discussing. It explains the distrust of literacy, the fear of figures made of bronze, the institutions for ensuring that no one family rules for too long and the personalisation of all innovations in the community in the form of spirits so that they can be limited by a human type of mortality.

This raises two further questions: To what extent is this domination of earth over sky a feature of myths in African society in general? And does it enable us to discover a unique feature in nonindustrial African societies south of the Sahara which is not common to other nonindustrial societies elsewhere in the world? If it is a unique feature of African societies south of the Sahara, then it would be possible to construct a model which would fit these societies and could be used to assist our knowledge of proto- and prehistorical societies in Africa such as those who lived around Tassili n'Ajjer in the Hoggar Massif eight thousand years ago and those who lived at Nok on the Bauchi plateau of Nigeria two to three thousand years ago. In other words, an analysis of African society which discovered an "African" paradigm would have at least one merit: It would suggest possible explanations of artifacts in societies which have no written history.[9] It is also necessary to assist in analysing Western misconceptions of African society so that we can see the assumptions with which our own society distorts the general picture of the nature of man, although we are arguing about societies which do not ask questions about the general nature of man!

Therefore, although it is obvious that our enquiry itself into this symbolic cosmology and our attempt to separate the diachronic from the synchronic is a completely alien one from that of the societies we are considering, its alienation from those societies should not be taken as a disadvantage. It carries no pejorative significance. We are merely seeking to discover the differences between those societies and our own, not seeking in a romantic way to assert that those societies are superior to our own because they have institutions for a gradual process of forgetting or because we are too concerned with the making of computer banks. Computer banks are necessary to our society and are unnecessary to nonindustrial societies and have in many cases destroyed them. However, neither type of society is superior to the

9. See, for example, Shinnie in Harris, 1971, pages 449–50. "Without a more detailed study of the nature of "divine Kingship" in African society, the existence of a God-King need not be taken as evidence of Egyptian influence."

other. Both have difficulties and problems common to any group of men living together. The problems of nonindustrial societies are those of any small group of men which needs to remain small. Our own society's problems are those of any very large, centralised society which needs to remain very large and centralised. However, it may be that our computerised society needs to benefit from the small group's understanding of their own nature in the earlier kinds of societies and to adopt some of their tolerance of small groups.

It will certainly appear to be true, however, that because of our own history of the development of centralising and rationalising authority all our descriptions of African society south of the Sahara have been distorted by our own paradigms. We see strong central organisations and unified structures as the ideal of all societies, and we impose on all other societies descriptions derived from a faith in these ideals that we attempt to understand. Consequently, we shall see that in the everyday invisibility of the sculptured art of Africa we can discover the key to an understanding of the thought and organisation of African society and also to its oral literature and to its modern written literature. It is the purpose of this book to try to discover the reasons why most African art objects are hidden away except for the brief space of time when they are in actual use, as well as to attempt to disclose the reasons for this singular fact in order to throw some light on African history and African writing.

We will show that many African societies cannot be understood by using a structural anthropology, such as that of Victor Turner, who sees change in African society in terms of a model he seems to have derived from the physical sciences. Individuals pass from one state to the next as they change from child to adult and from adult to elder. A state is "any type of stable or recurrent condition that is culturally recognised."[10] The individual leaves the state he is in, passes through an intervening or liminal period in which his state is ambiguous to a new stable state in which he "has rights and obligations of a clearly defined and 'structural' type and is expected to behave in accordance with certain customary norms and ethical standards."[11]

Turner emphasises the unstructured features of the liminal period (although he does admit that it can also be considered as a "realm of pure possibility whence novel configurations of ideas and relations

10. Turner, 1967, page 94.
11. Turner, 1967, page 94.

may arise").[12] He supports the theories of Dr. Mary Douglas in her book *Purity and Danger*[13] that initiates are ritually unclean because they have not yet assumed their rights and obligations in society. Therefore, they do not exist anywhere, are "invisible," are kept in a secret place and disguised by masks or painted stripes. When they are initiated they are brought into contact with the deity, "the unbounded, the infinite, the limitless."[14] We shall see in this book that we may arrive at a more perceptive understanding of the African societies we are discussing if we turn Turner's and Douglas' model upside down. It is possible, then, to regard the infinite as polluting, the whiteness of the sky as a symbol of impurity and deity as a destructive force to be kept isolated and guarded, hidden away except when its use is absolutely necessary. The initiates have to be exposed to its power in order to accept some of the limitations of structure, but structure is not regarded as a desirable characteristic or state. It is limiting and inhibiting. Kubik describes the way in which the male initiation house of the Mbwela of Angola (who are very similar to the Ndembu of Zambia, described by Turner) is a centre of creativity for the males of the village.[15] It is shielded from deity, therefore, in the same way that the crops are shielded from the king, regarded as bearer of deity among some West African peoples, lest he harm them with his fire. The initiates are protected by the earth in all those societies because the earth is the symbol of creativity and the sky is the symbol of rigidity, of fate and of death. Structure, stable states are something which have to be accepted, but they represent a kind of entropy. They are an unfortunate necessity of man's existence as a man, which he will escape from in the grave. But the grave does not mean death; the grave means continued living, avoiding stability and entropy. Death takes place, however, when a man leaves the world too early before he has reached the grave at the end of his life.

In the Bagre myth of the LoDagaa of northern Ghana, translated by Jack Goody, "the affairs of God bring great suffering"[16] and the gods ask that the Bagre society rituals should be performed "because of suicide, aches in the belly, pains in the head."[17] It is the white

12. *Ibid.*, page 97.
13. Douglas, 1966.
14. Turner, 1967, page 98.
15. Kubik, 1969, page 12.
16. Goody, 1972, page 135.
17. *Ibid.*, 1972, page 121. (But a recurrent formula in 'The White Bagre').

initiates who are the hawks, who are greedy and "made a din,"[18] the black initiates who are "the knowing ones" who understand the mystery. However, we shall see that in the Bagre myth "the beings of the wild" are the creatures who first obtained an understanding of the secret of god, deceived man in his innocence. They used their knowledge of god to limit man. It is as if god is a power which must be left remote and distant. If he comes near at hand, as in the person of a demigod, then his power can be used to harm men, and the creature using that power must be appeased. There is no need to appease the power of god while it remains with god, but it is dangerous when it does come close at hand.

God (or "divine power," as we shall see later that it is better to translate the concept) is therefore a source of the limitations on man of law and order which are enforced by the "beings of the wild" in Goody's translation of the LoDagaa Bagre myth. This concept of a power in the sky which is somehow imposed on the earth by beings superior to man by virtue of their knowledge of it, but nevertheless corrupted by the power it gives them and for that reason often to be regarded as hostile and malevolent, is a concept we find in many African societies south of the Sahara. It seems to serve the purpose of shifting the responsibility of men's misfortunes onto other beings and away from the remote, high god and therefore makes misfortunes the result of behaviour by spirits who are more controllable, less implacable and less perfect. Such beings can possess men in trances during masquerades and other ceremonies, and their behaviour can be observed and the means by which the social groups can meet the threats they propose. Persecuted minorities (such as the women in the peripheral possession cults described by I. M. Lewis in *Ecstatic Religion* where the Hausa Bori of northern Nigeria is a kind of women's liberation)[19] can be possessed by these beings and a ready excuse offered for their nonconforming behaviour. Priests and kings can be possessed by them in what Lewis calls "central possession cults" and excuse the unpopular regulations or ruthless sanctions which they have to impose on their people. We shall see in the next chapter that some of the most unpopular regulations or ruthless sanctions that have to be imposed are caused by a farming community's need to observe the seasons, by the need to regulate time.

It has been suggested that the regulation of time in nonindustrial

18. Goody, 1972, page 127.
19. Lewis, 1971.

communities differed from our own linear demarcation of time in that it followed a repetitive pattern. Man himself was seen as seasonal much as Shakespeare made Jacques describe him in *As You Like It*, taking part in a stage performance, but one which nature played out every year. Edmund Leach tells us that this concept of time is symbolised by Cronus, the Greek god who castrated his father, Uranus, because he kept pushing his children back into the body of Ge.[20] The Frazerian explanation of this repetition of an event is that it symbolises the farming year, which is why Cronus carries a sickle; he cuts the wheat in order to obtain the harvest. Mircea Eliade tells us that each time these events are ritually enacted, the people concerned are celebrating an *"illus tempus"* and creating the illusion that they do not grow old or die; they merely go on repeating events that have already taken place. Leach, however, sees this explanation as a circular view of time and prefers the theory that Cronus symbolises a theory of time as alternating like a pendulum. Hermes, the messenger of the gods, is symbolised as a phallus and goes backwards and forwards, taking souls to Hades and bringing back souls from the dead. Leach tells us that his explanation is of a "more structural kind," but it does not seem to be less a repetition of events than the *illus tempus*, and Leach's structural alternative in which the phallus of Hermes is a third element in a charade of role reversal does not help us to understand the African societies discussed here any more than the opposition of chaos and order or pollution and structure in Turner and Douglas.

In Mary Douglas or Victor Turner there is a theory that African societies see man's development from birth to death as the opposition between structure and chaos (limbo). It is the major premise of this book that African society and especially its art can be best understood as seeing man as forced into a rationalised and rigid structure on the one hand and expressing a principle of individuation on the other. It is not the structure which expresses the values of the society but the unique individuality of each group and each man as part of his group. However, as we have seen, this is not an egoistic individualism. Each individual's unique characterisation derives from his particular group and does not exist apart from the group.

At the same time it is not possible to understand African art by means of Eliade's theory of the *illus tempus*.[21] African societies and

20. Leach, 1961, page 130.
21. Eliade, 1957, page 30.

African art are not trying to stand outside linear time and are not celebrating the eternity of a myth. Their time is admittedly not linear because it is the time of each group in relation to each group. Each and every group has its own time and its own space, and, therefore, there is no universal time and space, no dimensional coordinates common to every society. Time is conceived differently from our Western experience of time but is not conceived according to any idea of the original neolithic or primitive; it is not conceived as a mere repetition of the "*hieros gamos*"[22] of the seasons, like the time of Bachofen's society of the "*mutterrecht*."[23]

Why is it that we cannot fit it into Leach's pendulum structure as an alternative to the circular conception of returning to the "before time" of the *hieros gamos* (a pendulum structure which moves backwards and forwards from grandfather to father and father to grandson every two generations, or from the husband's family to the wife's family and back to the husband's family). In fact, this movement is from side to side, and if it goes forwards in a zigzag, as Leach suggests, it is still linear. It is clear that time, in the societies we are concerned with, is regarded by each group as related to the actions of ancestral figures in the past. In other words, the passing of time does not just mean a renewal of the same physical events each year, the fertilising of the crops by the rain from the sky in the spring and the cutting off of the ripened heads of corn in the autumn, so that the events keep coming round on a turning circle; nor does it mean simply the alternation of generational solidarity or marriage alliances. It means instead a series of events in the past which helps to create the group in its unique character but which fits into a different series of intervals for another group so that their character was created by their own series of time intervals. The constants for one group are not the same as the constants for another group. Consequently, time is seen as expanding forwards and outwards like a fan and is neither linear, circular nor alternating. Events are forgotten if they are destructive to one group, but they might be remembered by another. Each group embraces events in its memory which adds to its personality as a creation of that group.[24]

22. See McCall, 1971, page 47
23. Bachofen, trans. Manheim, 1967.
24. This concept is expressed very well in a passage in the novel *Return to Laughter* by Eleanor Bowen (a pen name for Laura Bohannan), which is the fictionalised diary of anthropological work in the field that actually took place:
Cutting through the moon was, for me, a complicated combination of weeks.

It seems as well that the comparatively small societies we are discussing not only remember creative events and forget destructive ones but deliberately refuse to adopt symbols which will last long enough to be destructive to the existence of these societies.[25] This model of a human society with a natural process of forgetting and remembering provides at the same time a feasible explanation of the phenomenon of nonliterate societies, which seems to be the most difficult phenomenon to explain in human society. There is no difference in mental capacity between the people in a nonliterate society and those in a literate society, although people in recently nonliterate societies have often thought it necessary to explain why they and their society remained nonliterate or have gone to great lengths to explain that it was in fact literate at some earlier date. There seems to be some spurious feeling that it was inferior to be nonliterate, which has been engendered by the efforts of the literate to assert their superiority. However, if literacy was regarded as essential by a nonliterate society, it is extremely difficult to understand why a written script was not adopted by that society. The society that produced Stonehenge must have had methods of making written calculations. The Ifa priests of the Yoruba had a complicated system of written symbols for their divination formulae, as did those of the Maya and several other nonliterate societies. Why, then, did they not use their symbols for communication?

At the same time, scripts existed in some societies for particular uses which were borrowed from other societies but were not in general use for communication. Such scripts were often regarded with great suspicion and were believed to have magical powers. Even today the drinking of "Muslim soup" (charms written in Arabic and washed off and drunk) by Nigerians is thought to confer invulnerability. A politician member of the Osagie society in the midwest state of Ni-

First there was the cook's seven-day curry week, high-lighting Saturdays. Then there was the five-day cycle of markets by which everyone made engagements. Finally there was the seven-day "beer-brewing" week which culminated in a named day impartially designating "Sunday" and "beer-drink." All these weeks ran concurrently, Kako's market coinciding now with curry Saturdays, now with beer Sundays, until, one day, Kako's market, Saturday and Sunday all happened at once and none of us could figure out how.—Bowen, 1954, page 69.

25. At Tassili n'Ajjer the introduction of signs in place of visual representation destroyed the vitality of the rock paintings, a reversal of theories of artistic evolution, such as that of Gombrich's *Art and Illusion* (Gombrich, 1960). Tassili rock paintings show a slow change from vivid representation to referential and schematic signification.

geria claimed before a public enquiry that if he drank Muslim soup he would be invulnerable to any bullets fired at him. Histories and despatches were written both in Arabic and in local languages in Arabic script in West Africa but were written and read by the "mallams" of the chiefs' courts. It was the need for these mallams in courts such as those of the Habe and the Yoruba in Nigeria and the need to import them from outside, which eventually led to the palace revolutions of the Fulani and their seizure of power.

What caused the fear of literacy? We have an even older example of a society refusing to become literate related to us by Caesar, writing of the Druids:

Report says that in the schools of the Druids they learn by heart a great number of verses and therefore some persons remain twenty years under training. And they do not think it proper to commit these utterances to writing, although in almost all other matters and in their public and private accounts they make use of Greek letters. I believe that they have adopted the practice for two reasons: that they do not wish the rule to become common property, nor those who learn the rule to rely on writing and so neglect the cultivation of memory; and in fact it does usually happen that the assistance of writing tends to relax the diligence of the student and the action of the memory.[26]

The two reasons that Caesar suggests for explaining why the Druids resisted the introduction of writing are conflicting. On the one hand, they wished to preserve their power, their monopoly of knowledge. On the other hand, they feared that memory and the preservation and transmission of this knowledge would suffer. It appears, therefore, as if they wished to keep their knowledge to themselves and, at the same time, were frightened that if they learned to write they themselves would lose their knowledge.

This is a feature of oral knowledge which has been borne out in our own century by the researches of scholars of Homer. G. S. Kirk, in his article, "Homer and Oral Poetry," wrote of the Serbo-Croat bards that they, in common with Homer, had an "exceptional verbal and rhythmic memory and complete familiarity with a large and varied stock of standard or formula phrases and themes"[27] and that the impact of writing was highly deleterious to those essential oral qualities. Field work by Parry and Lord in Yugoslavia proved this to be true.

26. Caesar, trans. Edward, 1917, Book VI, page 14.
27. Kirk, 1964, page 80.

It is often true, as Caesar suggested, that the priests in a non-literate society are jealous of their knowledge and their powers and reluctant to place them at the disposal of others. Their position depends on their reputation in the face of great competition and rivalry. Franz Boas has described how a Kwakiutl Indian shaman in Canada lost face to such an extent that he disappeared with his entire family and returned a year later, having gone mad.[28] As we shall see in modern African literature, there has been a great concern with the investigation of this theme. Examples are the rivalry between Ezeulu and Ezedemili in the novel *Arrow of God* by Chinua Achebe (Nigeria)[29] and the alleged superiority of Anwuanwu in *The Great Ponds* by Elechi Amadi (Nigeria).[30]

Present-day social anthropologists are still following Caesar in attributing the priests' resistance to writing in many pre-literate societies in the rest of the world as well as in Africa to a political motive, a means by which the priest preserves his power. Another political motive for restricting literacy might be the prevention of conflict. Melville Herskovits told how, when he asked a Dahomey elder to relate his senior wife's clan's history, he replied that it was a mystery guarded by his wife's clan's elders and was no business of a member of another clan.[31]

Wyatt MacGaffey has described how the Bakongo elders advised him that the truth could never be ascertained from more than two or three elders gathered together. When he entered a meeting of clan elders and asked for an account of the history of the houses and lineages of the elders at the meeting, "the pauses grew longer, the compromises less satisfactory, the shuffling of feet more evident."[32] In a society in which lineages and clan histories are fuel to keep old quarrels burning, written histories are obviously a permanent reminder of feuds and hatreds. When the Fulani lineage succeeded to the Emirate of Zamfara, they destroyed the written chonicles kept by their predecessors and had a new one written in accordance with their own version of Zamfara history. Perhaps this explains also the fact that the Ashanti chiefs employed Islamic scholars to write letters in the Ashanti language, Tsui, but in an Arabic script, while they

28. Boas, 1930.
29. Achebe, 1963.
30. Amadi, 1969.
31. Herskovits, 1958, page 15.
32. MacGaffey, 1970, page 35.

and their people remained illiterate and did not care to write their language down themselves.

There are two political reasons, then, for resisting literacy and the use of written records. On the one hand, there is the desire of the priests or rulers to keep their knowledge and esoteric mystery to which they have privileged access; on the other, there is the desire of social groups to avoid conflict by obliterating records of past quarrels. These are the reasons which have been emphasised by Western theorists of social structure in recent years. However, the second motivation of Caesar's priests for avoiding the introduction of writing —the fear that it might actually harm the knowledge they possessed— may be the more important one and leads us to question whether the preservation of power and the conflicts it produces are in fact the best way to describe the actions of the priests in these societies. As we shall see later, power is not regarded as a desirable objective in nonindustrial African societies (and it may be that past nonindustrial societies in other parts of the world regarded it with the same kind of abhorrence). Igwu, the priest of Aliakoro in Amadi's novel *The Great Ponds*, resisted using his powers to harm Olumba in the neighbouring village of Chiolu because Olumba had sworn an oath that if he died in six months some ponds rich in fish would be seen to belong to Aliakoro. The priest of Ogbunabali, the god of the night, had promised them that his god would kill anyone who tried to kill Olumba by "strange charms or witchcraft."[33] Igwu was happy working in his own village on small difficulties afflicting his fellow villagers and was drawn reluctantly into a head-on conflict with a powerful god by the aggressive Wago, the leopard killer. In such societies a priest might not wish his knowledge to be more widely disseminated because of his fear that it might be used for harmful purposes. In Western societies we are strongly attached emotionally to the idea that knowledge should be available to everyone, that there is no justification for withholding knowledge on the ground that it might do harm. In nonindustrial African societies, however, it is thought that knowledge is dangerous when used by people who nurse hatred, individuals who are sometimes classed as witches. In such a society knowledge must be used in the interests of the well-being of the whole society and is not the prerogative of any individual who might work against the interest of that society. The society's memory must be

33. Amadi, 1969, page 94.

controlled by a natural process of dying and rebirth. It is not controlled, however, by the imposition of a unifying structure to which everyone must conform. Structures must be subject to continual change. Harmony in the society is not achieved by the stability of structures. Rather it is achieved by ensuring that no structure will last too long, and therefore it is important that the memory of a particular structure should not persist in the society when it starts to destroy the equilibrium achieved by competing groups. Although it is accepted that patterns of behaviour are handled with great care from one generation to another and the acquisition of responsibility is made into a long and difficult process, the rigid uniformity of patterns laid down for members of different groups is naturally often felt to be restricting and irksome.

However, it is important that the knowledge of how to control the memories of competing groups so that no one memory limits the others' should be handed down, and the transmission of this knowledge is a difficult and important task for the elders and priests in the society. It is a knowledge of how memory can be controlled in such groups in the interests of the individuals who make them up.

This kind of knowledge must have been available to Plato when he wrote the *Phaedrus*, perhaps the earliest discussion we know which is devoted to the disadvantages of literacy and one which is extended to a discussion of the disadvantages of "programmed" verbalisation. Plato begins by putting an argument on the nature of time into the mouth of Phaedrus, who in turn reads an argument obtained from the rhetorician Lycias. Lycias argues that the care of a man for a boy whom he does not like is superior to that of a lover.[34] Socrates points out to Phaedrus that the argument is ill-conceived and repetitive, and he himself states a case against the attentions of a lover on the grounds that a lover is maddened by passion and is therefore inconsiderate and overpossessive of the boy he loves. But then Socrates says that he feels he has committed a blasphemy and must correct it by arguing the case for a lover to avoid incurring the displeasure of the god of love, asserting the superiority of heaven-sent madness over man-made society.[35] Lovers are those who strive to become possessed by a god. "Reaching out after him in memory, they are

34. The whole argument should be considered against the background of the Greek practice of taking boys as lovers in a relationship in which they would learn acceptable behaviour from an older man. See Vanggaard, 1972.
35. Plato, trans. Hackforth, 1952, page 56.

possessed by him and from him they take their ways and manners of life, in so far as a man can partake of a god."[36] Therefore, a lover is he who cultivates his soul's memory of a god and pours out this memory into the "soul of the beloved."[37] And so when Socrates relates the myth of the invention of writing by the Egyptian god Thuth, who claimed it would improve memories, he tells Phaedrus that Thamus objected to Thuth's claim on the ground that what he had discovered was a "recipe not for memory but for reminder."[38] It is clear that Plato had a special kind of memory in mind—the soul's memory of the god from which it derived its own being and to which it owed its particular disposition.

Plato's arguments in the *Phaedrus* against the virtues of literacy therefore are not the arguments of a guardian of esoteric knowledge who is afraid of losing his power like the shaman, nor are they the arguments of a guardian of political secrets who is fearful that writing will keep alive old hostilities and resentments, especially those against the families in power. Plato argues against literacy because he regards knowledge as a kind of divine madness which can be passed on by means of oral discussion, by means of the dialectic. Any other form of knowledge becomes rigid and inflexible, like rhetoric. "Any work . . . is a matter of reproach to its author . . . if he regards it as containing important truth of a permanent validity."[39] Plato makes Socrates describe writing as analogous to painting. "The painters' products still stand before us as though they were alive; but if you question them, they maintain a most majestic silence. It is the same with writers' words, they seem to talk to you as though they were intelligent, but if you ask them anything about what they say, from a desire to be instructed, they go on telling you just the same thing forever."[40]

Plato's *Phaedrus*, in fact, provides a fitting introduction to an account of why African societies south of the Sahara do not display their art. The members of these societies do not reject everything that has been remembered in a visible and repeatable form, and often a visual repetition of learned behaviour is provided in the dance (a form which Plato also recommended as a means of passing

36. *Ibid.*, page 100.
37. *Ibid.*, page 100.
38. *Ibid.*, page 157.
39. *Ibid.*, page 161.
40. *Ibid.*, page 61.

on prescribed behaviour patterns, in his last work, *The Laws*).[41] The dance enables individual members of a group to learn to behave as part of a group without hampering their own innate dispositions. Various cults with various dances exist, and when an individual does not fit into a particular cult, cannot dance its dance, he is advised to join a cult more suitable to his disposition, with a god his particular soul remembers.

Plato's psychology seems to be very close to the psychology of nonindustrial African society. The social groups are cults, dedicated to a number of gods, but we shall see that they regard each individual as a creative part of his group and that his particular contribution must not be so constrained that it does not add to the creative development of the group; he must be left free to express his own dialectic. In his final prayer to the divinities Socrates asks, "grant that I may become fair within and that such outward things as I have may not war against the spirit within me."[42] This sentiment is expressed throughout African art and literature. A man's memory of his god must remain his personal experience. It must not be destroyed by external forms. A man in a group has to accept the need for certain patterns or constraints, expressed in habits of daily life and in the dance. However, it is important that these patterns should not become a rigid *Gestalt*. Nonindustrial African societies have ways of avoiding the rigidities of the *Gestalt*, in particular by the use of cults and of divination. In order that the cults and the diviners are able to carry out their functions the art must never become a frozen symbolism, must never make the structure of the present into a lasting and visible structure which takes too long to destroy. The present must become *invisible*.

41. Plato, trans. Bury, 1926, Vol. 1, pages 91 ff.
42. Plato, trans. Hackforth, 1952, page 66.

2 Limiting the King's Power

Literacy has obscured a knowledge of the psychology of the individual. It has emphasised man's capacity to communicate his knowledge of the external world and has neglected his knowledge of how to communicate with individuals in his immediate vicinity. The non-literate societies of Africa have preserved this knowledge of communication between individuals in small groups, and their art reflects the preservation of this knowledge. Art is hidden away or destroyed, made invisible in African society so long as it is lineage art, because members of lineages are afraid of permanent constants. They have understood that the fear of dominating, powerful and lasting constants is a permanent fear of the human individual living in a group. Man's dynamic unconscious is afraid of the rigid pattern, of the Gestalt which is supported by wealth and political power and imposed on him by other individuals. We shall see that the current view of a nonindustrial society is that it is constantly imposing the Gestalt, not constantly destroying it, but that this approach is not a helpful one when considering African art.

In nonindustrial African society the fear of the rigid Gestalt is expressed by the way in which the king is isolated from the elders and the adult societies. It is the elders' and the mature adults' fear that the king's imposed pattern might last too long which makes them enclose the king in a prison of taboos and prohibitions.

An individual is initiated into the association of the adults at a very

25

early age, and that association is a kind of "closed shop" which he or she may not join until they are nearing puberty. Belonging to the association shows that they are ready to learn to accept the responsibilities of parenthood but does not imply that the process of learning can be completed at the initiation ceremony, as some writers seem to suggest. Membership in the association means that they will attend future initiation ceremonies and future annual festivals and will gradually take up the full responsibility of their roles as adults by teaching what they already know to their juniors. They will assist at ceremonies until they are old enough to conduct them themselves.

Usually they find that the acceptance of full responsibility involves their opposition to the elders who form their own association and that on the deaths of their fathers or brothers they too may become eligible to join the association of elders; but obtaining access to the full status of an elder is another long process rather like the one they began as a young initiate and went through in order to become a mature adult. The association of elders can make the process difficult by making success depend on the learning of secrets they preserve for themselves and on the making of sacrifices and the distribution of food and drink at prescribed ceremonies which a poor man can ill afford. It is in consequence of carrying out these necessary conditions that the eldest son of a deceased Edo elder in Benin in Nigeria may lose his inheritance to his brother who is wealthy enough to meet the obligations imposed by the elders and is entitled to replace him if he can give his father an adequate "second burial," the conditions for which are dictated by the elders. We shall describe such a second burial in Chapter 4.

Many African societies do not have kings, but they do have clans, whose senior elders are chosen to lead them and to guard the secrets of the ancestors. They often keep the secrets in a box or a basket which is guarded by the representation of the founding ancestor of the clan. In such societies the senior elder guarding the clan's box of secrets may appear to have the same position as the king. The adults' associations are his opponents if he becomes too powerful. The opposition between the senior elders and the mature adults is expressed in the art by the hieratic rigidity of the figures guarding the ancestral box of secrets and the flexibility and openness to innovation of the masks. The elders' associations themselves are the upholders of the rigid conformity to the patterns established in the past by their im-

mediate ancestors and the mature adults' associations. Side by side with the age associations of the mature adults there may exist cults for individuals who are so nonconforming that they have become alienated. Adults' associations are institutions in which everyone can avoid rigidity and which individuals can join at an age when they most fear and dislike rigidity, and there are cults they can join if they have rebellious personalities. (There are cults which exist for overconforming personalities as well.) Some cults, such as the Ekine masquerade of the Ijo Kalabari in the Delta region of Nigeria, use possession by the most feared water spirits who come from the farther points of the community and are the most difficult to control. The members of the Ekine society are not individuals who fit into the normally accepted hierarchical pattern of society, and yet the values they express in their masquerade are the values expressed by the behaviour most highly esteemed in an Ijo Kalabari man.

It is easier, however, to show the negative results of rigidity in order to understand how the nonindustrial societies expressed their antipathy to rigidity and how this antipathy is the underlying principle of their institutions by describing the institution of the so-called "divine" king. We shall see how "divine" kingship is more like a burden borne by certain royal clans and how, although individuals in these clans are proud to belong to their clans, they often accept the office of king with great reluctance.

The lineages in noncentralised African societies have a very clear idea of the development of the individual. In fact it is the development of the individual which is the principle concern of such a society and explains why certain institutions are avoided, except when they are absolutely necessary for coordinating arrangements, which means the welfare of groups of lineages. Political theorists in Western society have been overconcerned with the development of centralising institutions. They have not paid attention to the fear and abhorrence that family groups have for the effect of this centralisation. Even an anthropologist who approached human society from the point of view of ritual and avoided a utilitarian approach, such as Hocart,[1] saw

1. Hocart, 1970, page 97:
The fundamental thing about kingship however seems to be that the king is identified with the sky, and amid the sky with the sun. It is here then that we must look for the reason why the embodiment of one deity should have been chosen to lead, and then to rule, rather than the embodiment of other deities. It must lie in the nature of the sky and the sun, or rather in the

the "sun king" as someone who had established himself as head of a hierarchy of court functionaries and ignored the fact that his blinding light was not thought of as an unmixed blessing in such a society. He and his queen and the members of their clans were often kept hidden away except when their presence was an absolute ritual necessity.

Let us therefore look at Hocart's "sun king" from the point of view of the individual in the family and as a member of a lineage. It may appear to contradict the theory that kingship is regarded as a necessary evil but one to be avoided whenever possible, that some societies should preserve royal clans and that members of royal clans are proudly conscious of their royal blood. First of all, then, it is necessary to anticipate the idea of destiny, which I shall discuss in Chapter 3, in relation to the Western idea of God. An individual is regarded as deriving his personality from his upbringing, but he obtains his destiny, the general course of his path through life, from the sky around him. The sins of the fathers are very definitely imposed on the sons because a man's ancestors live in the earth and help to shape the course of this life, but first of all he obtains his own personal destiny from the course of destiny in the sky. Kings must then belong to lineages whose destiny is to become kings. The Yoruba personal soul which kneels before the source of destiny may not ask for the unattainable. If he asks for something unreasonable he will not get it, and therefore it is no good asking not to be a king if the individual concerned belongs to a royal lineage or a clan. However, such an individual is not going to become a king unless his destiny is approved by the ancestors of the other lineages, whose gods are those of the original earth.

The earth is the source of individualism of the kin group, in this case of its separate personality with a soul, which understands itself so long as it remains discrete and unique but whose boundaries merge imperceptibly with the larger grouping of the lineage, which in turn has its own soul and personality and is more controllable and understandable than the clan or group of lineages with a common apical ancestor.

The king represents order over an even wider grouping, a group-

beliefs about them. They must be conceived as playing a predominant part in the universe.

It is, however, the general argument of this book that there is no rule that can be applied universally to associate particular symbols with particular roles in African society. We point out in Chapter 8 that some African rulers are more aptly associated with the moon.

ing of clans, and therefore represents classification and rationalisation because the wider groupings can be understood only if they are subsumed under general, unifying concepts. The king symbolises the ruler that must be obeyed by the unique and individual personalities of the kin groups, but the need for submission to these rulers is often antipathetic to their uniqueness of character. The roles demanded by living in accordance with general principles, applicable to a large number of kin groups living in a wider territorial area, force each separate kin group and lineage into a rigid pattern which is abhorred and has to be as general and as loose as possible. It is the king's unenviable task to impose the more general rules, such as the days on which markets are held, to enforce general taboos by means of the death penalty or to determine when the crops will be harvested. In order to observe the people on whom he had to impose the rules, he has to sit up in the sky and therefore he is close to the gods of the sky. But the gods of the sky are not controllable by the priests of the group, and therefore they are remote from ordinary people's lives. Consequently, the king, whose destiny is controlled by the gods in the sky and not by ancestors and the earth, must remain remote from the members of the kin groups, even from members of his own royal clan. Thus, Henderson tells us that the Onitsha king[2] has to become a "ghost." Normally he carries a horse-tail switch, which ordinary men carry only at relatives' funerals, in his left hand (the hand of death) and may not meet the collective incarnate dead. (If the chief of the incarnate dead crosses his palace threshold he must stop being king.) He may not sit on the ground and is supposed to have no bodily functions. He must show no emotion in public, and no one should see his mouth open and see him eating or drinking. He is called "Rock which stems the flow of the great river" because rocks represent immobility and stability. He is secluded from contact with other men for fear of pollution, and all those who live with him must be secluded too. Because he is the bearer of the sky spirit for his people, representing their contact with the sky, his drums have to be beaten when the dawn comes, and no activities can begin until then. It is he who fixes the calendar and foretells the seasons. The most important of these functions is that of deciding when crops

2. The Onitsha king is a good example of the institution of kingship in Africa, which has widespread similarities in many African societies which have kings, because it has been described in very careful detail recently by Henderson in *The King in Everyman* (Henderson, 1972), and its ideographic symbolism seems very similar to that used by the priest in Achebe's *Arrow of God*.

shall be planted and harvested. It is important in a community which relies heavily on harvesting its crops and storing them and eking out a supply from one harvest to the next that the farming year should be carefully ordered. Crops must be planted, cultivated, harvested and stored at the right time. Otherwise, whole families would die of starvation. Therefore, the order imposed on the community is seen to be that imposed by the sun, the moon and the rivers. These are implacable forces which determine everyone's fate, and therefore they are sources of destiny. It is necessary that kings or priests should be dedicated to understanding them, but to accept this dedication is to be close to the implacable and to be tempted to use it without mercy to obtain personal ends. Therefore it is essential that there should be some control over the individuals who are close to these sources of power so that they should not be tempted to use them for self-aggrandisement or out of some megalomanic *idée fixe*.

How these forces are interpreted to the community by a king or priest and how his position as the regulator of the farming year may cause him to lose touch with that community has been described, together with all its intricate cosmology, expressing the encounters between individual personalities in the group, in a profoundly perceptive novel by Chinua Achebe, *Arrow of God*. Achebe's central character is described as a priest with the name of Ezeulu, or priest of Ulu, the deity of six villages. However, the same title in the Onitsha area of the Igbo people has been translated as "king." Achebe's priest seems to have the same functions as the Onitsha king and all the other so-called "divine" kings in Africa south of the Sahara, the kings of the Yoruba, the Igala, the Jukun, the Ashanti, the Mossi, the Baluba and many others spread across the continent who all behave like priests—that is, they carry out rites which help them to determine what pattern the sun, the wind and rains, or the sea and the rivers, are demanding from the community in a particular year so that its individual members survive. Therefore, it might be better to refer to these kings as priest-kings, although we risk confusion with the priests who have power over the kings, the priests of the earth. A distinction has to be made, but the English language does not seem to have words which can help us make this distinction. The kings are not priests in the same sense as priests of the earth are priests, and they are not "divine." (Ezeulu in *Arrow of God* is half man and half spirit while the spirit is seated in his head, but he is a

man carrying a spirit, not half of a spirit.[3]) African kings are con-
sidered divine only in the sense that all men are considered divine.
However, the word "king" does carry the sense of a man who sits
above the community and makes or ratifies binding decisions. As we
have seen, the king in nonindustrial African societies ratifies decisions
about the beginning and ending of the seasons and about night and
day, which have already been made by natural forces in the sky and
rivers. The word "king" also carries the sense of a regimen which is
opposed to the natural inclinations of mortal men (inclinations which
are symbolised by the earth, which in the societies we are discussing
is regarded as ultimately superior to the sky). For want of a better
word, therefore, we shall retain the word "king," but we shall see
that his functions are nearer to those of a rain-priest in African so-
cieties farther south.

To return to Achebe's *Arrow of God*, Ezeulu was made "priest-
king" for the six villages of Umuaro when they were losing a war with
another group of villages. He was chosen to unite them, but he was
chosen from the smallest of the six villages so that he should never
be tempted to acquire too much power. In the end he meets a force,
the British administration, with which he attempts to ally himself.
In doing so he adopts a position of self-destructive arrogance in rela-
tion to his own people, and they reject him and his god or spirit.
He sends his son to the local mission and is accused of sending him
there because the Christians' god needs a human sacrifice in order to
"sit on" Ezeulu instead of his own god, Ulu. He tries to stop a war
over land disputed with a rival group of villages, and when the British
administration steps in to stop the war, he is seen as their ally.
Offered the position of "warrant chief" on appointment of the
colonial administration, he refuses it. He is so proud of his strength
that he tries to demonstrate his power by delaying the harvest of the
new year, causing the yams to rot in the ground and the community
to go hungry. However, the whole of the encounter between Ezeulu
on the one hand and the colonial administration and the mission on
the other is expressed in terms of the priest-king with symbols which
are ubiquitous in Africa. We can compare him with the Onitsha
Eze, or king, who is the seat of a spirit from the sky and is associated

3. "One half of him was man, the other half *mmo*—the half that was
painted over with white chalk at important religious functions." Achebe, 1964,
page 241.

with tall trees, such as the kapok or the iroko tree, because he sits in a position where he can survey the widest circle or configuration. Sometimes he is part of a hierarchy of lesser gods or chiefs, as in the Ashanti in Ghana or among the Fon-speaking people in Dahomey, for example. The chiefs of the nine Onitsha nonroyal clans have similar, though lesser, powers to the king. They are closer to the earth, somehow more defined in their uniqueness and individuality, understanding the personality of their own clans and guarding their specific characters and understanding the demands of their particular environment in relation to their particular community, but they too can take life, a feature which is not general in nonindustrial African societies. (For example, in Jukun society, only the Aku, or king, can take life.) The right of the chiefs of the nine Onitsha clans to take human life is expressed by a chief's association with the silk-cotton tree.[4] In Arrow of God Akuebue, Ezeulu's son, describes him to a policeman: "He is tall as an iroko tree, and his skin is white like the sun."[5] Tall trees express the power of the chief because they emphasise his remoteness from the earth in his chiefly office, and yet the fact that his public appearances reenact his installation and a funeral at the same time emphasises that his spirit is remote from the growth and development of the kin groups, who do not die because they are regenerated by the earth. The king dies every time he goes back to the sky and his mortality, his link with the sky, must be reenacted every year to emphasise how transient is the rigidity of his control, his destiny with its source in the sky. It appears, therefore, as if many of the African societies we are discussing regard law and order as an unfortunate necessity which must be imposed within very rigid limits. The chief or the king must insist on only the bare minimum of rules. He can decide when planting and harvesting shall take place and fix the days of the calendar, the days on which certain gods can see that paths are kept open and that streets are kept clean and is solely responsible for the power of life and death over his subjects, but as soon as he exceeds these powers he can be forced into abdication or suicide. And so in Arrow of God the six villages said to Ezeulu's ancestor, "You will carry this deity for us. At first he was afraid. What power had he in his body to carry such potent danger?"

4. During their installation rites, senior chiefs must plant a kapok tree, the spiritual emblem worshipped by man-killers and linked with their personal Ikenga spirit; they must henceforth give this tree an annual sacrifice of a dog (the animal that symbolises death).

5. Achebe, 1964, page 173.

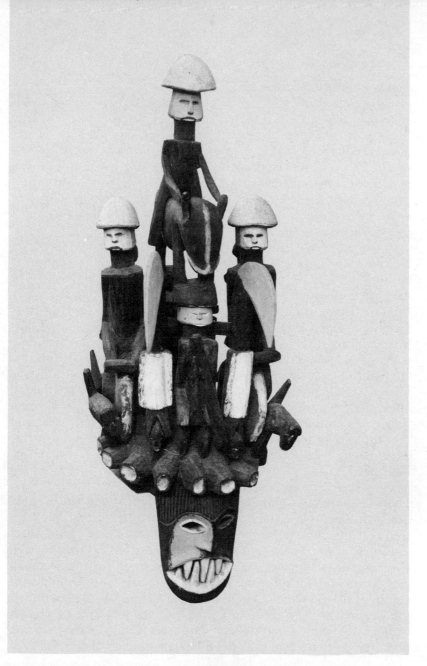

PLATE 3. Many carved figures and masks are painted half-white to represent that the owner or wearer is possessed by a demigod, "half man—half spirit." (Igbo, Nigeria)

And Ezeulu signifies that he is an ordinary man who has been deliberately set apart by an act of obeisance. "He went down on his knees, and they put the deity on his head." Later Akuebue tells him, "I am your friend, and I can talk to you as I like, but that doesn't mean that I forget that one half of you is man and the other half spirit." Consequently, being a priest-king or a king is not necessarily a privilege, and belonging to a royal clan does not necessarily carry great advantages, although members of royal clans are unusually pleased to be members of them whatever the disadvantages. On the other hand, they do not wish to be chosen as king.

It was assumed that the Ewi of Ado of the Yoruba people of Nigeria was very reluctant to become king, and he was "captured" by the efa, the town police, while he was hiding in the bush.[6] The member of the royal lineage who was chosen for the office was difficult to discover because he was so poor and had such a lowly position in society.[7] Kings may be chosen from these members of royal lineages or clans who have dissociated personalities. Kings are often reluctant to assume office, and their lineages are often outside the established power structure in the society which is controlled by the lineages of commoners. If they obtain a great deal of power while in office, it is regarded as a misfortune. The dangers of the power from the sky which is working through the king is expressed by the fact that the king is not allowed to visit plantations in case his dynamic power would burn the crops.[8] The king must not get angry, and he must put his hand in water to quench the fire if he appears to have taken offence.[9] To show that they possess the power from the sky, Jukun kings are not seen to eat, sleep or die. That is, they are not subject to the laws of organic matter derived from the earth. We have seen that the Onitsha king is regarded as dead or as a ghost, has a similar status to a "cult slave" and every year enacts his own funeral. He does this before the "new yam" festival by going into seclusion in a trance which is called his "dreaming" when he is smeared with a white chalk and is dressed in nothing but a loincloth. He mourns all the people who have died during the previous year and communes with his gods and the ancestors for four days. When the king emerges from his "dreaming" he has proved himself guiltless of the deaths of

6. Lloyd, 1960, page 227.
7. Henderson, 1972, page 130.
8. Lloyd, 1960, page 235.
9. Henderson, 1972, page 127.

those who died during the year and shows that he and the community have been filled with strength, fullness and richness of "life"[10] by emerging from the palace wearing his great headdress and performing a joyful dance. At the king's real funeral, however, it is the king's senior son who emerges into public view, wearing a king's attire, carrying his ceremonial sword and dancing to the war drums along with the senior chiefs.[11] The new king does this after he has spent twenty-eight days in seclusion and has been subjected to ritual humiliation, being insulted by the prime minister and being made to work with his hands in public, chopping wood with an adze, carrying a pot of water on his head, scraping the bark off a yam, pounding yam in a mortar and repairing the thatch in the prime minister's compound.[12] During his seclusion he sleeps beside the "king's termite hill," "to commune with the ghosts of former kings who are said to look at him through the apertures."[13]

The Onitsha king is now considered to be "dead." As he needs to act with the power of a ghost, he himself has had to become a ghost. During the installation ceremonies of other Nigerian kings who also enact their funerals the king has to run round a mound while being flogged. At their installation the kings of Panda were disrobed and clothed in women's loincloths. The Ewi of Ado was dressed in rags and beaten before being dressed in a white cloth.[14] Such rituals show that the king's existence is separate and distinct from the earth but is in no way a superior one. His tallness does not indicate that his tallness and apartness make him in any way superior to beings who live in and on the earth. He is the representation of unalterable laws, but these laws are an unfortunate imposition of the sky and the seasons. It is because he is a "being" apart, forced to live with the attributes of the sky, that he may not leave his "dirt" on the earth. Consequently, he is usually confined to his own compound and may not leave it except at the New Year's ceremonies. And so Ezeulu in Achebe's *Arrow of God* travels over to see the district officer and says: "I have heard one or two voices murmuring that it is against custom for the priest of Ulu to travel far from his hut,"[15] and to begin with Ezeulu tries to avoid making the journey. He tells the district

10. Henderson, 1972, page 396.
11. *Ibid.*, page 298.
12. *Ibid.*, page 303.
13. *Ibid.*, page 304.
14. Lloyd, 1960, page 228.
15. Achebe, 1964, page 162.

officer's messengers, "Tell the white man that Ezeulu does not leave his hut."[16]

We shall see that the "dirt" that a man leaves is regarded as an extension of his soul. Therefore, the "divine" king is not allowed to leave his dirt outside of his own compound. The stools and urine of the chief of Sukur in Adamawa in Nigeria were sent back to his compound when he was away from home, and the Jukun king's sputum was preserved in a cloth together with his hair and nail clippings. If we describe this as expressing his purity we are in danger of elevating him to a position of superiority he did not possess. The fact that he could not leave his excrement anywhere merely emphasised this separation from the living groups which were grown from the earth and on whom he had been selected to impose an unpopular straitjacket of temporal and spatial rules.

Sometimes individuals take it on themselves to try to impose such rules on the community without having a god "seated" in their head, without being chosen as instruments of implacable forces, hostile and antipathetic to growth on the earth. Their lives end in catastrophe not only for themselves but for the group to which they belong. An individual who tries to impose a particular solution on the group opposes forces which are bigger and stronger than himself in order to do so.

In Achebe's first novel, *Things Fall Apart*, Okonkwo's exaggerated pride is illustrated when he beats his younger wife during the week of peace sacred to the earth goddess before the crops are planted. "And so people said he had no respect for the gods of the clan. His enemies said his good fortune had gone to his head. They called him the little bird *Nza* who had so far forgot himself after a heavy meal that he challenged his *chi*."[17] A hostage, Ikemefuna, from another village is given to Okonkwo to look after, and when the oracle decides he must be killed, Okonkwo himself strikes the death blow with his machete, although he has been warned that to do so would be a sacrilege, as he has treated the boy like his own son. His impulse to hide any emotion or sympathy and to demonstrate an implacable strength is too strong for him. His friend Obierika tells him that what he has done "will not please the earth. It is the kind of action for which the goddess seeks out whole families."[18] Okonkwo's gun

16. *Ibid.*, page. 157.
17. Achebe, 1959, page 140.
18. *Ibid.*, page 119.

explodes and kills a boy at a funeral, the son of the elder who had warned him about Ikemefuna. "That boy calls you father. Bear no hand in his death." And so Okonkwo has committed a crime against the earth and has to leave his clan for seven years, returning to his mother's kinsmen. His son goes to join the newly arrived mission, thinking of the cruel death of Ikemefuna, and a woman who has always borne twins, who were immediately taken away, also joins the mission. Okonkwo sees in all this the fate of his personal *chi*, or destiny spirit. In other words, Okonkwo's place in his clan is that of a man whose father was well known and always in debt, and this leads Okonkwo to exaggerate his own ruthless determination and brings misfortune as a result. We see clearly here how the Igbo *chi* expressed the circumstances of a man's birth, his position, in relation to the forces in his social environment. Okonkwo's popular name was "roaring flame," but he sees that "living fire begets cold, impotent ash."[19] We also see here the idea expressed that will become more and more explicit in Chapter 5 of this book—that the exaggeration of a man's ego as a result of an ill-fated destiny spirit leads to an entropic state, one which cannot be fertilised by the earth. Okonkwo is not happy with his mother's kinsmen, although his mother's younger brother tells him that "mother is supreme." Okonkwo finds it is "like learning to become left-handed in old age."[20] His ambition has been to become one of the lords of the clan, and it now seems that this honour is to be denied him. When his mother's clan refuses to drive out the missionary and his converts, he regards them as a womanly clan. His father's clan would not behave like this. The village decides that the group can fight its own battles because Okoli, who is alleged to have killed the sacred python, dies, and so there is no reason to molest the Christians.

Okonkwo, returning to his own village, decides that a punitive massacre of a neighbouring village by the white administration as retribution for killing a white man was allowed to take place only because the people of the village were weak and foolish. "Why did they not fight back?"[21] The son of a snake priest outstrips the white missionary himself in his zeal for the new religion and rips up the

19. Achebe, 1964, page 140.
20. *Ibid.*, page 119. Women are associated with the left hand in many African societies, and the fact that the left hand is often the hand of death (see page 29) as well introduces us to the idea that we shall meet later that death and regeneration—or fertility—go together.
21. Achebe, 1964, page 159.

mask of an egwugwu, an ancestor returned from Mother Earth through an anthole.

That night the mother of the spirits walked the length and breadth of the clan, weeping for her murdered son. It was a terrible night. Not even the eldest man in Umuofia had ever heard such a strange and fearful sound, and it was never to be heard again. It seemed as if the very soul of the tribe wept for a great evil that was coming—its own death.[22]

And the next day the assembled egwugwu, members of a masquerade society, incited by Okonkwo, come to the church and reduce it to a heap of earth and ashes. Six members of the village are summoned to the district commissioner's office, Okonkwo among them, and they are locked up; their heads are shaved and they are kept without food until they agree to collect the fine imposed. When Okonkwo returns home his family see the stripes from the warder's whip on his back. He goes to a village meeting to demand war against the white man, and when some of the court messengers turn up, Okonkwo strikes off the head of the leader with his machete only to discover that the village breaks up in tumult. It does not want war. Okonkwo hangs himself, and the village people ask the district commissioner to let his men take down the body and bury it, as they must not touch it. It is an offence against the earth to commit suicide, and so a man's clansmen cannot bury him.

In Okonkwo's case the power which caused him to commit suicide was the British colonial administration, but it happened because he had a bad chi. There is a similar suicide of a man whose pride and arrogance cause him to oppose a power too great for his own individual strength in The Great Ponds, the novel by Elechi Amadi, from which we have already taken the example of a diviner. We saw how that diviner, Igwu, was forced against his will into a contest with Ogbunabali, the god of night, by Wago, the leopard killer, because Wago wanted a rich fish pond, owned by another village, for his own village, Aliakoro. Olumba, who has taken an oath that if he dies his village will lose the fish pond, lives beyond the time appointed by his oath, but Wago drowns himself in the pond before he can die of wounds incurred in a fight with Olumba. By committing suicide he defiles the ponds so that no one can fish in it, and he dies with a smile on his face.

22. Ibid., page 168.

"We have lost the pond of Wagaba," Diali moaned.

"Is Olumba dead?"

"No."

"What then?"

"It would be an abomination to fish in a pond in which someone committed suicide."[23]

We shall return to this novel to discuss how a power which is greater than any of the powers embodied in the gods of the village cannot be understood by any of the local priests. In the case of Wago, however, he was fighting with powers the local priests understood but against which his own stubbornness of character would not allow him to yield.

Nevertheless, even a man who has been chosen a "priest-king" in order to control local forces may suffer from pride and arrogance, and these can cause his downfall. The danger to Ezeulu in Arrow of God is expressed as a kind of fire burning him up. Thinking about the god sitting on his head: "The thought became too intense for Ezeulu and he put it aside to cool."[24] His burning with pride may mean that his particular sky-spirit has forsaken him, and it means that the people who chose him not only reject him but reject the spirit which has forsaken him and therefore forsaken them.[25] This explains the calamity which overtakes Ezeulu at the end of Arrow of God. He refuses to eat the sacred yams in time to assure that the new yams may be harvested and risks spoiling the crop by leaving it lying on the ground, as well as making everyone go hungry for several weeks. He does this because he has been kept away from his compound by the white man, and he takes great pleasure in proving his new power to the people. But it is as if he has been contaminated by associating with a greater source of power and is no longer sensitive to his limitations. His power has got out of hand. He says, "Who is to say when the land has been desecrated, you or I?" And his mouth is "shaped with haughty indifference."[26]

He has a rival, Ezidemili, who comes with a rival god, Idemili, the

23. Amadi, 1969, page 217.
24. Achebe, 1964, page 233.
25. Ibid., page 148. Akuebue to Ezeulu: "No man however great can win judgment against a clan."
26. Ibid., page 190.

water spirit, who he claims is superior to Ulu,[27] spirit of Ezeulu. Idemili holds the rain clouds up, and Ezidemili's head is severed from his body at death and kept in a shrine just like Ezeulu's. Both their heads, then, are kept away from the earth. Ezidemili always sits on a mat, and his feet may not touch the earth. His god is also symbolised by the royal python, which moves in a slow and stately way. Ezeulu's god, however, does not identify his real opponent, the British administration, but makes the mistake of claiming that Ezidemili's god is his opponent. He rebukes Ezeulu for the pride that is causing him to oppose the wishes of the community, but he mistakes what is causing it. The god himself is too arrogant. Ulu says to his priest, "Who told you that this was your own fight? Beware you do not come between me and my victim or you may receive blows not meant for you. Go home and sleep and leave me to settle my quarrel with Idemili, who wants to destroy me so that his python may come to power."[28]

However, at the end of *Arrow of God* we are not left with the understanding that Ezidemili has become Ezeulu's successor. Ezeulu's son was sent by his father on a sacrifice to the Christian mission, who is ultimately going to triumph with a new god, albeit the reign of that god may be as short-lived as the British colonial administration. Ezeulu's prophecy that the new god of the white man will triumph is expressed by the symbolism of the left hand. He tells the people in his village, "When I was in Okperi I saw a young man who was able to write his book with his left hand. From his actions I could see that he had very little sense. But he had power; he could shout in my face, he could do what he liked. Why? Because he could write with his left hand."[29]

By drawing people's attention to this singular fact about the white administrative officer Ezeulu is expressing his realisation that now the British colonial government has power over life or death, because, as we have seen, the left hand was the hand of death for the king of the Onitsha Igbo. It also symbolised the power over life and death of the Yoruba Ogboni society in western Nigeria, but the Ogboni society were the representatives of the earth who retained ultimate control over the king. In Yoruba society they kept the power of exe-

27. *Ibid.*, page 157. Ulu is established by a human sacrifice. The preservation of the head is also significant. See pages 70 and 73.
28. *Ibid.*, page 219.
29. *Ibid.*, page 213.

cution to themselves and placed greater limits on the powers of the king than he had among the Igbo speakers farther east. Again we are reminded of the association of the left hand with fertility as well as with death because of the Ogboni society's relation to an earth cult.

In the play *Kongi's Harvest*, by Wole Soyinka, the Yoruba Oba, Danlola, is imprisoned by Kongi, the dictator, and the prison superintendent has stopped the royal drums. Danlola swallows his anger at this desecration, and his words symbolise his submission to the representatives of the earth and explain the mockery which has been made of the habitual balance of power by Kongi with his Reformed Aweri Fraternity.

DANLOLA: Good friend, you merely stopped
 My drums. But they were silenced
 On the day when Kongi cast aside
 My props of wisdom, the day he
 Drove the old Aweri from their seats.
 What is a king without a clan
 Of elders? What will Kongi be without . . .
 Sarumi, what name was it again?
SARUMI: The Reformed Aweri Fraternity.[30]

The Reformed Aweri Fraternity is a group of intellectuals which Kongi has formed to discuss the affairs of state and to suggest solutions to Kongi's problems, such as persuading Danlola to present Kongi with a new yam at the annual yam festival, to symbolise the submission of his spiritual power to that of Kongi. However, the Reformed Aweri Fraternity has no power to depose Kongi in the way the Aweri had the power to depose Danlola, a mystical power derived from their understanding of Ogun, the god of death, symbolised by the left hand, and their relationship to the earth goddess and her powers of rebirth. It is this power Danlola acknowledges when he dances to the left: "Delve with the left foot for ill luck; with the left again with ill luck, once more with the left alone, for disaster is the only certainty we know."[31]

When describing the status of Danlola, Soyinka has the same problems that any writer of English must have when translating Yoruba into English. Sarumi, a junior Oba, sings Danlola's praises first in Yoruba and then in English. In Yoruba he sings "*orisa l'oba*,"

30. Soyinka, 1967, pages 3 and 4.
31. *Ibid.*, page 100.

in English "the king is a god," but the Yoruba cannot be translated exactly. The only translation possible is "the Oba is an Orisa," which does not mean "the king is a god" but that the Oba is a kind of demigod. It is important to remember, however, that the interpretation of ritual is not the same for all members of the community. Thus while some naïve members may regard the king as a god, those who are merely sceptical observers may regard him as possessed by a spirit on specific occasions and under special circumstances. A new play of Soyinka's, which he was still revising for publication at the time this book was written, is called *Death and the D. O.* and deals with the case of a rank-holder's son who committed suicide out of shame because his father had not had the courage to commit ritual suicide after the death of the Oba. The son had returned from a university education abroad, and one of the points made in the play is that his Western education did not overcome his impulse to see the old rituals carried out. His father, Elesin, was the Oba's chief of horse and has to die in order to lead the Oba's horse to him in the next world. When he fails to commit suicide the praise-singer speaks with the voice of the dead Oba:

PRAISE-SINGER: Elesin Oba! I call you by that name only this last time. Remember when I said, if you cannot come, tell my horse. What? I cannot hear you? I said, if you cannot come, whisper in the ears of my horse. Is your tongue severed from the roots, Elesin? I can hear no response. I said, if there are boulders you cannot climb, mount my horse's back, the spotless black stallion, he'll bring you over them.[32]

If there were sceptics in this particular Yoruba society, Elesin's foreign-university-educated son was not one of them. However, an alternative explanation is still possible—that the Oba's chief of horse had to follow him because he was too powerful and would stand in the way of the next Oba and the next chief of horse. The myth of the king needing his horse was a convenient way of dispensing with those who became too powerful while he was alive.

To return, then, to *Kongi's Harvest*, Sarumi sings:

We lift the king's umbrella
Higher than men

32. Soyinka, 1973.

But it never pushes
The sun in the face.[33]

Sarumi indicates that the king's power is not absolute and everlasting.
The king never claims to be a rival of god, symbolised by the sun. His
umbrella shows that he is part god or part kin to the sun because he
is able to shade men from the sun but not that he is god completely.
The drummer sings:

I saw a strange sight
In the market this day
The sun was high
But I saw no shade
From the king's umbrella.[34]

In other words, the Oba Danlola had lost the power to shade his peo-
ple from the sun.

Finally Oba Danlola agrees to present the new yam to Kongi when
he hears from his son that it is the wish of Segi, queen of the prosti-
tutes in the night clubs, and therefore the leader of rebellious youth.
She is the queen who has been the mistress of Oba Danlola, of Kongi
and now of Daodu, Danlola's son, on whom she has conferred the gift
of life and who calls her "My eyes of rain, Queen of the Harvest
Night." Her intervention ensures a period of chaos and insurrection
which she brings about by throwing open a copper salver containing
the head of an old man, her murdered father, in front of Kongi when
he is ranting and raving in his megalomanic speech: "no one is left
but Kongi and the head, Kongi's mouth wide open in speechless
terror."[35] In the last scene Kongi's organising secretary is flying
towards the frontier when he meets Oba Danlola, but Danlola, after
some deliberation, declines to go with him. His reign is over.

In *Kongi's Harvest*, then, we find that Soyinka has indicated
concepts found in many West African societies relating to kingship.
Oba Danlola is a chief who understands the power of the sun in
producing the yam harvest; Kongi is a dictator who tries to usurp
the Oba's mystical powers but in doing so incurs the wrath of the rain
queen, whose goddess lives in the sea and who confers life on the land.
Kongi's egotistical arrogance has caused him to ignore the mystical

33. Soyinka, 1967, page 8.
34. *Ibid.*, page 84.
35. *Ibid.*, page 84.

power of the rain queen and to imprison her father and, after Segi's father has escaped, to hunt him down and have him shot. The Oba has forfeited his own right to rule, however, having lost control of mystical power when giving way to Kongi. It is indicated that he should abdicate in favour of his son when Daodu gains the love of Segi, possessed by the goddess of life and fecundity. When he understands that Segi wishes it Oba Danlola agrees to take part in the dramatic confrontation of Segi's followers with Kongi at the yam harvest, a confrontation which reminds one of the *Bacchae* of Euripides and is, in fact, described by Soyinka as a "bacchanal."[36]

Kongi's Harvest, therefore, demonstrates the Yoruba pronouncement that the earth is superior to the sky. The king is chosen to bear the spirit of the sky, which is symbolised by the sun, but he must always defer to water and earth, who in this instance use the Orisa, Ogun, as their servant. The spirit of iron and of death, closely associated with the earth, he carries out the wishes of the earth and the sea when the king no longer understands the power of the sun; and he also destroys usurpers such as Kongi when they try to become false suns to impose an order which ignores life. We shall see that it is in the symbolic metalanguage of this association that we can discuss the reasons for the everyday invisibility of African art.[37]

36. I discuss Soyinka's adaptation of Euripides' *Bacchae* in Chapter 7.
37. It also explains the different uses of the two metals, bronze and iron, in African art. Iron is associated with the earth because it is a metal that rusts; bronze is associated with brightness and the sun.

3 Destiny and the Creative Force

The truth about matters of belief and the cosmology of African societies often seems to be a matter of conjecture. If two eminent African scholars, such as William Abraham and Kofi Busia, can give different versions of the African idea of god in Ghana,[1] while both have grown up speaking Akan languages, it is not surprising that Western scholars have also given conflicting descriptions of the same idea. In fact, one social anthropologist has admitted that his theories on the subject of a god in one African society changed over years of intensive research. Dr. Jack Goody has written in his introduction to The Myth of the Bagre, "in translating the Bagre myth of the Lo-Dagaa one was instantly struck by the fact that its whole tone and intent was much more 'theistic' than I, as a non-initiate, had experienced in LoDagaa religion, and as I had obliquely described it in Death, Property and the Ancestors."[2]

A Western account of the meaning that can be given to god and gods in a West African religion is that given by Robin Horton of the Ijo Kalabari of the Niger Delta. The Ijo Kalabari man has a tamuno, or personal creator, who joins his spirit to his body when he is born. Before he is born he tells his creator how he proposes to live on earth,

1. Abraham says that Onyame is not held to live in the sky by name, but simply above, up there (Abraham, 1962, page 54), while Busia quotes an Ashanti proverb: "no one shows a child the sky" and says that the sky is the "abode of the Supreme Being." Busia, 1954, page 12.
2. Goody, 1962, page 28.

and this *fiete boye*, "speech before coming," or *so*, "destiny," decides how his spirit will live once it has joined his body. Horton tells us how a man becomes the cult priest of one of the heroes because it has "held" him, but "at the climax of certain rituals" we see the priest standing before the symbols of the hero and crying, "My destiny gave you to me."[3] An individual can also be advised by a diviner to go back to his *tamuno* and ask for a new destiny if he is dissatisfied with the one he got, and this is called *bibi bari*, "calling back to the mouth."[4] There are also lineage destinies and village destinies, and if the members of a particular lineage have a particular kind of personality or a village has a particular kind of character, this also is attributed to their lineage or their village destinies. Finally, there is an *opu tamuno*, or great creator, a female creator of the whole world, closely associated with the sky, which is synonymous with her and, like destiny, signified by the word *so*.

Opu tamuno gives the community its *so*, but when the community no longer exists *so* goes back to its source. It seems as if even *opu tamuno* owes her existence to *so*, and her individuality as the creator goddess is of a union between *so* and the form given her by the world of which she is the goddess, as if she were the universe of all the individuals she creates. Between her and each individual person there are no subordinate essences of *tamuno*, but "while the group has no collective *tamuno* over and above the *tamuno* of its individual members, it must have a collective *so*."[5]

Similar accounts of a sky god who gives each individual his destiny at birth and takes it away at death are given for the Igbo of Nigeria by Henderson,[6] for the Yoruba of Nigeria by Bascom,[7] for the Fon of Dahomey by Mercier[8] and for the Ashanti of Ghana by Rattray.[9] For the Igbo, when an individual chooses to "enter the world" he makes a pact with a particular essential being (*chi*), selecting his length of life and his future activities; the choices so made are marked by the *chi* on his hand as his *akala-aka* ("marks of the hand"), or "destiny."[10] For the Yoruba, the ancestral guardian soul (*eleda*,

3. Horton, 1962, page 205.
4. *Ibid.*
5. Horton, 1962, page 207.
6. Henderson, 1972, page 107.
7. Bascom, 1969, page 115.
8. Mercier, 1954, page 228.
9. Rattray, 1927, pages 153–54.
10. Henderson, 1972, page 107.

iponri or *irin*) goes to Olorun, the sky god, before a child is born and, kneeling before Olorun, chooses its own destiny. The Fon *selido* goes to Fa, the will of the pair of supreme gods, for its *kpoli*, its destiny, in the shape of a bag of sand in which its life pattern, its *du*, has been traced.[11] Rattray quotes Christaller as saying that the Ashanti *Okra* leaves the body at death, and that is why a man pants while he is dying because the *Okra* is identified with the breath. The *Okra* is associated with a particular day of the week after which an individual is named, and the day is known as the one on which he "washes" his *Okra*.

We have seen that for the Ijo Kalabari, *so*, or destiny, is linked with the sky and *opu tamuno*, or the superior deity, with the sun, and it seems as if this ideographic symbolism to describe god is similar to that of many other groups of people in West Africa.[12] In general, the destiny souls are white souls which need ritual washing to keep them clean and are associated with the day of birth and the place in which an individual finds himself in the calendar. They give him a pattern from which he cannot deviate. The king must be so white and separate that he must not be seen defecating.[13] It seems to depend also on the perplexing and ambiguous concept of power or force, which is thought to exist in all phenomena, and is described by some interpreters as the concept of god and by some as destiny itself.

Of the Igbo *chi*, Henderson says that it is "life" (*n d u*) but also that it is the *chi* in a person (or "the spiritual essence of the being itself") and "the life essence of the entire universe, a universal self called *chi-ukwu* or *chukwu*." After looking at several other African cosmologies it seems as if Henderson may be wrong in identifying the Igbo life force with the universal self. We have seen that Horton

11. Abraham writes that the Okra is "the guardian spirit of man, the bearer and instrument of his destiny." Abraham, 1962, page 59.

12. "God, sun, sky and rain are a set of linked concepts, at least etymologically," but Goody goes on to say that he has never heard of the sun identified with God or any deity. Goody, 1972, page 25.

13. See Soyinka, 1967, page 4.
 The nude shanks of a king
 Is not a sight for children—
 It will blind them.
 When an Oba stops the procession
 And squats in the wayside
 It's on an urgent matter
 Which spares neither king nor god
 Wise heads turn away
 Until he's wiped his bottom.

48

makes a careful distinction between the Ijo Kalabari *so* and *opu tamuno*. Another description of the life force is the one in which Verger describes the *ase* of the Yoruba: "It embraces all mystery, all secret power, all divinity. No enumeration could exhaust this infinitely complex idea. It is not a definite or definable power; it is Power itself in an absolute sense, with no epithet or determination of any sort. The various divine powers are only particular manifestations and personifications of it; each of them is this power seen under one of its universal aspects."[14] Verger has taken *ase* and expanded it into a metaphysical principle which seems to owe more to Plato and to Hegel than to any African religion. Like Henderson, translating the Igbo language, he admits that there are other Yoruba words for "life" and other concepts of life but seeks to take one concept and use it to explain all the others. It seems more likely that there is a different universe and a different organisation of that universe every time a word is used. But for the purpose of the paradigm that we are investigating, in order to reach some understanding of African art, literature and society, as compared with our own, it is necessary to form some conceptualisation that will help us to understand the sense of the words used. If we assume that words like *ase*, *so* and *chi* do not stand for a personalised god, then it is possible we should be thinking of a cosmogony in which these words stand for a principle of form and which when united with the natural world produce ever-widening isochronous spheres of being. The sun or the sky is one member of this isochronism with superhuman powers; God is another. The sun is a member which has succeeded in keeping its power by adopting an inflexible pattern, producing night and day. Man can only ally himself with it and in doing so take on some of its characteristics of inflexibility which makes him dangerous to other men and to the earth.[15] Is this power some energised force the earth uses to produce creativity and individuality? The sky gives a man his destiny because it must be recognised that it imposes on him and his kin and social environment habits of behaviour which are extremely difficult to change. However, he can change his destiny by appealing

14. "We must realise that in Yoruba vocabulary *orun*, the sky, is associated with the idea of death, and the *ara orun* people of the sky are the dead; whilst *aiye* means world, earth, life and the *araiye* are mankind, living people." Verger, 1966, page 35.
15. It might also be regarded as a burden or responsibility for the individual. Henderson points out that the Igbo of Onitsha regard it as the ultimate goal for every person to lose his *chi*. Henderson, 1972, page 109.

through the priest to the sky. The intercession of the earth with the sky produces rain and water and those periods of a fertile but apparently chaotic interregnum between the reign of kings, when the rain queens manage the affairs of state, a period of chaos but a period of renewed creativity. Yet when Goody writes of the LoDagaa in Ghana, he warns us against composing an elementary diagram in our minds of an opposition between earth and sky because the LoDagaa also think in terms of a polarity between earth and the ancestors. He points out that "from the actor's standpoint, the shape of the supernatural world changes according to the divinities he is propitiating." We should bear in mind, therefore, the point made on page 17 that time and space are not conceived in terms of any simple schemata. Time is not a continuous circle from one year to the next, running the gamut of planting and harvest, fertility and fruitfulness, earth and sky, rain and sun, queen and king, the world and god, nor is it a continuous alternation between these poles, aided by the messenger of the gods. Instead it is a multitude of scattered points acting as centres from each of which time and space have a different organisation, each one an alternative isochronism.[16] Energetic activity by individuals' ancestral souls can change the organisation at any of these centres, but individuals in other centres try to impose a pattern on outlying centres, very much in the same way that the sun tries to impose a pattern on the earth, withdrawing the shade of night without consulting man. The symbols of the ideographic language reflect the psychology of the individual, externalise his dynamic unconscious in which he is continually trying to assert life against death, or creative individuality against rigid patterning imposed by his environment. Words like *so* and *chi* conceptualise the thinking about individual psychology expressed by the relations between entities, between gods and man, between the sky and earth, between the sun and darkness or the regulation of day and night.

We can, for example, see a different organisation of the gods in Elechi Amadi's first novel, *The Concubine*, and we might suggest that it is because he is describing a particular society of his people, the Igbo, from the river area of Nigeria that their "rigid" gods are those of the river and the sea. Rigidity and inflexibility, however, are expressed in their society differently from that of their neigh-

16. As expressed by Ezeulu looking for the new moon outside the district commissioner's office: "Why should the sky of Okperi be familiar to him? Every land had its own sky; it was as it should be." Achebe, 1964, page 179.

bours, the Ijo Kalabari, perhaps because they are not basically fisher-
men and therefore do not feel at home on the sea and the rivers in
the same way as the Ijo, for whom the rivers are as reproductive as
the earth and who, therefore, regard the rivers as a source of indi-
viduality and creativity. This may explain also why the forms of
marine and river life play an important part in Ijo masks and sculp-
ture.[17] In *The Concubine* the first husband of a very beautiful woman,
Ihuoma, dies from an illness after he has been weakened in a fight.
She is left a widow with three children. A young unmarried man,
Ekueme, woos her, but Ihuoma is reluctant because Ekueme is al-
ready engaged to Ahurole. Furthermore, Madume, the man who
fought her first husband and wounded him, declares that he also
wishes to marry Ihuoma, but when he enters her compound he stubs
his foot against an old hoe, buried in the ground, and his big toenail
comes off. The diviner warns him that unknown spirits, some from
the sea, have teamed up to destroy him and helps him to perform
a ceremony to rid himself of the spirits. Madume, however, con-
tinues to bother Ihuoma and is blinded by a spitting cobra. Finally
he commits suicide. Ekueme persists in asking her to marry him,
and she refuses while his parents go on with the preparations for his
marriage to Ahurole. His father humiliates him by making Ihuoma
refuse to marry him in front of him. Ekueme's marriage to
Ahurole is rushed through, and Ahurole is upset because Ekueme
prefers his mother's food to his own. She is given to uncontrollable
fits of anger. Ekueme beats her and she runs back to her parents.
After she returns, their marriage goes from bad to worse, and Ekueme
complains to Ihuoma about her. Ihuoma asks her friend to ask
Ekueme to stop pestering her, but she is unhappy because of the re-
spect and prestige she has won. "The women adored her. Men were
awestruck before her. She was becoming something of a phenome-
non."[18] But "it was as if they were confining her to an ever-narrowing
prison."[19]

Ahurole meets her husband outside Ihuoma's house and goes to a
medicine man for a love potion, which drives Ekueme mad, so that
he rushes off into the forest, where he is found sitting in a tree with
a club and will not come down until Ihuoma is sent for to ask him.

17. Therefore, there is a polarity—a polarity between the rigidity of regulated
and stable patterns and changeable creativity. But it is an abstract polarity
and not one of a consistent relationship between symbols.

18. Amadi, 1966, page 199.

19. *Ibid.*

Ekueme's marriage to Ahurole is dissolved, and it is agreed that he should marry Ihuoma, but the diviner advises against it. "Ihuoma belongs to the sea," he says, "when she was in the spirit world she was a wife of the Sea-King, the only spirit of the sea. Against the advice of her husband, she sought the company of human beings and was incarnated. The Sea-King was very angry, but because he loved her best of all his wives, he did not destroy her immediately she was born. He decided to humour her and let her live out her normal earthly span and come back to him. However, because of his great love for her, he is terribly jealous and tries to destroy any man who makes love to her."[20] This, then, is the reason her first husband died and Madume went blind and committed suicide. Ekueme insists, however, on going through with the marriage, and his parents persuade him to consult another diviner who has a great reputation and who claims he can bind the sea-king and prevent him from doing harm. The sacrifice is to be performed in the middle of the river and includes a white piece of cloth, a white hen, a bright red cock, seven ripe plantains and a brightly coloured male lizard. Again we find the theme of competition between rival diviners. The new diviner, Agwotorumbe, "was enjoying his immense popularity in the face of his rival"[21] and "it was the village diviner's confessed inability to tame the Sea-King that caused his visit."[22] But the village diviner is not unduly worried by his rival's popularity. ".The people would come flocking to him as soon as his rival had gone." Ekueme is very frightened of confronting the sea-king in the middle of the river at midnight because he cannot swim. He has difficulty in finding a boatman, but at last one agrees to do it for fifteen manillas, a boatman who is sceptical about whether the sea-king exists. Finally, Ekueme is killed by a barbed arrow shot by Ihuoma's son, hunting a lizard for the sacrifice.

We see in this novel, then, that the wife of the sea-king who insists on having an earthly life is too beautiful and too good to bring happiness to any man. She is trapped in her own goodness and beauty. Her husband, the god, is feared because it is not right that his wife should be allowed to stay among ordinary men. People whose lives are too good and who are too well behaved do not fit into the village community. They impose on it a too rigid structure of be-

20. *Ibid.*, page 369.
21. Amadi, 1966, page 270.
22. *Ibid.*

haviour. In Amadi's river Igbo society it is the sea-king who likes riches and clothes and dressing in bright colours and conferring wealth, but to be too successful in imitating his behaviour is to court disaster. However, it is not unknown for a man to pit himself against a god and to think that he can succeed as an opponent to the god. However ideal a god's behaviour and whatever his wealth, a man with confidence has a chance of prevailing. Perhaps Ekueme would have been able to marry Ihuoma if he had not lacked confidence.

Sometimes the gods are seen as men who become heroes, leaders of the community who brought it to the lands it occupies, and then become deified. A succession of high gods might mean that an earlier leader or hero was succeeded by another who was more easily remembered or identified with particular events in a particular character. Mercier's account of Nana Buluku and earlier or more remote gods than the Fon pair of gods, Mawu-Lisa of Dahomey, seems to show that the Fon se can produce symbolic expressions of a regression of remote deities, each one beginning further back in time and representing the ancestor of the present pantheon. Each earlier or more distant god is less defined than those who are nearer and whose dialogue with men is more intimate. Nana Buluku is the creator of what exists now, but Mawu-Lisa are demiurges (in Mercier's terminology),[23] who came later and are known better now. Someone has the responsibility for having brought the gods into society. In the LoDagaa Bagre myth it is the "beings of the wild."[24] The Ijo Kalabari can get rid of the gods when their value to the society is disputed.[25] A god is an individual who brings a particular pattern of behaviour into the community and uses a power similar to the power used by magicians to make it continue. But someone has to introduce that god with this new pattern, and it may be the founding ancestors, the heroes who represent those who came a long time ago leading a group into its present environment for the first time. When they came they brought a god with them but later were deified and themselves came to replace their own god as the supreme god, as head of the pantheon.

23. See Mercier, 1954, page 218.
24. Goody, 1972.
25. Horton quotes a proverb: "If a spirit becomes too violent, they will tell him the stick he is carved from" and goes on to say, "Literally, if a spirit's demands become too burdensome, the whole congregation can join together to destroy its cult objects and by this unanimous act of rejection render it powerless to trouble them further." Horton, 1962, page 204.

It seems at first, then, that the elemental power or force of the earth straining towards reproduction can be changed by gods and man, can be directed in a pattern, that the force of deity then becomes a restricting power taken over by gods and men in opposition to the power of the earth to renew itself in new forms, to the earth as a trouble-maker. Whatever restrictions the sky or god and man, using the regulative power of the sky, impose on the earth, however, the earth can continue to renew itself and remain "senior" to the sky.[26] In an Ibo myth the earth sends the vultures to the sky as messengers to ask for rain because man is suffering, not because the earth is suffering. The seniority of the earth is expressed in an Idoma prayer, quoted by Armstrong. They took the sacrifice to the East; the East said "Send it to the West." They took the sacrifice to the West and the West said "Send it back to God." They took the sacrifice to God and God said "Send it to the Earth, for the Earth is senior."

In Rattray's account of the Ashanti they seem to conceptualise the difference between a power of fertility and a power of personality in their distinction between *mogya*, or the blood provided by the matrilineage, and the *ntoro*, or the clan personality provided by the patrilineage. On top of that there is the third concept to which we have already referred, of *okra*, the life or breath, which Rattray says is sometimes confused with the *sunsum*, or clan soul, but Abraham says is "that in a man which antecedentally takes leave of God."[27] When it departs from the body at death it returns to its god to justify its earthly existence. This pattern already laid down for us has to be kept white and clean, so that it can be easily seen and not made confusing, must not be contaminated by ambiguity. What Rattray says about the earth and the Queen Mother seems to relate to the earth of the ancestors and the matrilineages. In describing the *Adae*, or the ceremonies for placating and soliciting the ancestral spirits, he tells us that in order to perpetuate a chief or lineage head's memory, his or her "white" stool is blackened with soot mixed with egg yolk (which is associated with fertility). Therefore, it seems from the point of view of our paradigm as if in this ceremony, described by Rattray, the soul, or *sunsum*, which is bound to the stool with fetters, is encouraged to go to the earth, which is black, and must no longer submit to its domination by the *okra* from the sky, which is white.

26. Armstrong, 1960, page 15.
27. Abraham, 1962, page 59.

Here, then, there can be no confusion between *sunsum* and *okra*. It also seems significant that after sacrificing to his stool the chief could not leave or eat until the Queen Mother had been to greet him, and, if she felt like it, she could keep him waiting. Rattray also describes the power of Queen Mothers, their place on the left hand of the chief, their ancient power to choose the chief,[28] their constant presence when the chief travels and in court and their privilege of rebuking the chief, questioning litigants and addressing the court. We might suggest, then, that when the chief is alive the stool is white because it descended from the sky, but when he becomes an ancestor he is taken care of by the matrilineages, who belong to the earth from whence sprang the indigenous inhabitants. While he is alive his white destiny must not be allowed to harm the earth, which must retain its fertility. And so the Asantahenes' feet were never allowed to touch the ground "lest a great famine should come upon the nation," and to this end he was followed by a servant carrying a spare pair of sandals in case one of his should break. And the earth in the person of the Queen Mother must have the last say in everything.

Rattray tells us as well that the most important part of Ashanti religion is that devoted to *samanfo*, the ancestral spirits. It does not, however, seem possible to take one aspect of religious belief in any of these societies and say that it is more important than any other. In fact, it seems that different aspects of the religion may be important according to the perception of the individual at his particular point in the society, as we have already seen. In Ghanaian Akan-speaking societies, the dissident gods are the gods of the patrilineages.

In many of the societies we are discussing there are four possible dwelling places for the separate souls of a man when he dies. There is his destiny soul in the sky; his ancestral spirit, which can remain in the house after death, "planted," as we shall see, in the ancestral shrine; his body, which has an ethereal double which lives in the bush or in the earth (in anthills, for example); and his own personal spirit, which can go to the land of the dead. The funeral ceremonies often involve complicated procedures to make sure that each one of these

28. Rattray, 1923, page 216. "With the death of a king, the property of the state reverted to the trusteeship of the Queen Mother, and the new king had first to prove his abilities before acquiring a right to the governorship of its property." (See also Tauxier, 1917, page 352, on the Mossi people of Upper Volta, where it is the eldest daughter who reigns until a new king is chosen.)

spirits or souls goes to its proper destination.[29] Each society puts a different emphasis on the importance of these different spirits for the individual. Usually the emphasis is changed according to the social structure, so that "destiny" souls are more important in centralised societies, personal spirits in acephalous societies and so forth.

What our paradigm seems to establish, nevertheless, is that there are two forces at work, representing the social aspects on the one hand and the individualising and differentiating aspects on the other, of each member of the group. They seem to be a polarised opposition of the one life force which becomes self-perpetuating in one of its aspects and infinitely changeable and unpredictable in the other. This polarity does often seem expressed in terms of an opposition between sky and earth, between deity and nature. Sometimes the life force seems to be divine, sometimes daemonic in the same individual or the same social group.

How this ambiguity of divine power and daemonic life force enters into social organisation can be seen in the next chapter with the ambivalent relationships between the elders and the age groups, the ancestors and the ghosts. The elders maintain the balance between the rigidity of the patterns which are unavoidable (and which it is sometimes the burden of the members of royal clans to maintain when they are forced to accept the office of king) and the demand for fertility, for life and change, of the new generation. Our paradigm is seen to consist of a balance between conservation represented by the elders and change represented by new generations which regulates the rigidity of unavoidable structures, and it is the elders who are responsible for this balance. In societies with kings or priests who have the power of kings the clan heads representing the elders ensure in their turn that changes introduced by kings do not last in a rigid perpetuity. We shall also see that the right of an elder or a king to impose the rigidity of his own isochronism at a particular place and time can be regarded as his right to define himself and that he is assisted in the process of definition by diviners who may require him to take an oath or alternatively to prove by his distribution of the profits that he is benefiting the whole society.

29. However, this does not seem to mean that the ancestor becomes a divided personality. He seems to go on existing in all four places at the same time until he is reborn.

4 Lineages and Age Groups

In the West African societies we have been discussing, the sun is thought able to impose rigidity from the sky; the king tries to impose rigidity from his seat on the stool[1] he has obtained from the sky;[2] and nearer to the earth and therefore not so powerful, because he is more subject to the earth's power of transformation and change, is the head of the family, an elder, who will eventually join the ancestors in the earth and who has a more ambivalent position than either the sky god or the king. When he dies he must be encouraged to join the ancestors and to come back again, especially if his life has proved to be productive while he was a member of the family. The ambivalence of his position makes him more aware of the dangers of rigidity. He is more concerned with preserving the particular individuality of his kin group. However, a senior clan elder may also in turn appear to be responsible for a rigid conformity in relation to the associations of young adults.

To encourage the ancestor to be reborn is to preserve the unique

1. Ibo elders and wealthy men who have been admitted to the Ozo titles or grades are sometimes buried sitting on a stool. The more elaborate stools are reserved for the higher grades in a hierarchy. See Cole, in Fraser and Cole, 1972, page 85.
2. It is said that the Ashanti priest Okomfo Anokye called down a solid-gold stool from the sky when the first Asantahene was appointed ruler of the Ashanti confederacy at the beginning of the eighteenth century. The golden stool alighted on the lap of the king. See Fraser, in Fraser and Cole, 1972, pages 139 and 140.

personality of the family and of the clan. The clan is regarded as living on a universe of its own, separate from the universe of all the other clans, but as part of the collectivity of clans it belongs to the unique universe of people who speak their language. However, while each family must strive to preserve its own particular form of expression, each clan, comprised of its groups of families, must also take care to assert its own identity. In this way each family takes care of its own destiny and preserves its knowledge of how to preserve its destiny and to conserve its power, and each clan looks after its own particular conserved spiritual power. But each bit of spiritual power is a distinct entity and is preserved only so long as it remains the power behind a particular form. In other words, the family is not the sum of the powers of each individual member, and the clan is not the sum of the power of each family belonging to the clan. Each is a distinct and separate personality existing when they are invoked. Thus we see in the LoDagaa Myth of the White Bagre that everything has its own deity, even meetings. Their myth relates that the elder brother went to the diviner because he slept badly and the diviner "poured out his bag."

> He picked up "deity"
> and began to ask,
> What "deity"?
> Deity of childbirth?
> Deity of family?
> Deity of daughters?
> Deity of grandfathers?
> Deity of grandmothers?
> Deity of the bowstring?
> Deity of chicken breeding?
> You reject them all.
> Deity of meetings?
> The cowries fell favourably:
> It was so.[3]

For "deities" to exist man has to create them; they are demiurges imposing certain kinds of pattern or *Gestalt* on nature and the earth. The sun and the stars can continue with their regular movement, day in, day out, but a man has to exist to create a social pattern in relation to this movement. The sky gods and the kings are created by particular groups of men to keep the pattern that the continued existence of

3. Goody, 1972, page 121.

their particular society requires. We have seen that when the pattern breaks down the god can be dispensed with and forgotten. On the other hand, a man who has had the special qualities which enabled him to regulate his social group's behaviour in their environment may be induced to come back in a new reincarnation, and his qualities may be remembered for a few generations. Therefore, the elders in a village ensure that their members are remembered ("planted") as ancestors when they die by ensuring that the eldest sons of the deceased elders do not come into their inheritance until they have carried out the rites of a second burial. They ensure that the members of their group in the society are not dispensed with. Nevertheless, success in regulating a social group and the wealth that it confers incites envy, particularly from those who will ultimately inherit it. We shall see that in the psychological theory of the people, we are discussing this envious attitude is often described as a drive for self-expression, a desire for independent definition on the part of the individual.

The ancestor would not exist as an ancestor without the help of his eldest son, and the eldest son often feels some feelings of ambivalence to his deceased father in his role as an ancestor. In terms of the model we have proposed of a drive towards individualisation in opposition to rigidity we can see the son's ambivalence as a need to assert his particular personality. For example, the ambivalence of a senior son's relationship with his father is described in Fortes' work on the Tallensi of Ghana. A Tallensi man has no "jural independence" until his father dies, and he cannot give a sacrifice to a lineage ancestor until then.[4] Consequently, the son feels resentful towards his father because his father bars the way to the son's assumption of authority. The son's resentment towards his father is recognised in ritual avoidances. (Fortes writes that "so deep is the feeling of latent opposition between successive generations that ritual avoidances also hold between a woman and her first-born daughter."[5] An eldest son may not eat with his father, use his bow or go into his granary. During the final funeral ceremonies the eldest son breaks these taboos in a solemn ritual.[6])

In Bradbury's work on the Edo[7] we can discover this principle of

4. Fortes, 1959, page 27.
5. *Ibid.*
6. *Ibid*, page 31.
7. The description of Edo burial and funeral rites is to be found in Bradbury, 1973. Father and senior son in Edo mortuary ritual, pages 213–50.

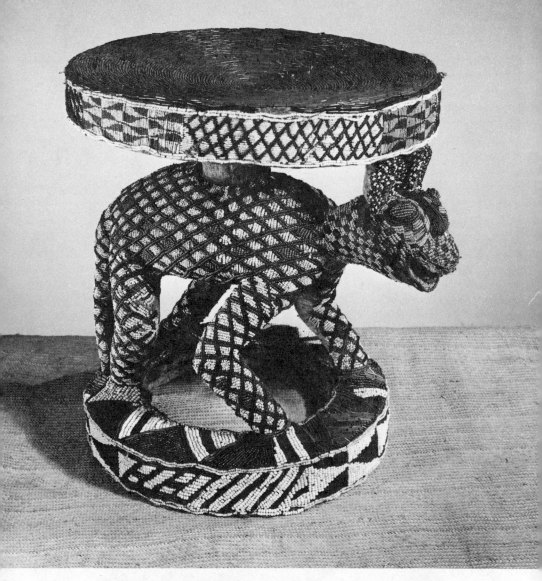

PLATE 4. Stools are ideographic representations of authority, and a stool with a leopard is a representation of the king's authority. The leopard is also the representation of the young adults' age associations that carries out the king's will. They take him into the villages, camouflaged by his leopard spots. (Bamileke, Cameroon) *Division of Photography, Field Museum of Natural History*

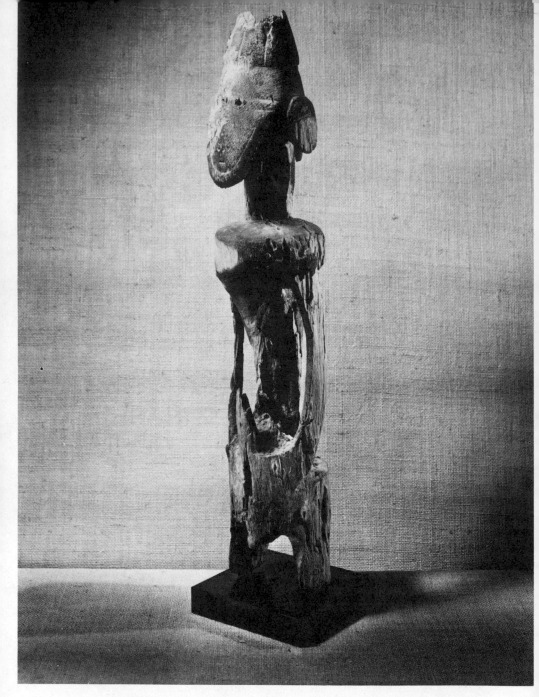

PLATE 5. The elders are "planted" as ancestors, but the earth is allowed to reclaim them slowly, using as its agents—the ants. (Mumuye, Nigeria) *From the Alexander Martin Collection (London)*

opposition of sons to fathers and elders institutionalised as an age group which both chooses the elders and supports their authority and acts at the same time in opposition to them. In Edo society again, a spirit goes to the sky god to choose a destiny for the body and presides over the fulfillment of the individual's destiny, and it is thought to have been a "good" one if, in dying, he joins the incorporated dead.

A dead father is entitled to become one of the incorporated dead, but a man who dies childless will not be given a proper burial and becomes one of the unincorporated dead, or a ghost. The ghosts are thrown scraps of food when sacrifices are made to the incorporated dead so that they will not snatch food intended for the incorporated dead. The senior son is responsible for burying his father properly, called "planting" him. Interment follows death quickly, but "planting" is made by means of a second burial, which may not take place in a poor family for twenty years. Waiting for the second burial, the father's ghost is resentful and aggressive and causes misfortune to its former dependents. Until the father is "planted" the senior son will have to go to the altar of a kinsman in his lineage in order to communicate with his ancestors. While he has to do this he is not considered to have made good his claim to inherit his father's property. If he should die before "planting" his father, one of his brothers who has "planted" his own father may step in and take the property for his own dependents. When he has "planted" his father the senior son inherits a major portion of his father's property and any hereditary office previously held by his father, and he is received as one of the lineage elders. He can become a village elder only when he is proposed by the members of his age group, the adults who are also the warriors and policemen of the community.

The adults who die without children and join the unincorporated dead display the characteristics of their age group, which is to be critical and resentful towards the elders in authority. They join in with their age groups in obstructing the funeral of an elder, because it is the task of the adult age groups to dig the grave, and while doing it they demand sacrifices to the adults who have become ghosts and display their hostility to the elders in war dances obstructing the path of the dead elder to the grave. After he has been buried his spirit of destiny, represented by a piece of chalk, is dragged back to the ancestral shrine, where it joins the other lineage elders, but the spirits of the members of the adult age groups who die childless remain in the bush. Bradbury himself points out that the opposition between

growth and order is symbolised in this way. The adults who die child-less remain in the bush and move about at night. Those elders who are granted full burial rites remain in the village.

The ideographic expression of these funeral rites is that with which we have become familiar in discussing kingship in Chapter 2. The corpse is washed and dressed in a white cloth. A goat is sacri-ficed over the water in which the corpse has been washed. Clippings of hair and nail parings are inserted into a piece of white chalk, which is the substitute corpse for the second burial. The real corpse is fed for a night with the left hand, but his kin dance round the grave to the right, which is his path to the land of the dead seeking to renew his destiny.[8] When he has finally been buried his hair is painted white on the right side, his body is symbolically thrown away in the bush in the form of two forked sticks which are at first erected to support a third stick and are pushed over by the buttocks of his kin, the buttocks symbolising fertility, before the white chalk, which symbolises his destiny spirit, is dragged back to the ancestral shrine at dawn guided by a white chalk line along the ground and through the doorway of the family house. Now the father's destiny spirit remains in the house and is pressed to become reincarnated. His ghost has gone to the land of the dead, and his body has gone to the bush, where live the unincorporated dead of the childless adults and those fathers waiting to be buried, those who have fulfilled their destiny but live in a world of potential change, symbolised by the earth. We have seen that the adult age-group societies of the Edo are seen as the source of change and innovation in opposition to the established order because they may die childless without fulfilled destinies. They seem, then, to carry out the same functions as the water spirits of the Ijo Kalabari. The Ijo Kalabari water spirits come from the creeks; the ghosts of the Edo wander in the bush. It is always possible to discover the principle of change and innovation in opposition to established order working as the characteristic of age groups in other African societies. Other examples are the Asafo society of the Akan speakers of southern Ghana, the LoDagaa Bagre society of northern Ghana and the Mukanda of the Mbwela of Angola.[9]

8. We might then suggest that the left stands for the individualising principle of the body, the right, for the principle of conformity to a pattern.
9. Similar institutions to the Mbwela are found among the Ndembu of Zambia and the Tchokwe of Angola and Zaire.

Some of these societies are matrilineal, some patrilineal. It might be suggested that in matrilineal societies, matrilineal male ancestors represent rigidity and the patrilineal dead represent innovation and disorder and that conversely in patrilineal societies the male ancestors of the patrilineage represent the ordering, rule-making principle, the dead of the matrilineage the opposing principle of change working against the established order. However, we have seen that in the Edo society described by Bradbury the patrilineal ancestors can remain "ghosts" in the bush and opposed to established order if they have no children to "plant" them. Consequently, there is an ambiguity inherent in every man's position until he has a grown-up son to "plant" him. Until that happens he does not know whether he is on the side of order or change. He begins by belonging to the working grade of youths, called *iroghae*; graduates to the middle grade, *ighele*, the warrior and executive grade; and ends by joining the *edion* when he becomes an elder. The funeral rites enact the father's journey to the land of the dead, and while the father's ghost is obstructed in its journey by the *ighele-orinbin*, the aggressive spirits of men who died too young to be "planted" by their children and therefore never completed the journey to the land of the dead, the living *ighele* of each ward demand gifts before they will allow the procession carrying the corpse to its grave to pass through their ward.

In the wider Edo society the adult is counterpoised between two opposed demands for his conformity, because the iroghen or the ighele are regarded as servants of the Oba. A boy is dedicated to the service of the Oba when he comes of age—that is, the age when he is old enough to enter the *iroghen*. His position as an agent of change in the village is reinforced by his position as an agent of the Oba. It is obviously wrong, therefore, to regard the organisation of Edo society as hierarchical. It must be regarded as existing in a state of uneasy equilibrium poised between the elders of the village on the one side and the king and those chiefs he has chosen to represent him on the other.

It might be expressed as well as a dichotomy between ghosts and "planted" ancestors' destiny-souls.[10] If a man has children he has left behind him the expression of his personality which belongs to the group he has created, and he has expressed his destiny in that group. Therefore, he can be "planted" and encouraged to come back;

10. We see in the next chapter that we cannot speak of a single soul for each individual. Each individual has several souls.

but, when he dies, "planting" him assists him to come back, but it also ensures that his soul rejoins the ancestral destiny-soul so that it does not interfere with his successor's soul and destiny. This is what is symbolised by inserting clippings of his hair and nail parings into a piece of white chalk, the substitute corpse for the second burial. The whiteness might be interpreted as symbolising the fact that the soul of the dead elder is no longer able to interfere in the lives of his successors and the attributes of his soul. That is, those external parts of his body which go on growing are sealed off from the new group formed by his son by being sealed away in the white chalk. The symbolism here seems to be similar to that employed in separating the soul of priest-kings so they will not use their power to impose themselves on the community more than is absolutely necessary, sending back their nail parings, their sputum and their excrement to the palaces they live in.[11] These things symbolise the continued influence of their destiny-souls and must be kept away from the lineages and family groups in the community so that they may be allowed to "grow" their own destiny-souls. However, they may be reincarnated later, bringing back their old personal form if it was a particularly reliable one. Their ghosts perpetuate their individual and particular personality. Edo society then demonstrates the ambiguous situation of the adult men who have not yet become elders by using their position as retainers of the Oba to curb the power of the elders while they reinforce the elders' authority as members of the ekpo, the secret society which carries out the sanction imposed by the elders on those who oppose their wishes.

11. See page 36.

5 Personality and the Creative Force

We can use the opposition of rigidity and the individual's desire to change and to define himself independently to try to understand what is meant by "the soul" in the African societies we are discussing. Parrinder has devoted a whole book to an attempt to analyse the various kinds of African soul or spirit, and large parts of other writers' books have also been devoted to this attempt. Talbot, for example, discusses "the four souls" of African religion and makes a comparison with the Egyptian "four souls" or to the Greek *nous* and *pneuma*.[1] It seems as if most of these attempts to discover four "souls" may derive from the presumption that African religion originated in Egypt in the remote past, although recent research on the Saharan cave paintings and neolithic deposits seem to suggest that African religions predated Egyptian religions and that both derived from a common root. It is this search for an Egyptian origin, nevertheless, which has dictated the attempt to discover a classificatory straitjacket for African psychology and seems to explain why Parrinder, in his *West African Psychology*, divides the various ideas into body essence, spirit, soul and oversoul.[2] Another influence is that of Durkheim,

1. Talbot, 1926, Vol. 2, page 259.
2. Parrinder, 1951, pages 203–205. The comparison of African culture with Egyptian culture has a long history. The earliest date it can be discovered presented systematically seems to be in the work of Charles de Brosses (v. de Brosses, 1760). Subsequently it formed the basis of comparison for Bowditch (v. Bow-

whose followers seem to suggest that many African societies describe the individual's psychology in terms of his membership in various social organisations and differentiate his various forms of consciousness in terms of these social organisations. Thus he belongs to a world or universe of people who speak his particular language and may be organised in a form of state. (This gives what Parrinder, Talbot and others call his "oversoul," similar to the Freudian superego.) He also belongs to a particular lineage or a particular clan, and so he acquires a patrilineal or a patrician soul. (In acephalous societies his patrilineal soul may correspond to his oversoul.) His body essence is given him by his matrilineage, and, finally, he has a spiritual existence which corresponds to his own uniquely defined character (his *existenz* contrasted with his *dasein*). It is this existential soul which is supposed to be seated in the right hand and forearm and which an individual cultivates in his search for self-definition.

When he dies his oversoul goes back to his god, his patrilineal soul joins his ancestors in the land of the dead, his body essence goes back to the earth and his spirit either becomes a ghost or is "planted" in the house of his family. (A model of souls based on this social psychology of four personalities is the one Rattray suggests for the Ashanti in Ghana, which we have referred to on page 53, where *Okra* is the oversoul, *ntoro* is the patrician soul, *mogya* is matrilineal body essence and *sunsum* is spiritual existence.) For the purpose of interpreting the art and for trying to discover the uniquely defined model which we can use to look at African archaeology and history, which was stated to be the purpose of this book, it is better to try to reconstruct a model from the oral literature and the visual and theatrical art of the ceremonies of the people themselves, in which an individual's consciousness is seen as composed of those elements which belong to the souls of groups which already exist and which try to perpetuate themselves and that part of him which belongs to the earth and which is striving for new expression and new form, which we might describe as his spirit, and which describes a wandering ghost if it is not "planted." The latter is seen as an energised force directed towards innovation and change in ways we have already pointed out. The administrative centres of the larger societies are seen as focal points of entropic stability, of the preservation of

ditch, 1821), Frobenius, Talbot, Lucas, Lady Fugard, Meek, Seligman, Jeffreys, etc., and may be said to have dictated the theory of the divine king as it is applied to the study of African society.

constants, identified with the sky as a kind of dome or umbrella, imposing the same patterns on everybody it includes in its purvey, or with the sun which imposes the order of day and night, and of the seasons. Any element in man which strives for stability, for self-perpetuation, uses the powers of kings, of gods and of the sky and the sun, of the town and the village. Any element in man which strives after change, invention and creativity uses the power of the earth, of the forest and the bush, which is constantly remaking and re-forming itself. Therefore, the destiny-soul, which we have seen determines that part of a man's personality which he owes to the features of his particular nation, community or clan, the patrilineal or matrilineal soul, determining that part of the personality of a man derived from his lineage, are all attempting to perpetuate themselves and look for stable states, while his spirit actively supports multiplicity, variety and instability. The former supports the preservation and repetition of social groups and individual lives, the latter supports their breaking down and aids the restructuring in new social groupings and new personalities, and it is this principle which causes the time and space of African society to be a pluralistic time and space. Each individual, each group, tries to assert its time and space from the viewpoint of its own existence; tries to create for itself and perpetuate its own unique personality, rather than attempting to fit into any other group's framework, and it derives its impulse towards this end from the desire of the earth of which it is made to differentiate itself. Thus it comes about that a life force which demands a unique expression from every form to which it gives birth can use that form of its expression to try to impose itself on every other form in its immediate vicinity. In groups it seeks the perpetuation of the group by means of repetition and order. In individuals it seeks the expression of the individual's unique personality which can ultimately be transformed into the persisting order of a group.

Thus it seems we can simplify the model of four souls derived by Talbot and Parrinder and others from their acquaintance with ancient Egypt and explained by Durkheim and his followers as expressions of a variety of social organisations. We can propose instead a kind of dualism. For example, the destiny-souls, the patrilineal souls and body essences of the Ashanti in Ghana are a wider extension of the souls of individuals in particular groups (representing the different personalities imposed by membership of the nation, the patrilineage and the matrilineage respectively). Spirits are the parts of individuals

expressing themselves apart from and even opposed to the will of each of these groups. There is an ambivalence in the forms of expression allowed to the latter, and it is institutionalised in secret societies (in those societies which have secret societies), initiation lodges and hunters' cults (they may also ally themselves with the patrilineage's soul expressing its opposition to the jural authority of matrilineages, or with the matrilineage's soul expressing opposition to the jural authority of patrilineages). But if we accept that there is a basic duality we can see from the idea of each group-soul trying to express its own personality how it comes about that some observers suggest that a man is thought to have three or four souls, all residing in different places when he dies. The oral literature and the rituals seem to support a thesis that the various parts of a man take on the attributes of the world to which they belong, the oversoul or destiny-soul takes on the attributes of the sky, the body essence takes on the attributes of the earth and where there are clan-souls they take on the attributes of the clan personalities.

We are suggesting, then, that it may be better to interpret these various souls as different personalities trying to impose their particular form of consciousness on one another. Thus the lineage forms a separate personality, a clan forms a separate personality, and the king embodies the personality of the nation. Each one struggles to dominate the others. A man or a woman has a different soul each time they take part in a meeting or activity which involves a different organisation of the social structure to which they belong. Each part strives to assert its particular individual personality and to define it, "to wash its soul," while the earth and the principle of fertility are working against it, making it return each time to the source of new forms which can exist only if they are not dominated by the old ones.

How then do we interpret what happens at death, for example, in the case of Bradbury's Edo elder, whose body has gone back to the earth, while his ghost has gone to the land of the dead? It appears, as we have seen, that the personality can be preserved so that the next time it returns to the social group—that is, in its next reincarnation—it will be stronger, will have a persisting personal and individual form. However, the part of the man which expressed his role in the social group, symbolised as his head, must also return and repeat that role. Thus his soul that goes to the land of the dead is "washed" before it takes the journey so that it can retain its separate identity as a part of the group which it has left, ready to return to it.

"Washing," then, has an ambiguous function. We have seen that it separates the man's soul from the soul of his successor so that his successor is able to define his own existence, but at the same time it enables the ancestor to keep those qualities unadulterated which were useful to his society and which can be used again if he can be induced to come back in a later generation.

It is an assumption made in Western thought and languages that an individual needs to discover his identity as if the physical separations of the body from the world it inhabits requires "a ghost in the machine" which directs the physical organisation of the body with the powers of an American President. If we use this model when thinking about the roles of souls in African society we will naturally assume that the ego-centred soul is thought of as hostile to the socially oriented soul. It seems more likely that the human personality is thought of as a balance of separate souls, each one of which may be the dominating factor in a particular set of circumstances and which should be allowed to exercise control when the body is formed in the appropriate circumstances. Thus the destiny-soul is important at national or clan ceremonies and when the individual is required to subordinate his will to that of the whole people, the patrilineal soul is important in the patrilineal context, the matrilineal soul in the matrilineal context and the individual soul is valuable when the personality is alone in the unordered and changing natural environment. Each one of these should be "washed"—that is, defined clearly when its demands need to be understood—but each separate soul of the several which make up one individual may become merged with all the others which form a particular social grouping, so that at national meetings, clan meetings and lineage meetings, to take examples, that particular type of soul as an individual is united with the others to form the one that needs "washing."

However, by some kind of natural process the particular circumstances of the time may create a situation in which a man's individual or principle soul may become merged with nation or clan soul and begin to impose its particular configuration of characteristics on the whole group and therefore becomes identified with the group's souls. That is what happens when the kings of Ashanti, Benin, Congo and other African kingdoms are installed. Their individual souls now become the soul of the nation.

However, it appears as if in these societies there is no need for the "integrated personality" of Western society. A man can have a

multiple personality with each separate personality adapting itself to the time and circumstances. Society is seen as a series of overlapping cells in which any other cells may grow and incorporate the others according to the historical and environmental circumstances. A man exists within a network of cells, and as we shall see in the next chapter it is the work of the diviner to tell him which one is enlarging itself at the expense of the others at any one time. We shall see that it is the particular job of the diviner to tell the individual whether he should accede to social demands or whether he should do what his particular role as a separate individual demands. This is represented in some of the societies we are discussing as choosing between following one's head or one's hand.

In many societies the soul of the individual acting responsibly in the interests of his social group is said to be seated in his head, while his soul which leads him to express his own particular personality and to separate him from the requirements of the kin group is associated with his hand. It is also not surprising that the members of his age grade or generation society encourage him to express his individual personality because their interests cut across the requirements of the lineages. A man or woman's loyalty to the club formed by their contemporaries may sometimes conflict with the requirements of their family and its elders. Thus in the Edo society described by Bradbury and in the Onitsha Igbo society (both in Nigeria)[3] the age-grade society presents a man with a carved figure which symbolises his personal soul, the Ikegobo of the Edo and the Ikenga of the Igbo. Bradbury tells us that "it refers to that aspect of the worshipper's individuality which is associated with the hand"[4] and that "the Hand is regarded as a more positive symbol of wealth and social achievement than either the Ehi (the destiny-soul) or the Head";[5] and he quotes an Edo saying, "If one's father does something for one, he makes one ashamed (i.e., by telling everyone how much one is beholden to him); if one's mother does something for one, she makes one ashamed; but if one's hand does something for one, it does not shame one."[6]

However, we shall see (page 144) that in order to be able to

3. Bradbury writes that the cult object he describes "is found in various forms over a wide area of the central part of Southern Nigeria on both sides of the Niger." Bradbury, 1973, page 261.

4. Ibid., page 262.

5. Ibid., page 264.

6. Ibid., page 265.

PLATE 6. The Ikenga is a type of figure which is widespread in the central and eastern parts of Nigeria and represents the young man's capacity to assert himself as an individual. (Igbo, Nigeria) *Lowie Museum of Anthropology, University of California, Berkeley*

PLATE 7. The entrance chamber to the Benin King's palace was covered with bronze reliefs when it was first seen by Portuguese observers in the sixteenth century. (Nigeria) *Thomas Picton*

follow the demands of his hand that he should express his own individual personality, a man must be prepared to pay compensation on a large scale to his social group. The penalty for being a witch is the payment of compensation to those who feel they have suffered misfortunes from the witch's mystical powers, and a hunter is one who pays for his right to follow his hand by providing meat for the community. The symbolism for the individual's personal soul, for the witch and for the hunter, is very similar, and all three pay for the right to make their individual decisions. At the same time the witch and the hunter try to hide their true natures from their social group in case they should be made to pay recompense, and the individual sacrifices to his personal soul in secret and does not publicly parade his individuality which it expresses if he can possibly avoid it.

Dualism in the doctrine of souls therefore expresses the idea that a man is ambiguous about his position in society. Is he to follow his head and his destiny which tells him to conform as a member of a social group, or is he to let his hand lead him to become an innovator, a performer, a hunter or a craftsman, going against his social group in the interests of change, if necessary? If he follows his head he sacrifices at his family shrine and in public; if he follows his hand he sacrifices at his personal shrine and in private. It is these two choices about himself which a man goes to a diviner to make, or which might be made by a diviner called in by a social group to discover whether a particular individual's selfish following of his own concerns is harming them, or might be made by a diviner called by the individual to decide whether his destiny as part of the group is harming him and whether he would not do better to pursue a different destiny, to pay attention, that is, to what his own personality demands. This alternative behaviour is expressed in many societies, and among the Yoruba and the Ndembu, by a change of cults, as we shall see in Chapter 6.

Being prepared to stick to one's personal opinions, the characteristic of a hunter like Wago, the leopard killer in Amadi's *The Great Ponds*, is also expressed by the willingness to take an oath. Members of age-group societies take oaths on entrance, and sometimes individuals take oaths to symbolise the fact that they will not change their minds about an important issue.

In this way it becomes evident how the model can be used as a means of approach to African art. In the art of the centralised empires founded after Islamic or Christian contact we have the sense

74

of form imposed on the material, of life trying to escape from form, whereas in the art of the kings before the sixteenth century and the lineages on their own since that date, we feel that form and material are infused with the same vital principle of expression and that there is a unity which does not exist in the corrupted court art of later periods.

We can see in the later court art that uneasy tension between an individual's unique character and his attempt to make himself timeless and universal that Mrs. Groenewegen-Frankfurt points out in Egyptian art when she tells us that Egyptian monumental art created an uneasy tension between an individual head and a rigidly formalised body. They were "joined to form a superbly dignified if always faintly disturbing whole."[7] She goes on to say that "the recognition that historic individuality and the dignity of the unchanging need not destroy each other but can be formally united in a way not lacking in harmony may explain two unrelated facts that in Egyptian art all human portraiture has a monumental characteristic and that this art requires the setting of a tomb."[8] African art has solved this problem by making the king's individual personality a unique collection of events which take place in their own time and space, while the ancestors go on repeating the pattern of the lineage in the clan and therefore express that pattern in a rigid and hieratic form.[9] Benin art after the sixteenth century shows signs of the destruction of this equilibrium and the attempt on the part of the king to use his political power achieved by a favourable geographical location in relation to the slave trade to usurp the function of the ancestors and to make his own lineage permanent, taking on the timeless character of the ancestors. When the king acquires ancestors his art takes on an uneasy rigidity. Indeed, it seems as if the whole of the Benin state was organised with this uneasy rigidity after the sixteenth century. The king, who was always the first-born son of his predecessor, strove to leave behind himself a public monument of his own individual personality, not only in works of art but in the organisation of the state. The iconology of the bronze sculpture reflected this drive to individual self-assertion in which the king saw himself as the state. The most important bronzes were those of the king's head, and his head was the seat of his uniquely determined destiny because that was

7. Groenewegen-Frankfurt, 1951, page 25.
8. *Ibid.*, page 27.
9. See page 148.

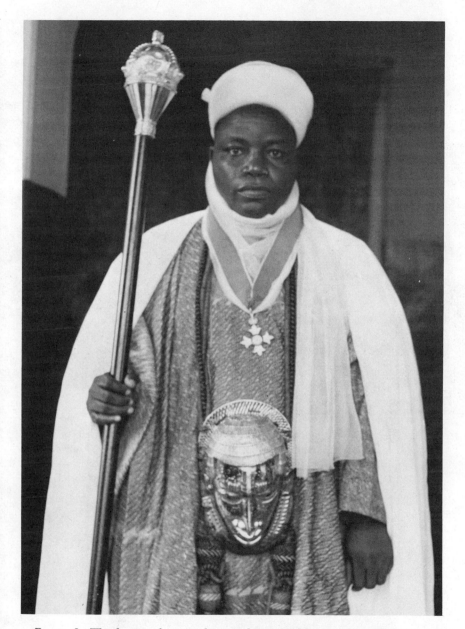

PLATE 8. The bronze face mask worn by many Nigerian kings represents the fact that the king's image is durable, transcends men's life spans, and is bright and shining like the sky. (Igala, Nigeria) *John Boston*

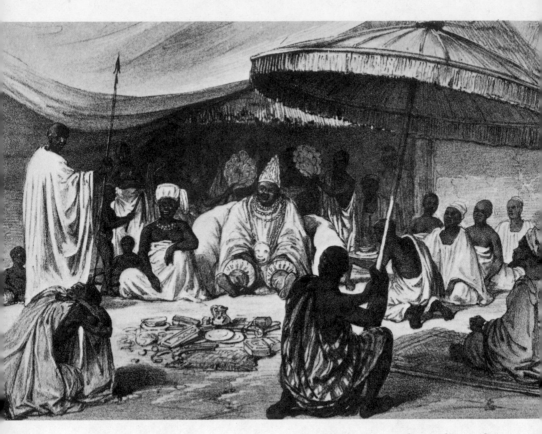

PLATE 9. This nineteenth-century drawing by an explorer shows the Igala king in Nigeria wearing his bronze face mask, but it also shows his royal umbrellas, which represent his ability to shade his people from the sun, and to encompass his particular social group and understand their special needs. *Frank Willett*

where his destiny spirit lived. (When the Igala king appears in public he carries a bronze head at his waist, and we are told that the Onitsha king also appeared with "his bronze head," which had been the climax of his installation ceremony.[10]) The later Benin kings' heads tried to combine monumentality and individuality unsuccessfully. The unique individuality of form of a king whose personality was a specific and once-for-all experience was expressed, however, in the Bakongo royal statues. By contrast we do not see an uneasy rigidity of form in the Bamileke beaded figures from Cameroon, the art of much smaller kingdoms where the king's soul could more easily express his society's personality. It seems, therefore, that the attempt by a king to impose the personality of his lineage on a large group produced an uneasy rigidity in the art of Benin, that Bakongo art solved the problem by defining each king's personality separately and carefully and that where the chief did not have to outreach himself to assert his personality, but was expressing his soul in a small group, the uneasy tension of form was not a problem that needed to be considered.

10. Jeffreys says that the bronze face mask held by the Eze Nri placed him above the law. Jeffreys, 1935.

6 Divination

We have said that if the basis of the way in which individuals understand nonindustrial African society is a dualism, it is a dualism of an opposition between conformity to a social group and a desire for individual self-expression. The demand of individuals for self-expression is satisfied by the activities of their adult age society before they take on the responsibilities of elders. We have also said that an individual who wishes to avoid the restricting pattern of his destiny may go to a diviner to ask his intercession in obtaining a new one. We shall also see that a diviner can assist an individual with a particular kind of nonconformity to join a cult and that in some societies, such as the Yoruba, the society forms a complex equilibrium of cults expressing various kinds of personality. In others, such as those of the Ashanti and the Fon, membership of each clan is thought to produce a particular kind of personality, and cults may be avenues of escape for individuals whose personalities do not conform to that of their clan. Again the diviner is called in for assistance in providing the avenue of escape.

Sometimes, however, the diviner is called in by a social group to detect individuals who are not conscious of their feelings of revolt and are therefore regarded as witches, and in many societies the only way in which a witch may escape responding to the demand to conform is to move himself and his immediate relatives and associates to some other locality. Then nonconformity expresses the fact that

an individual is unable to come to terms with his social or economic environment. It has been said[1] that witches and their detection are important in Central African societies when the splitting away from the social group is important and that in stable societies witchcraft is merely peripheral to the main preoccupation of the society.

In the writings of those social anthropologists who have worked in Central Africa, the diviner's job is represented as discovering those who have thoughts which are antagonistic to the society and pointing them out so that they can be persuaded to conform. Their ill-wishing may cause ill-health or misfortune to those with whom they do not agree. Sometimes their ill-wishes are reinforced by mystical powers, and the mystical powers have been somewhat artificially divided by some writers into witchcraft and sorcery.[2] If the mystical powers take effect without the ill-wisher willing the effect, he or she is known as a sorcerer. In some societies women are especially singled out for the description of witches. One explanation given is that men have a guilty fear about their having relegated women to the position of a lower status and therefore assume that they will naturally express their resentment by using mystical powers. Witchcraft as a divisive factor becomes important then in societies with matrilineal inheritance where there is a high rate of divorce and where the men need their mothers or sisters to inherit.

Witchcraft among women is also important, however, in some West African societies where women are designated witches because they have power and freedom and the men are jealous of them.[3] The women's power is achieved by their not conforming to the men's wishes. Thus in some situations witchcraft can indicate the resentment of the less fortunate. This resentment can be a divisive force where the witches are free to move on, but in other situations witchcraft can indicate the use of power obtained by their freedom of ac-

1. Douglas, 1967.
2. Based on the division made by the Azande in their language as described by Evans-Pritchard (1937), whose book can claim to have started the modern study of witchcraft in Africa. The work of modern social anthropologists on African witchcraft is well known, and we need only to show here how it fits the paradigm of an equilibrium between conservation and change in African society. A concise summary of the problems posed to social anthropologists by witchcraft has been made by Lucy Mair (Mair, 1969).
3. Nadel, 1952, page 22. Nupe husbands (in Nigeria) "are often heavily in debt to their wives, and the latter assume many of the financial responsibilities which should rightly belong to the men as fathers and family heads. This reversal of the institutionalised roles is openly resented by the men who are, however, helpless and unable to redress the situation."

tion. Witchcraft therefore is ambiguous. It can be regarded as valuable both by those who use it as an excuse for separating themselves from their neighbours and by those who may benefit from its uses by receiving a share in its rewards, or alternatively it can be regarded as inimical by those who drive their neighbours away or by those who do not personally benefit from its use. The mystical force used by witches as an instrument of their power is also ambiguous. The force exerted by a witch can be the same mystical force used by a ruler to carry out a cohesive role in his society.

However, before we refer to any more examples of the role of witchcraft in nonindustrial African society we must point out the limitations of the evidence. Every social anthropologist has his own model of the African society he is observing. Victor Turner in his paper on "Ndembu Divination"[4] and his book *The Drums of Affliction*,[5] describing the social role of diviners and beliefs held about society symbolised in divination ceremonies among the Ndembu of Zambia, Angola and Congo-Kinshasa, represents their world as one in which there is an increasing number of formal social structures into which a man grows, contrasts the liminal state of the initiate before initiation and describes the role of the diviner as one of persuading the recalcitrant individual to fit in, to adapt himself to this world and to leave the liminal world of pollution and chaos behind. Mary Douglas has her own particular model. In her *Purity and Danger*[6] she describes the witch among the Lele of the Congo as an individual whose position in society is ambiguous, a role not clearly defined and understood and therefore polluted. The use of a particular model may lead a social anthropologist to overlook certain features of a society. (We have seen that another social anthropologist, Jack Goody, has admitted in his introduction to *The Myth of the Bagre* that he had previously underestimated the role played by deities in their religion.[7])

It is therefore better to make it clear that when we refer to a social anthropologist's description of an African society that it is his description to which we are referring and that the society may be markedly different from his description of it, especially in its use of symbols, which is what we are especially concerned with here.

4. Turner, 1961.
5. Turner, 1968.
6. Douglas, 1966.
7. Goody, 1972, referred to on page 45.

That is why it is sometimes necessary to make it plain that we are taking our evidence from a particular individual's description of a society by referring to what he describes as if he were the owner of it —e.g. Evans-Pritchard's Azande, Turner's Ndembu, Douglas' Lele and Middleton's Lugbara.

To return to the concept of mystical force, we can look at Evans-Pritchard's Azande society, where it is those who feel jealousy who are guilty of using mystical force for purposes of witchcraft. All misfortunes and most deaths are normally thought to have been brought about by witchcraft, and "a witch attacks a man when motivated by hatred, envy, jealousy and greed."[8] A man who falls sick or meets with some other misfortune calls in a diviner to decide who is responsible, but no action is taken on the diviner's decision until recourse has been had to an oracle, poison administered to a chicken, twigs exposed to white ants or two pieces of wood which stick together when rubbed (the oracle of "the rubbing-board"). If the chicken succumbs to the poison, the twigs are eaten by the white ants or the boards stick together when rubbed, the witch is truly identified. However, there is still some room left for the decision made by the leaders of the social group after the oracle has decided, for example, that the death of an individual may be attributed alternatively to vengeance carried out by a man's kin for his death by witchcraft by using vengeance-magic. In the past this decision was normally made by a prince, and his right to decide what was witchcraft and what vengeance-magic could be used as an instrument of his authority.

Resentment against a witch is not harboured permanently, because when a man or woman has been identified as the source of a particular misfortune and compensation is paid by their kin, the matter is finished with. However, some individuals have a particular tendency towards witchcraft. One man described by Evans-Pritchard had a reputation for drunkenness and taking free drinks from his neighbours, but they were inclined to give him the drinks for fear of his retaliating with his witchcraft if they refused. It appears from Evans-Pritchard's description in general that it is particularly the poor and underprivileged individuals who are reputed to be guilty of witchcraft, because they are the ones who are particularly prone to resentment.

However, in the case that Evans-Pritchard has given of an indi-

8. Evans-Pritchard, 1937, page 100.

vidual who is believed to be particularly prone to witchcraft, his mystical powers seem to derive from the fact that he was a misfit in his society. He did not conform to its established norms. We shall see that in African societies generally one kind of individual who is especially singled out for the suspicion of witchcraft is the hunter, and the hunter is accused of witchcraft not because he is poor but because his occupation as a hunter gives him a reputation for secrecy. He is like Evans-Pritchard's Azande drunkard in that he is a non-conforming individual, but it is his personality as such, a misfit, that in fact enriches him and leads others to be jealous of him. Individuals of this kind who have their own cult are described by Victor Turner. He was told by an Ndembu informant, "Hunting is sorcery, for hunters have snake familiars which kill their relatives to increase their power." He found that if they had bad reputations they had no shame but in fact enjoyed them. Their principal cult symbol was a forked branch of the kapepi tree because its name meant "the wind," and it stood for the hunter's invisibility and ambiguity when stalking game. A symbol associated with the forked branch and placed beneath it during the hunters' rituals is a piece of earth from an ant nest. It is cut into the shape of a cube and called "the little hut of the ancestor shade."[9] These pieces of ant nest show that the hunter's proper home is in the bush. Huge ant nests are hillocks that hunters hide behind when they are stalking game.[10] The double meaning of the anthill that hides someone and behind which transformations take place is to be found in a modern play by the Ugandan playwright Robert Serumaga. It is called A Play. In this play a man called Mutimukulu has lost his wife to a stray bullet from a soldier's gun, but he himself feels partly responsible for his wife's death because he had some share in causing the soldiers to be firing at innocent people. A year later, on the anniversary of his wife's death, he is compelled to face this truth, and a ghostly head appears, saying:

> There is an anthill where I am sitting,
> And you and truth have parted, and gone your different ways
> When you meet on the other side of the raised ground
> The truth will have become a leopard with horns on its head
> Will you let it eat you, or will you speak out in its face.

9. Turner, 1967, page 294.
10. Ibid., page 295.

In a radio interview the playwright explained that these lines refer to a story that his Luganda-speaking people have about a man who meets a cattleman from Ankole. If the cattleman asks the man to meet him on the other side of an anthill after going round it backwards he should refuse because the cattleman might turn into a leopard with horns on its head. This creature is called *ngolo* and must be met face to face. "It's a kind of coming face to face with a truth on the other side."[11] In Serumaga's play, therefore, the anthill is used as a symbol of deception and therefore has the same ideographic value for the Baganda as for Turner's Ndembu where it describes the hunter's capacity to deceive his quarry. Hunters are individuals who are allowed to practice deception, but Turner follows Evans-Pritchard in that he refers to Ndembu divination in its search for evasiveness and deception as principally concerned with the detection of malevolent powers. Turner writes, "Among Ndembu, the diviner regards his task as the practical one of revealing the causes of misfortune or death."[12] Witches are held responsible for misfortune or death by using their mystical powers, and they are capable of an infinite amount of trickery in hiding deceits. At the beginning of the consultation of a diviner he uses head pads made of a long grass known as *Kaswamany'wadyi*, its name derived from the Ndembu word "to hide" and the word for a bird like a partridge that hides in the long grass. The people who consult the diviner pass under a frame of sticks like a goal post on which head pads of *Kaswamany'wadyi* have been placed, because the grass in them is twisted "like the witch's attempts to deceive it," and remind the diviner of what he is looking for.[13] By passing under it, the consultants and their kin show that they are not themselves harbouring the sorcerer. It is important to remember for what we shall point out later in this

11. Robert Serumaga, interviewed by the author, BBC, London, July 21, 1970.
12. Turner, 1968, page 27.
13. The same symbol of a twisted strand standing for witchcraft and for disguise occurs in West Africa. In a description of a Bangwa "cry-die" or funeral of a chief in Cameroon, Brain and Pollock describe the Lord of the Night Society. "The Lord of the Night Society has mystical information reserved for the ears of the chief. He is believed, ritually, to transfer to his mask the late chief's attributes of shape-changing. These activities are visualised by the Bangwa in the form of a twisted root or rope which is kept by the Lord of the Night Society, as controller of the royal mysteries of witchcraft." Brain and Pollock, 1971, pages 82–83.

chapter that when it is used by hunters' cults this same grass symbolises the hunters hiding in the bush to catch animals.

Thus Turner writes as if the function of the diviner is to seek out all that is secret, dark and hidden and as if all the objects used in the ritual of divination are devised with this end in mind. The diviner uses a basket similar to a winnowing basket, symbolising the fact that in his search for the truth he is sifting the grain from the chaff. The basket contains a number of objects of which some are small carved figures. For example, a group of three figures bound together with horn represents the elders of the kin group or the headman and his kin, a figure with his chin in his hands and his elbows on his knees represents someone who is irresolute and changeable, a figure of a man with his hands clasped to his head in the traditional posture of grief represents a mischief-maker who carries tales from one person to another.[14] The other objects in the basket besides carved figures are direct references to the situation they symbolise, pieces of calabash to represent seeds in the womb or the matrilineage, the limp nerve from an elephant's tusk to represent impotence or the root of a tree which takes a long time to decay in the ground to represent "long ago." Each object, however, is a symbol with several different meanings alluding to the context which is provided by the other objects with which it is discovered at the top of the heap after the basket has been shaken. The symbols with multiple meanings for which the objects stand are known as *chinjikijilu,* and this name is derived from *ku-jikijilu,* which means "to blaze a trail in the bush" because the marks made along the trail "lead from the unknown bush to the known village." The diviner has the same kind of power as the hunter and in fact becomes a hunter of witches, and diviners are just as suspect as hunters. They are men who succeed in society by using their wits and may be proud of their position as men who do not to fit into that society. Their conclusions are often unpopular and may place their lives in danger, and, just like the hunter, they boast of their independence from the group.

Their collection of objects then are called symbols by Turner and are said to "blaze a trail in the bush." It might be suggested, however, that the diviner does not work by considering all the various meanings of his objects and fitting them together as if he were composing a jigsaw puzzle. Rather he uses the objects like the beads of the Yoruba diviner, which suggest verses. Each arrangement of the

14. Turner, 1968, pages 35–42, and Turner, 1961, pages 10–11.

Ndembu diviner's objects suggests a social situation, and by observing his clients' reactions to his description of that situation the diviner perceives the psychological effects. In this way he can observe which members of the group are ambitious, which resentful, which careless and so forth, until he can suggest a solution. In deciding who is a witch or a sorcerer he knows he may be helping a necessary process of schism, and by forcing a section of a group to leave and live elsewhere because they are not prepared to accept the judgment of the majority that they should expel the offender he is behaving like a surgeon performing a necessary operation. In fact the group with the witch or the sorcerer may feel pleased that they have him because he may be useful to them later when seeking to increase their own power.

Another society in which the power of witchcraft is said to be the reason for the movement of individuals away from their home villages is that of the Nyakyusa, described by Godfrey and Monica Wilson. The Nyakyusa live on the northwestern side of Lake Nyasa and still have plenty of land to expand into. Witches are said to have pythons in their bellies, but defenders against witchcraft are also said to possess pythons. Both witches and "defenders" send their pythons to "eat" those they wish to attack. Witches are usually people who are proud and aloof and do not share their food willingly with their neighbours. However, a witch who has been driven out may not be regarded as a witch in the village to which he has been driven to move, and it is not always certain in his own village whether he is a witch or a "defender." In fact a witch who has been driven out may be fetched back because he would be a good "defender." This fortune may be attributed to witchcraft by one person but to defence against witchcraft by another.

In Nyakyusa society an accusation of witchcraft is used to drive a man out so that he goes off to live in another village. An example of fission working in the opposite direction, where the younger generation accuses the elders of witchcraft as an excuse for breaking away, are Middleton's Lugbara living on both sides of the border of Uganda and Zaire. Middleton's Lugbara are a group who speak a Nilotic language, whereas most of the people who are described in this book speak Bantu languages or languages related to the Bantu group. It should be pointed out, nevertheless, that speaking a type of language is not a necessary indicator of a homogeneous group of cultural features and that many of the people in the area we are considering

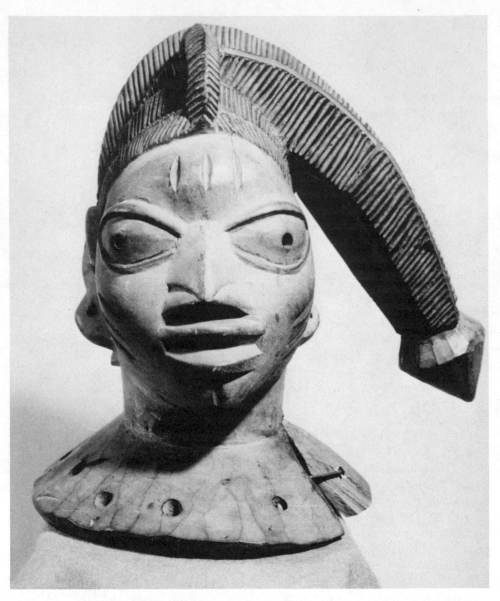

PLATE 10. A Gelede mask of Eshu, the Yoruba messenger of the demi-gods who is a cult figure at every market place and who leads the masks at the Gelede cult for Yoruba women conducted by their sons. (Yoruba, Nigeria) *Lowie Museum of Anthropology, University of California, Berkeley*

speak non-Bantu languages and yet have cultural features which appear to be similar to the core group of people who speak Bantu languages. Middleton's Lugbara are an obvious case. They have a double-descent method of reckoning affiliation and inheritance; they practise shifting cultivation and regard hunters as carrying out the role of innovators and explorers, which, as we shall see in Chapter 7, are the most important features of the Bantu speakers of sub-Saharan Africa and creates the unique feature of contrasting visibility and invisibility in their art.

Middleton describes the splitting of a lineage into two separate lineages in a process which takes fifty years. The elder leading a lineage is expected to use his mystical power to hold the lineage together. He uses it as a weapon against younger members whose selfish attention to their own interests threaten to split the lineage, and he claims to have brought sickness on men whom he considers are acting selfishly against the interests of his lineage. But the same elder can be accused of using witchcraft, using his mystical power illegitimately, when members of his lineage wish to have an excuse for segmentation and to move away as a group. Middleton shows that the greater the number of segmentations in Lugbara lineages the more frequent are the accusations of witchcraft.[15] An elder can invoke the ancestral spirits to bring sickness to members of his lineage if they do not respect his authority, and he is expected to do so. He would be thought a weak elder if he did not. His excuse for doing so is the limitations imposed on him by the gods. An elder with a large lineage is compared to a tall tree, in the words of a Lugbara himself, quoted by Middleton:

There are many trees in that forest; some are great and some are small. The trees that are big push the smaller ones aside, and the smaller ones use the big ones for support against the wind and against the other big trees. We men we are like that; some are big and others are small ones which lean against the big ones. The big ones are our elders and rainmakers.[16]

The duty of maintaining the tall tree, then, imposes on the elder the unpleasant duty of invoking the wrath of the gods against his sons. When they reject his authority they describe this action as selfishness and accuse him of using witchcraft to obtain his own ends.

15. Middleton, 1960, page 228.
16. Middleton, 1960, page 230.

Witches can also be useful in some societies at some periods when they are not useful at others. They are the people in the society who are regarded as the most quarrelsome or as those who have cause to harbour resentments which would make them quarrelsome. The Nyakyusa of Malawi had no need of quarrelsome men under the British administration before independence. In fact Monica Wilson tells us that they were regarded as "a liability, likely to get their fellows and their chiefs into trouble with the administration" and that she was told by her Nyakyusa informants, "We did not drive away violent men in the old days; we said they will fight with us in future."[17]

Thus what is a disadvantage in one social situation may be an asset in another, and none of the social groups with which we are concerned ever regards aggressive behaviour as bad at all times. Witchcraft is a kind of secretive aggressive behaviour and may even be the kind of aggressive behaviour of which an individual himself may not be consciously aware. Witchcraft can also be regarded as an asset in some social situations and not others and may be differently regarded under different historical conditions. For example, Verger has pointed out that the description given by Nadel of the attitude to witches among the Nupe (which we discussed on page 79), that witches are women who are regarded as malevolent by men through a fear of their economic power, may have been true of the Nupe only since the Islamic conquest and unification in 1833 and that, prior to that event, the Nupe may have regarded witches in much the same way as their neighbours, the Yoruba.[18] Among the western group of Yorubas, the Gelede society for the appeasement of witches has a masquerade which is conducted by the men. The first masquerader to appear at a Gelede festival is possessed by Eshu, the Yoruba messenger of the gods, under whose care all markets are conducted and to whom, therefore, the Iyalode, who is both the leader of the women, the chief of the witches and the chief of the market, pays special attention.

There seems no reason, therefore, why Verger's explanation of the Yoruba witch and Nadel's explanation of the Nupe witch should not both be correct. In both societies women become traders and accumulate wealth. Consequently they are open to the suspicion that they will use their wealth in their own selfish interests and will not

17. Wilson, 1951, page 80.
18. Verger, 1965, page 148.

use it to benefit the group as a whole. Again we see that it is the witch's exclusive attention to her own self-interest which is alleged by the group and produces their suspicion of her. Mary Douglas has suggested that witches are not very important in strong, centralised societies such as the Azande of Evans-Pritchard. The detection of witchcraft does not play an important part in the social transformations in Azande society. It causes no fissions. The suspicion of witchcraft is confined to those who are poor or suffer misfortune. We might suggest alternatively that wealth must be evenly distributed in Azande society and that men are not in a position to accumulate wealth to further their own selfish interests at the expense of others. As it is unusual to be consistently poorer or less fortunate than others in the society, it is the poor and unfortunate who are in an ambiguous position and who are therefore accused of witchcraft, in contrast with Verger's Yoruba or Nadel's Nupe, where the rich women are not trusted.

However, it makes no difference to the diviner's role whether the witch is suspected of becoming rich through self-seeking or is suspected of malevolence through excessive misfortune or poverty. In the one case the witch is trying to avoid placing her wealth at the disposal of the social group; in the other the witch is resentful of the good fortune of members of the social group. In both cases the diviner is looking for a refusal to conform and a secretiveness in the individual's behaviour in order to be able to avoid conformity. Nevertheless, the refusal to conform has an element of ambiguity, because in the case of the alleged witches who use their secret knowledge to enrich themselves they may assist their kin or their neighbours, and so long as other individuals benefit as well they may regard the witch as an asset. In a society in which the extent of most people's possessions do not differ much from their neighbours', the less fortunate may be seen as a reason to congratulate oneself on one's good fortune, and witchcraft may be seen as a source of amusement and entertainment, a constant and consuming interest to make life more complex and varied, which is what the consultation of oracles in Azande life appeared to be to Evans-Pritchard.

Witches, then, are people in the society whose position is ambiguous because it is not certain whether they support the social group or are opposed to it. Individuals who are poor or who have grudges may not support the group, as in Evans-Pritchard's Azande society. Individuals who go their own way and have some kind of superior

90

knowledge which enables them to enrich themselves may not necessarily benefit the members of their social group, such as the hunters, in Turner's Ndembu society. Women who are regarded as having served their function when they have produced a male child and who then leave their husband's compound to set up a trading establishment are regarded as suspicious by jealous males among the Nupe and the Yorubas, and again there is a doubt about whether they are mainly self-interested or have their neighbours' interests in mind also when enriching themselves.

It is living in an ambiguous position which makes it important to guard secrets. Witchcraft, self-seeking and secrecy are all related. The keeping of secrets is also ambiguous. It may produce power, and such power is approved if the profits derived from it are distributed for the good of the social group. Cults and secret societies preserve secrets for the benefit of their members exclusively, and then their members have to be prepared to distribute the profits derived from their access to the secrets for the benefit of the members of their particular group. (A parallel to the African examples would be the secret societies of horse dealers that flourished in England in the seventeenth century, particularly in East Anglia. There were recipes for making a horse's coat shine when it was to be sold and for other purposes, and an oath was taken for access to these secrets on pain of death for breaking it.) Kings and priests are suspicious of secret societies because they are suspicious of all people who have access to secrets other than their own, but kings and priests pay for the preservation of their own secrets which entails the right to assert their individual will on the society by distributing a very large part of the profits. In *Arrow of God* Achebe says of Ezeulu, "Long, long ago there had been a fifth title in Umuaro—the title of King. But the conditions for its attainment had been so severe that no man had ever taken it, one of the conditions being that the man aspiring to be king must first pay the debts of every man and every woman in Umuaro."[19]

A king, then, or an important rank-holder is an individual who can afford to pay dearly for the right for his pattern of living to be imposed on his social group, a right which is expressed in many African societies by the beating of the king's rhythms by his drummers at the

19. Achebe, 1964, page 239. Goldie described a case of a royal cult which had become extinct as no one was willing to undertake the burden of office. Goldie, 1890, page 43.

dawn of every day. It also enables the king to make an open dis-
play of his "objects," the contents of his treasure chest, and for his
lifetime the objects which represent his personality become symbols.
It is better not to describe the objects in the diviner's basket as sym-
bols, however, as we have already seen.

The guarding of a box of secrets, which is associated with the
leader's preservation of the group or alternatively with an individual's
selfish attention to his own interests, is a widespread feature of the
metalanguage of symbols in the whole area of Africa south and
west of the Sahara, but the "box of secrets" has also very different
meanings, according to whether it is guarded by rulers (kings, chiefs
or elders) or by diviners. The rulers' secrets are a means of discover-
ing other people's secrets by discovering their deviations from the
rulers' patterns. Therefore, they must not be allowed to concen-
trate power in the hands of his family for too long. The "washing"
of the ruler's relics when he dies fixes them in their revealed pattern.

We have said in Chapter 2 that the seclusion of the king, his hid-
ing behind a veil, his use of an interpreter, his not eating in public,
his feet never touching the ground, the return of his hair clippings,
feces and sputum to his palace, the sacrifice of his wives and servants
when he dies, would all be interpreted as symbols for the restriction
of his soul. It is given the opportunity to exercise power by its reten-
tion of a rigid pattern, but its pattern must not be allowed to over-
shadow the alternative expression of the personality of its successors.
It will, however, be seen that in societies such as the Yoruba, where
there is a very finely developed equilibrium between the cults or
secret societies (which include the king's cult), the cults can be
seen as an outlet for the expression of individuals' personalities and
that the king's successors are also allowed the development of their
personalities during his lifetime. Thus the king is secluded to ensure
that his power should not hamper the development of viable alter-
natives which may be necessary as the social and national environ-
ment changes.

In these Yoruba societies, therefore, it is provided that each of the
groups comprising the society should be allowed to preserve its
secrets but that no one group should be allowed to use its secrets
to flourish at the expense of another, or use them to hamper the
development of another whose flourishing might be of value to the
whole society. "Washing" the soul limits its influence to the con-
fines of its particular pattern. We have seen that it explains why the

use of white in rituals implies restriction rather than purification.[20]

The restrictions imposed by painting an individual with white patterns or dressing him in white clothes are the same as the restrictions limiting him to his own compound and preventing his dirt, which is an extension of his soul remaining behind to become confused by other souls. Being forced to keep a clear pattern is in itself a restriction. However, everything that is white and bright and associated with what is tall and far-seeing (including the ndako gboya masquerader of the witch-hunting cult of the Nupe, as well as the kings or priests dedicated to the sky gods already described) may become dangerous to creative individuality because it is far-seeing and can penetrate the secrets of others. Being far-seeing is the equivalent of being inflexible.

It is then the rigidity of the king's imposed pattern which must not be allowed to last too long in the society. The king is far-seeing and has the power to "cut"—that is, to ignore the interests of other individuals and groups when making decisions. However, he is allowed to exercise these powers only on ritual occasions.

In such circumstances the secrets of the king are not secrets while he ceases to be king, and they cease to be secrets at his funeral. Then they become the fixed pattern which the king imposes on all the various groups in the society, and they must be given clear expression so that the groups may be able to define for themselves exactly what pattern the king was imposing on them. "Washing" the king's soul in public ceremonies is a description of that process of definition.

While the king is alive, however, his pattern of society enables him to see into everyone else's secrets if he feels the need. This is why the representation of the chameleon is such a potent object in the regalia of kings. It is the animal which can take on the colouring of the king's subjects so that the king's personality appears to be their personality, and it is the animal which pursues its own course, ignoring all obstacles. It has an implacable purpose.

We must reject the use of the word "symbol" for the diviner's objects for the reasons given here. A symbol can become restricting. If it is used repeatedly with the same meaning it becomes an instrument of power, and it is only rulers, kings and elders who can use objects as symbols of power and then the configuration of their symbols must have a strictly limited power, limited to a particular place

20. See page 64.

for a restricted length of time. The diviner's objects must retain their ambiguity. They must not form restricting patterns. The king's particular and individual set of symbols must keep its rigidity because it is his function to set a pattern of a particular kind and to see that it is maintained, but the diviner's box of symbols must be flexible, responsive to new patterns which may be forming themselves in the community.

In fact Turner's Ndembu diviner has a similar function to the Yoruba diviner, who helps to determine what cults particular individuals should join, because the Ndembu diviner also helps to choose cults by discovering the cause of afflictions, and afflictions can be regarded as limitations on particular individuals. One of the principal functions of the diviner in Ndembu society is to discover what spirits are causing afflictions, and these spirits may be seen as hidden forces which impose a pattern on individuals from which they are unable to escape. Is it as if the function of the Ndembu diviner is to look for the destiny-souls of individuals, the limitations within which they must accept that their lives must be lived. Cults of affliction are cults of the spirits of ancestors who insist that they have been neglected, but at the same time, when a novice has been initiated into a cult, he or she has a prescriptive right to assist in the cult rituals. The more rituals in which the devotee participates, the greater the prestige attached to a place in the hierarchy of the cult. Consequently, the cult can be seen as a contemporary institution for individuals who do not have much importance in everyday social life. The limitations imposed by the ancestor are an excuse for performing an unusually important role in the cult. At the same time the cult may give individuals the opportunity to act out kinds of behaviour they are denied in everyday life. For example, the Ndembu Nkula cult rituals conducted on behalf of barren women include songs and dances in which the women dress up as hunters and wear the skins of the genet, which invoke thoughts of promiscuity. The songs and dances exaggerate their desire to take a masculine sexual role. Then the men express their latent feelings of ambivalence by cutting down the *mukula* tree, which represents both the matrilineal spirit of the cult and the matrilineage. They express their resentment against the matrilineage.

Turner suggests, "It might be plausibly argued that a woman's 'masculine protest,' expressed in frigidity, periodic disorders and

barrenness, is what is being cut away and destroyed, when the tree is felled and the cock slaughtered."[21] Thus he concentrates on the "magical" aspect of the cult and does not emphasise the opportunity that it gives the participants to act out roles to which they are not normally accustomed, a form of compensation which is also allowed to members of Horton's Ijo Kalabari Ekine society in western Nigeria when they use the most fearsome water spirits as an excuse for their own individualist behaviour. Turner's Ndembu woman-adept is allowed to give the name of her cult to any child born subsequent to her initiation into the cult, an initiation which was the direct result of her suffering misfortune. A male child born in these circumstances can perform feminine Nkula rite actions at its own puberty ceremonies.

We see, then, that the search by Turner's Ndembu for the causes of affliction by mukishi spirits cannot be attributed simply to discovering a means of avoiding misfortune. The cult leader's role would better be described as the search for reasons for the individual's nonconformity. Illness and misfortune thus become a species of nonconformity. The rituals of the cults which are concerned with their cure attempt to bring to light the hidden facets of the individual's character which have made him resist the unaccustomed behaviour the afflicting spirit is now demanding of him.

Turner has pointed out that the rituals in Ndembu society act as a means of integration in communities which are continually subject to fission and change. The ritual, "although it operates in a contingent and fitful manner in particular situations, and lacks great natural, seasonal or regular performances, still continues to stimulate in its members sentiments of tribal unity, of a general belonging together, which transcend the irreparable division and conflicts of interest in the secular social structure."[22] From the point of view of the psychology of the individual, which, it is suggested in this book, provides a better paradigm for studying material culture and interpreting works of art than the analysis of social structure, it is better to turn on its head the function of ritual according to Turner and to suggest that social cohesion in Ndembu and similar societies is maintained by rituals in which individuals are allowed to express their own particular differences to other members of their society. They can bring their secrets into the open to be examined by the adepts of their

21. Turner, 1968, page 86.
22. Turner, 1957, page 302.

particular cults but shielded from the close examination of the adepts of other cults. Thus, ritual does serve an integrative function in a fissiparous society, but the emphasis of our paradigm should not be on the unifying symbolism of the ritual so much as on the opportunities it gives for individuals to act out the unique features of their characters. An "affliction" then becomes, as we have already suggested, an unbearable limitation of an individual's will. It is seen as a personalised force, but its principal characteristic is that it places restrictions on an individual's movements. If an individual feels that the pattern of his movements is being restricted, then he can place the blame on some spirit-individual who is restricting these movements. The rituals for the appeasement of this spirit are occasion for the individual to "let himself go," to carry out nonconformist behaviour.

McKnight has shown that matrilineal ghosts are frequently more "afflicting" than patrilineal ghosts.[23] However, if an "afflicting" spirit is an excuse for nonconformist behaviour, the fact that matrilineal ghosts are more "afflicting" seems to show that the members of the matrilineage have more cause for rebellion. If the ghosts of the patrilineage are more "afflicting," then we should expect that the members of the patrilineage are the ones who feel most restricted.

We have seen, then, that there are two functions which may be carried out by the diviner. In looking for witches he may actually assist the process by which nonconforming groups move further away; in looking for "the afflicted" he may assist individuals to discover the limitations imposed by their own personality or by that of members of their group and help them to recognise their own unconscious resentments of those limitations. We shall consider the latter in the discussions of "cults" in the next chapter.

The discovery of witchcraft and the discovery of afflicting spirits are seen, however, to be similar in their objects, the discovery of the individual's resistance to social demands or to inexorable patterns of daily life. It is therefore the diviner's search for these nonconforming individuals known as witches that may become a means of fission in the society, a way of telling single individuals or groups of individuals that there is no room for them and that they should go and seek a new place to live.

We saw that the king's or the elder's collection of objects always retained the same pattern, but the diviner's collection formed a dif-

23. McKnight, 1967.

ferent pattern for each individual or group which influenced them. The secrets of rulers, therefore, differ in kind from those of diviners. The function of the ruler's collection of secrets is to detect nonconformity, defined as an infringement of the pattern fixed by the king in accordance with his collection, but the diviner's collection is a method of persuading individuals to reveal their nonconformity. Therefore, secrets in the hands of diviners may be used as a technique for fomenting rebellion, and sometimes those who have paid for the diviner's assistance have the instigation of rebellion as an end in mind. Sometimes the cults they form to express nonconformity have rebellion in mind, as we shall see in Chapter 7. Kings, therefore, are very often afraid of cults and have good reasons to be so. Their secrets are intended to prevent rebellion; the secrets of the cults are often intended to create it. Evans-Pritchard wrote that the Azande princes disliked secret cults and tried to keep them out. He also said that the king of Dahomey suppressed secret societies and that they existed only on the borders of his kingdom.

7 Definition and Ambiguity

The Zande and Fon kings' fear of cults may be compared to Pentheus' fear of the Bacchic cult in the *Bacchae* of Euripides and explains why the Nigerian playwright, Wole Soyinka, became preoccupied with the figure of Dionysus and discovered analogies with the Yoruba cult of Ogun in his studies of Greek literature as an undergraduate at the University of Ibadan. In Soyinka's version of the *Bacchae*, Tiresias, the high priest of Thebes, becomes a wily priest manipulating the political forces in the society with the same guile that is known to have maintained the power of the priests of the Ibo Arochukwu oracle until recent times and must have been a characteristic of the *babalowo*, the Ifa diviner, of Soyinka's own Yoruba-speaking people.

In Soyinka's version of Euripides' *Bacchae* Tiresias allows himself to be flogged as if he were a slave, a madman or a criminal, chosen to wash the dirt of the old year away—the "filth, pollution, cruelties, secret abominations—a whole year's accumulation."[1] His attendants simulate flogging him, and Tiresias chides them with taking the performance too seriously: "Fools! Blind, stupid, blood brutes! Can you see how you've covered me in weals? Can't you bastards ever tell the differences between ritual and reality?"[2]

Tiresias explains to Dionysus that it is not politic to have a slave

1. Soyinka, 1973, page 242.
2. *Ibid.*, page 241.

revolt at that particular time. "It is necessary to wait for a more propitious day." And he implies that "if one more slave had been killed at the cleaning rites, or sacrificed to that insatiable altar of nation building . . ."[3] the revolt would have come too soon. When Dionysus asks him if he was not endangering his own life, he reminds him of his own history. "Then I shall pass into the universal energy of renewal . . . like some heroes or gods I could name."

It appears, therefore, as if Soyinka sees Dionysus as the corn king and imposes on Euripides the explanation given by Plutarch, the priest of Delos with its Isiac mysteries, four hundred years later than Euripides. Plutarch identified Dionysus with Osiris and saw Osiris as the corn king, sacrificed every year for the good of the crops. No trace of the Osiris myth is to be found in Euripides, and in our own society it is difficult to dissociate it from Sir James Frazer and *The Golden Bough*, a version which may also have derived from Plutarch and his cult of Isis. Nevertheless, we might ask in turn whether Soyinka's own people are not closer to the original source of the Isiac mysteries than either Plutarch or Frazer and whether Dionysus is not the original Osiris. Has Soyinka turned the cult of Dionysus into a Yoruba cult or did Dionysus and Ogun, the Yoruba god of iron as well as wine, derive from the same original source? The ideographic language used by Euripides to describe Dionysus is very close to the ideographs employed in the Yoruba festivals of Ogun. Ogun is the *orisha* who likes palm wine, whose favourite sacrifices are the dog and the bull. Dionysus is also Bacchus, the god of wine, and Dionysus wears the horns of a bull,[4] while Agave, mother of Pentheus, refers to herself and the women with her as dogs, "hounds who run with me, men are hunting us down! Follow, follow me!"[5] Dionysus as Bacchus, like Ogun, is a hunter and the chorus sings, "Our king is a hunter." We are told as well by other sources than Euripides that the Bacchantes, the cult adepts of Dionysus, painted themselves white, as do the initiates to Ogun in Nigeria today.

Nevertheless, it may be disputed whether Osiris was a corn king and therefore it may also be disputed whether Dionysus was a corn king if we allow that he had any common origin with Osiris. The Isiac cult of Dionysus as Osiris and named Serapis was artificially introduced by Ptolemy administering the southwestern part of the Alex-

3. *Ibid.*, page 242.
4. In the Attic festivals his procession ended with the sacrifice of a bull.
5. Euripides (trans. Arrowsmith, 1969), page 224.

andrian empire and attempting to forge a single pattern from all the cults to be found in that empire.[6] It seems to be from this ancestry that Plutarch's description of Isis and Osiris has come down to us, and thus we might propose that the Frazerian interpretation of Osiris as the corn king derived ultimately from the Ptolemaic attempt at the unification of all the cults of Saharan North Africa, Crete, Greece, Asia Minor and Egypt.[7]

The description of Isis and Osiris that we find in Plutarch tells us that Osiris was dismembered by Typhon (Seth) every year and that his mother collected his pieces together so that he could be reborn. This myth could be related particularly to the Nile's annual drought and flood, with Typhon as an ideographic representation of the sea. However, Plutarch also tells us that Osiris could be identified with Dionysus in his Lydian form—that is, his form originating in Asia Minor and in Mesopotamian religions whose basis is the myth of Ishtar and Tammuz or the procreation of the crops by a union between the earth and sky. If Isis is identified with the earth, then we can see that the Frazerian divine king, the corn king, also derives from the Lydian version of Dionysus, a king who is sacrificed every year for the fertilisation of the crops, into whom life is infused by his mother, the earth, who is also his wife, the queen. The annual fertility ceremonies, according to the Frazerian myth, involve first the killing of the king, then the purification or washing away of everything associated with his old regime, and then his rebirth with the help of the queen. However, it is the regenerative role of the earth which seems to be emphasised in the ideographic cosmology of the African myth and one which is also enacted in the ceremonies. The earth mother re-creates the phallus, and as it becomes erect it takes on a rigidity of pattern imposed by the sky which it must eventually discard when it returns to the earth. The king or the elder looks for his definition in the sky, but he returns to the earth as a source of regeneration and fertility. Thus it appears as if the dualism of sky and earth in the Mesopotamian myth is avoided in the African myth and that Isis may derive her ithyphallic ideographs from an African source.

6. However, there were similarities to the Isis rituals of Egypt in the Anthesteria festival at Athens in the sixth century B.C., and we might suggest that Dionysus derived from Osiris at a much earlier date. For Dionysus depicted riding on a boat on wheels in sixth-century Scythia (and even earlier), see Pickard-Cambridge, 1953, page 14.

7. See Legge, 1950.

The Nigerian poet Christopher Okigbo, who died fighting for Biafra in the Nigerian civil war, asserted that the mythic garments of cultures are interchangeable. In an interview with Robert Serumaga[8] in July 1965 he said, "The modern African is no longer a product of an entirely indigenous culture. The modern sensibility which the modern African poet is trying to express is by its very nature complex, and it is a complex of values, some of which are indigenous, some of which are exotic, some of which are traditional, some of which are modern,"[9] and he went on to add, "I wear an Italian jacket—I'm not an Italian, I'm an African. I wear a tie and I'm very comfortable. I'm not wearing Nigerian dress—I'm not comfortable in Nigerian dress—it doesn't make me a non-Nigerian."[10]

For Okigbo, in his "Lament of the Drums," the drums

> . . . invite us
> To a sonorous
> Ishtar's lament for Tammuz[11]

in which "The wailing is for the fields of crop" and "The wailing is for the Great River."[12] Tammuz, Mesopotamian god of the corn, is mixed with Osiris of the Nile. Nevertheless, to throw light on the ideographic language of African art the Mesopotamian and African myths must be kept separate. We must be able, for example, to explain why the figures of Isis carry the Uraeus and why the male ancestor cult figures can be female. The earth or the queen does not wait to be fertilised by rain from the sky. She herself creates the erect phallus. The queen as the earth is ithyphallic, and Osiris is also reborn as a snake—that is, the queen as the earth re-creates the erect phallus.

It is clear that Soyinka also does not overconcern himself with imposing limits on the mythopoeic origins of his work. The themes derived from his classical studies make useful plots, and the myth of the corn king helps him to adapt Euripides in the same way that plots from Restoration dramatists such as Wycherley or from Spanish dramatists such as Lope de Vega help him with plots from

8. See page 82.
9. Duerden and Pieterse, 1972, page 144.
10. Ibid., page 145.
11. Okigbo, 1971, page 49.
12. Ibid., page 50.

his own plays.[13] It is, however, the ideographic imagery belonging to the cluster of myths and ritual of the African cults which had a common origin with the myths and rituals of Isis-Osiris (or possibly connected with Hathor and Horus at an earlier period), which is to be found as an underlying inspiration of Soyinka's work from the very beginning.

In Soyinka's first published play, *The Swamp Dwellers*, Makuri, the old man whose son has returned from the town, warns a stranger, a blind beggar from the north, that some land may not be farmed. "The land that we till and live on has been ours from the beginning of time. The bounds are marked by ageless Iroko trees that have lived since the birth of the serpent, since the birth of the world, since the start of time itself. What is ours is ours. But what belongs to the serpent may never be taken away from him."[14] In *The Swamp Dwellers* the earth is ithyphallic.

In *Kongi's Harvest* the female regenerative principle underlies the plot as we have already seen[15] and in Soyinka's second novel, his most recently published work at the time this book was written, *Season of Anomy*,[16] the discovery of a goddesslike figure of a woman amid the ritual chaos is the underlying theme. Ofeyi is a writer employed by the government information service to sell the regime's cocoa with a public-relations programme for which he writes and designs the advertising. Iriyise is a beauty queen used by the promotion experts of a government-organised cartel to "sell" their cocoa. When Ofeyi is enlisted in support of a subversive campaign launched by Aiyero, a commune, Iriyise disappears and Ofeyi sets off in search of her through a country torn by atrocious murders and destruction. He finds her in Temoko, a vast prison with the dimension of a concentration camp, after a nightmare journey in which he traverses cells filled with prisoners persecuted until they are half human, lepers and lunatics. Here there is clearly the progress of Dionysus Zagreus through dark caverns in the bowels of the earth. "It seemed suddenly important that he find out where and why Iriyise was hidden in the con-

13. Compare the plot of *The Lion and the Jewel* (Soyinka, 1973) with William Wycherley's play *The Country Wife* (Wycherley, 1675). In conversation with the author, however, Soyinka has said that the plot of his play is a widespread theme in the theatre and owes no special debt to Wycherley.

14. Soyinka, 1973, page 93.

15. See page 43 above.

16. Soyinka, 1973.

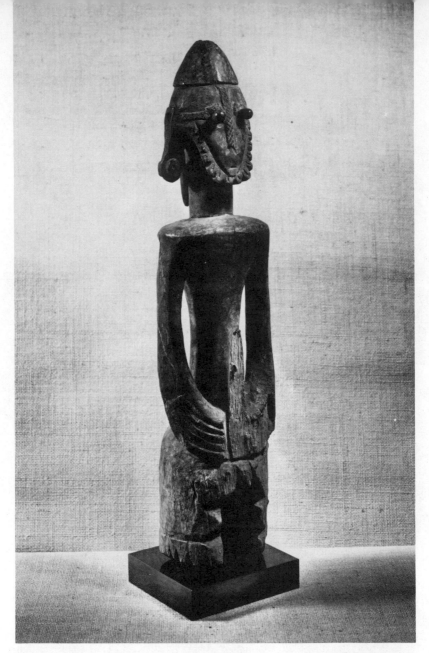

PLATE 11. The Mumuye ancestor figure seen, in Plate 5, to have been
eaten by the ants, the agents of the earth, is here seen as the erect phallus
he became at his "planting." (Nigeria) *From the Alexander Martin Col-
lection (London)*

voluted bowels of Temoko before another step brought him nearer the physical revelation."[17] (We might ask in fact whether the Orphic sources of the Isiac cult are not nearer to Africa than the Ptolemaic superimposition of Mesopotamian myth which we find in the Plutarchian and Frazerian versions.) In *Season of Anomy* Iriyise, the earth mother, is the key to Ofeyi's self-determination, which we have seen is parallelled by Isis' creation of the erect phallus (and in African art the "planted" deceased elder expresses the fact that he has completed the process of self-determination by taking the form of a phallus). In *Season of Anomy* Soyinka is asking the young adults of modern African states to define themselves and shows that there are parallels between their state of mind in public and their private impotence.

This is one characteristic of Soyinka's work, nevertheless, which unquestionably relates it to our paradigm of the dialectic implicit in the opposition between the groups seeking conservation and those seeking self-determination. Soyinka probably regards it as unnecessary to tell us to what extent the ideographs employed by the Ptolemaic Isiac cult, Sir James Frazer and the study of Greek drama have influenced him and how much of his work is original Yoruba ritual and myth, but the use he makes of his writing in relating it to an existing political or social situation is a characteristic of dramatic performances in social groups throughout Africa at the present day and was obviously the most important feature of the nonindustrial African society and one which more than any other feature of nonindustrial African performing art helps us to construct our paradigm. In other words, it is the balance between the established pattern of the older generation and the impatient demand for change of the new generation (exemplified in the satirical plays of the masquerades related to social groups which were constantly exploring new territories and adapting themselves to new techniques) which demonstrates the nature of our paradigm and which is its most striking parallel with the cult of Dionysus and its annual dramatic festivals in ancient Greece.

The Dionysiac cult was feared and resisted all over the Greek world of the Aegean islands in the Mediterranean, and we have seen in recent years how secret cults have played their part in Africa in the struggle for independence (the most obvious example is the part played by the cult of Mau Mau in Kenya).

17. *Ibid.*, page 304.

However, cults are only to be feared by rulers when they get out of hand, and they get out of hand only when the ruler's repression is too intolerable to be borne any longer. Cults may exist peaceably in a society when they allow individuals to express the differences of their personalities in such a way that they are assisted by the cult to accept the workable pattern of the society. The cults help individuals to accept the restrictions that must be imposed if everyone is to live together in peace. This is the role played by the cults in Yoruba society, and then the cult which may be revolutionary in times of rebellion may merely play the role of king-maker when kings die.

Apart from the Isis symbol, another persistent ideographic symbol in Soyinka's work which seems to be derived from both African and Mediterranean rituals is that of the carrier, which he introduces directly to begin his adaptation of Euripides' *Bacchae* with the ritual flogging of Tiresias.[18] In the original myth it seems possible that Pentheus' sitting in a tall tree to spy on the Bacchantes is the true "carrier" because "carriers" in ancient Greece were also hung in trees. It is a theme in Soyinka's work which goes back to older rituals in ancient Greece than those of the cult of Isis, the theme of the carrier who assists in the purification of the New Year by bearing the confusion of the old one away on his back. We still retain something of the spirit of the carrier and putting the past behind us in our own society when we make New Year's resolutions.

In Soyinka's play *The Strong Breed* the theme of the carrier sacrificed in a purification ceremony is first introduced. Eman, a schoolmaster, refuses to give up an idiot boy whose death is being used to carry away the sins of the previous year and who has taken refuge in Eman's house. Eman says that a carrier of the old year's sins should be willing. Oroge points out that the boy can be made willing, seems to imply that he can be made drunk or drugged, to which Eman replies, "Then it is only a deceit. Do you believe the spirit of a new year is so easily fooled?"[19] Jaguna, the leader of the idiot boy's pursuers, jibes that Eman is unwilling to offer himself in the boy's place although he would be best fitted for the role as the stranger in the village. Eman therefore elects to become the carrier and is hunted and killed like an animal by being hung in a snare-like man trap in the trees.

The heaping of the sins of the old year on a carrier who took them

18. See page 97.
19. Soyinka, 1973, page 129.

away with his death was a characteristic feature of many African societies, according to reports, but it is by no means clear that this ceremony merely absolved the community from its sins. It appears more likely that the ceremony was in accordance with our paradigm and that it was similar to the *Apo* festival of the Ashanti during which it was obligatory for an Ashanti subject to insult his king.[20] Such festivals were designed to increase the clarity of the image of the pattern the king was imposing on the society. They cleared the pattern from contamination because they helped the king to see how he should govern the society. They said that the king had to be clear in his own mind what the pattern was that he wished to impose and had to remain faithful to it during his life as king.

In some sections of Yoruba society the king was assisted to do this by the cult of Oro, an adult's society for wearing the masks of the ancestors particularly associated with the punishment of those who opposed the wishes of the king. The ancestor masks of Oro were very tall and associated with the tallest trees, such as the silk-cotton tree. The Oro society of the Yoruba may have had its counterpart in the Ndako Gboya society of the Nupe, which was known for its witch-hunting proclivities only by the time it was observed in the nineteenth century. As we have seen, the converse of this ideograph was to be found as well as the association of the king with tall trees in the Onitsha Igbo society, where the tall ghosts of the ancestors wearing masks entered the king's compound when it was felt necessary to show him he had incurred their displeasure and had to die.

Thus the ideographic representation of height by the use of tall trees and tall masks is associated with a Yoruba cult whose function is to ensure that the king preserves his distinct features. Although it carries out the king's right of execution, it also imprisons the king in his own personality, imposing on him the responsibility of conforming to a personal pattern which must be the over-all pattern of his particular kingdom as a social group while he is alive.

Parallels can be found in the pre-Isiac Eleusinian mysteries of Athens, where the initiates wandered in dark underground caverns before coming out into the light and where there was a ceremony of obligatory cursing at a bridge before washing in the sea. We might suggest that the Eleusinian mysteries assisted an individual to discover and remember his destiny. We might also suggest then that the carrier of Soyinka's adaptation of Euripides' *Bacchae* and of the

20. Rattray, 1923, pages 152–67.

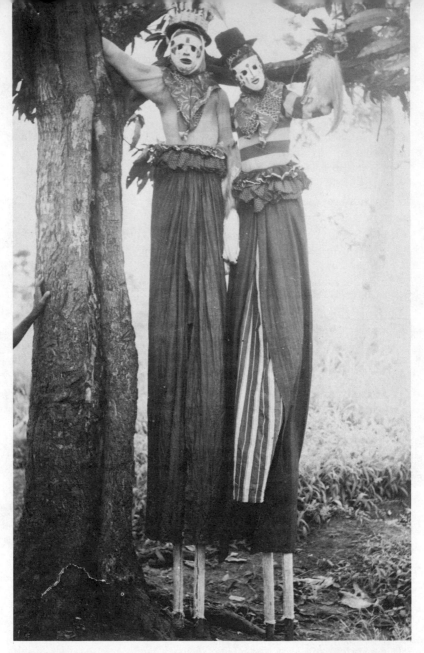

PLATE 12. The masks of the ancestors walking on stilts, the tall ghosts, who are able to tell the king that he no longer represents the contemporary social group, are also a common ideographic representation in eastern and central Nigeria. (Idoma, Nigeria)

Yoruba and Igbo societies of western Nigeria in which historical ex-
amples have been recorded, the Ashanti cursing at the annual Odwira
ceremony and the coming into the light and the cursing at the bridge
in the Eleusinian procession at Athens in ancient Greece were all
designed as a means of creating concentration. (That is why the
Western habit of making New Year's resolutions would be their
spiritual counterpart.) The ceremony of the carrier who bore away
the sins of the old year among the Onitsha Igbo was a symbol to the
members of that group that they must conform to the pattern that
their kings and priests said was necessary to the survival of that par-
ticular group. It had the same effect as "washing" the ntoro, or clan-
soul, for an Akan speaker or hunter in Ghana. "Washing" his ntoro
told a man what his character as a member of his clan should be and
reminded him of his need to preserve it himself. "Washing" his
ntoro for a hunter told him how he needed to behave with his par-
ticular character in order to survive when hunting an elephant. He
had to have a worked-out strategy, he had to remember it and he
had to concentrate on it. There had to be no distractions or diver-
sions.[21] With this in mind we can understand why a typical Igbo
Ikenga,[22] symbol of the male adult, carries a sword in the right hand
and a head in the left. The sword in the right is an idiograph represen-
tation standing for implacable resolution; the head in the left hand
may be interpreted as an ideograph standing for the fact that the man
needs to remember his destiny and to live in accordance with it be-
cause it is the sign of his success as a head-hunter. The arbitrary kill-
ing that once took place after the installation of the Baluba king was
an ideographic representation of the fact that the king had to perform
unpopular tasks and that he was not expected to refrain from any act
that was necessary in order to perform them.[23]

"Washing the soul" or concentrating on a decisive course of action
in accordance with one's role or destiny, sweeping up the dirt in a
man's compound after his death and burying his clothes and other
possessions with him, wrapping his hair and nail clippings in white
clay ready for his second burial, returning a king's sputum and excre-

21. Fraser, 1928, page 161.
22. See page 70.
23. Bradbury says that the Edo diviner may quote a verse to a man who is
failing in some enterprise: "Ogwegwa says you should complain to your Hand, if
you do not want the weeds to spoil your farm," and that "he implies the con-
sulter's personal responsibility for his fortunes, and counsels self-reliance." Brad-
bury, 1973, page 264.

ment to his own compound are therefore all seen to be linked as procedures necessary for definition. A man must define himself, if necessary with the help of a diviner, in order to be able to make personal decisions.

We might suppose that the Bacchic or Dionysiac festival from which the Greek theatre emerged was associated at first with the cursing by the followers of Dionysus' boat in the procession during the Anthesteria, or spring-flower festival at Athens, and that its counterpart in the Osiris procession in Egypt with which it merged later was the impediment to the procession of Isiac boat by the followers of Seth, the followers of Seth being also the masked satirical actors or the unburied dead in the Yoruba Egungun and similar ancestor cults in West Africa. Such a festival would contain first the plays which enacted the attempt to prevent Osiris completing his journey in the land of the dead and then the plays which stated his definition, his "washing" and "planting."

In the stela in the East Berlin Museum which records a statement by an actor, I-kher-nefret, of the Egyptian Twelfth Dynasty, he relates, "I performed the coming forth of Horus-Osiris when he set out to defend his father. . . . I drove back the enemies from the neshmet boat. . . . I overthrew the enemies of Osiris. . . . I performed the 'great coming forth.' "[24] Does this actor not describe the process of definition which is observable in almost all the rituals associated with kings, ancestors and adult cults throughout Bantu-speaking Africa?

In many societies satirical plays are performed at the time when the crops have been planted and the first shoots are beginning to appear above the ground. The young adults put on masks in which they caricature the behaviour of the elders. At the same time they introduce figures who represent changes in the society—for example, strangers from outside who are bringing in innovation, northern Nigerian followers of Islam in southern Nigeria or Europeans and Americans among the Baluba of the Kasai in Zaire. The satirical plays state that the elders are forgetting their roles as elders, that, for example, they are enriching themselves and neglecting their responsibilities to their lineage groups; and so these plays are asking the elders to remember their societal roles and if necessary to redefine them. That is, if there are changes taking place in the community by which the elders could use their privileged posi-

24. Quoted from Wallis Budge by Gabre-Medhin, 1973, page 1.

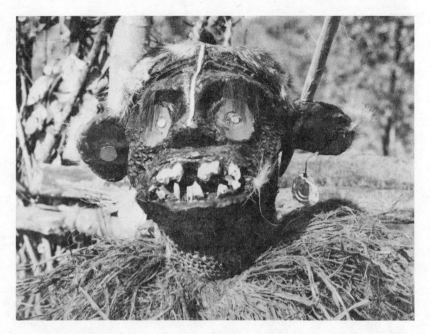

PLATE 13. This mask, called "Luchazi," represents the changes intro-
duced by the cultivation of rubber in Central Africa. (Lunda group,
Zambia) *Gerhard Kubik*

tions to enrich themselves, they are reminded that the young adults
are also aware of these changes and would like to see them adapted
to the good of the community as a whole.

While the elders are reminded of their responsibility the young
adults are also reminded of their responsibilities to the lineage. For
example, in the Ijo Kalabari Ekine society the drum is used as an
instrument for reminding the young adult initiate that he may not
allow his individual strength and capacities to lead him too far away
from the society and its needs. When the Ekine society masquerader
wears a mask (the mask represents the most distant water spirits who
bring innovations into the community) for the first time he must
recognise the drum calls of his ancestor in the rhythms played by a
drummer who is constantly trying to confuse him with cross-rhythms.
He must do this while he is embraced by the young women among
the spectators and handed draughts of palm wine. By being able to

continue to recognise the drum calls of the ancestors he demonstrates how an Ijo Kalabari man should behave in life, attentive to the need to introduce changes for the benefit of the community, however confusing the appeals to his senses may be.[25]

The introduction of innovations into the community by means of the masks of the Ekine society is paralleled in many other African societies. For example, the possession cults of the Songhai in Niger contain the spirits of Fulani immigrants into the society, the masks of the Egungun society of the Yorubas of Nigeria may satirise European administrative officers or northern beggars and in modern Baluba society special cults have sprung up in which cult leaders are possessed by the spirit of Europeans or Americans. These are urban thrift clubs to which members contribute a small part of their weekly earnings and have the right to draw on them in times of trouble. Possession by the spirit of a successful foreigner thus indicates that the profits of societal changes realised by intrusive foreign innovations may be placed at the disposal of the society's members.

25. See also page 45 for Horton's account of the Ijo Kalabari.

8　Secrecy, Associations and Hunters

Diviners are responsible for discovering when people are hiding dangerous or valuable secrets. It is clear that a diviner can exercise great power in a society because he is the individual who decides whether a member of a particular group is of a mind to preserve the group by his behaviour or whether he is more concerned with the profitability of his own self-seeking. At the same time the diviner may decide whether it is profitable to divide a group because it has become of an uneconomic or unwieldy size. In such a case he may use the demands of self-seeking individuals to split the group and encourage their section to go elsewhere. Their attention to their own interests thus becomes an asset, and if their self-seeking is designated witchcraft or sorcery, their witchcraft or sorcery is regarded as an advantage to the group they take away with them.

Thus diviners can determine the size and shape of all the groups in their society. In order to do this they sometimes come together in associations of diviners. Associations of diviners known to have wielded great power in the history of Africa are those of the Poro societies of Liberia and Sierra Leone and of the Igbo-speaking people of Nigeria.

We see, then, that witchcraft can have an ambivalent meaning according to its social context, and secrecy can have the same kind of ambivalence. It can mean the guarding of valuable mysteries or the ability to hide oneself in order to discover useful information or

it can mean the private nurturing of resentment and the devising of treachery. It is generally associated with a self-seeking individualism and pursuing one's own individual purposes in defiance of the group which requires the keeping of secrets. Witchcraft is associated with the hiding of secrets.

However, secrets are also kept by people whose function it is to search out self-seeking individualists in the shape of witches, and the secrets kept by these detectives often form rigid and undeviating patterns known to their preservers so that they can discover deviations from them. These rigidly patterned collections of secrets are kept by rulers, the guardians of ancestral cults and kings.[1] A more flexible kind is kept by diviners.

The diviner in African society is often described as "washing" his eyes in a special fluid in order to be able to detect deviations, and in this respect his behaviour is similar to that of diviners in many other parts of the world. However, the seeing of kings must be distinguished from the seeing of diviners. Kings see deviations from the pattern that they must impose. Diviners look for a concealed pattern in order to understand it.

The contrast between the rigidity of the farsighted ruler and the sensitivity to outside influence of the diviner can be seen as a pervasive principle in African art. The art of chiefs and kings expresses a visible rigidity of pattern to which it demands that individuals should conform. Nonconforming individuals require a secretive art, the art of the cults or the secret societies, and diviners need a secretive art to understand chiefs and their relations with such individuals. This explains why the art of kings which is said to demonstrate their farsightedness is clearly visible. Sometimes the rulers themselves take on some of the characteristics of the diviner (represented ideographically by the chameleon in their regalia), but while the diviner may often be said to assist the nonconforming individual, the chief or the king is more frequently represented as his opponent. The efforts of the king to see everything are directed towards preventing the secret activities of individuals, and the king's own secret societies are a method of detecting conspiracy in others. The efforts of the diviner may be directed towards assisting the individual in his

1. In societies without kings the elder who is responsible for guarding the relics of clan ancestors can have the same responsibility for clearsightedness as a king, but his ideographic symbolism is different from that of a king in other respects.

secrecy, because the diviner is frequently employed by the individual to assist him in his nonconformity. We have seen that the individual who can most frequently afford to pay the diviner for this assistance is the hunter and that this is why the hunter is the most common symbol of fission and rebellion.

The hunter is also the leader of the young adults' societies. When a young man reaches the age when he can hunt and fight he may be given an ideographic symbol of his right to express his particular individuality in the group and the right to voice his opinions. Among the Igbo-speaking people of Nigeria this symbol is carved in wood and is called an Ikenga.[2]

We have said in Chapter 4 that many African societies are conscious that the two elements of conformity and rebellion, openness and secrecy, conservation and innovation exist in the same individual so that every individual has an ambiguous position in his social group.

Divination is then a matter of deciding which dictates an individual will follow, those of his head or his hand, and some societies have an ideographic symbolism to express an individual's ambiguous position in his social group in these terms.

We have seen also that in Ndembu society hunters are expected to have hidden and secret intentions and therefore are expected to be good at witchcraft.[3] In most other African societies the ambiguous individual is not regarded essentially as a liability. His deviousness may make an asset, and his determination to pursue his own paths may benefit others if he succeeds in enriching himself. His refusal to accept the limitations imposed on him by the group may ultimately help the group.

Divination to decide the real nature of an individual's personality is represented by some writers as a means of helping an individual to come to terms with his prearranged destiny and as expressing the individual's resolution of his ambiguity. The diviner shows him what manner of individual he is by reminding him of his antecedents. Thus Fortes writes that every homestead of the Tallensi is full of ancestor shrines and that each shrine exhibits a different combination of ancestor spirits. The diviner must be consulted in any crisis or social problem to decide which particular group of ancestor spirits

2. See page 70.
3. See page 82.

has combined together to bring it about and what sacrifices should be made and of which shrine.[4]

In modern psychological terms we might say that a man is born with a personality which he is given partly by his mother's genes and his mother's behaviour in his upbringing, partly by his father's genes and his father's behaviour in his upbringing; and in an African family group, which is much more complicated than a nuclear family group, we should have to take into account the environmental influence of his aunts and uncles and half-brothers and half-sisters. These are also the social factors which affect his whole extended family. Later a fourth element is added. As he grows up he meets an ever-widening circle of his kindred, and it becomes more and more difficult for him to avoid the dictates of history.

According to Fortes, then, a man's destiny in West African belief is not just the impersonal determination of an individual's life history in the Greek sense, nor is it the reward for just deserts in the Jewish sense. It is a combination of both, something that a man can change if only he has the information available about all the possibilities, and it is the job of the diviner to understand all these possibilities and show them to him so that he can make a choice. To illustrate this description Fortes quotes Bascom writing that before a child is born his soul kneels before Olodumare to choose its fate on earth. (Bascom calls Olodumare the "deity," but we might do better here to translate the word as the "source of destiny.") If the child makes a humble and reasonable request he will get it; if he asks for too much he won't get it. Bascom goes on to say that diviners can influence the immediate future but that they cannot alter the whole course of a man's destiny.[5]

However, it appears that by taking care to go to a diviner to discover as much information as he can about himself an individual can discover the limits within which he can make changes in his own patterns of behaviour and so change the immediate course of his life. (In the ideographic language of symbolism referred to on page 73 for the Edo-speaking people we might say he would be told whether to follow his head or his hand.)

In Bascom's vast work on Ifa divination he talks about the diviner presenting the man consulting him with the Ifa verses revealed to him by the divining beads as if they acted like a kind of Rorschach

4. Fortes, 1959, page 32.
5. Bascom, W. R., 1951.

PLATE 14. The model of a figure shown here is a representation of a king's "night society" of the Bamileke group, in the Cameroon. The king's resolution coupled with his ability to adapt to change is represented by the chameleon on the young adult's head. (Cameroon) *Division of Photography, Field Museum of Natural History*

PLATE 15. This Dan mask shows a number of basic white formal shapes floating about on the background of a dark-shadowed cloth and indicates graphically how Dan masks invite a projection of eidetic images from the spectators. Many contemporary Western kinetic artists use the same visual means. (Ivory Coast) *Photothèque Musée de l'Homme, Palais de Chaillot (Paris)*

test in which the man discovered a new combination of possibilities of behaviour. I think that if we look at African art and particularly the masks this later explanation of Bascom, or rather of Ribeira, from whom he in turn got it, is more obviously the correct one.

This is the impression we get from the work of Wole Soyinka. The Yoruba-speaker does not see the world as such a stark place that he cannot avoid discomfort and trouble. He sees it as a world of many and varied combinations of the factors in people's lives and one in which changes of direction are always possible. In the Dan Masquerade described by Himmelheber,[6] the faces of the masks are "open" because they must suggest alternative possibilities of interpretations to the spectators.

Once more, however, we find the dichotomy which underlies all the art and literature and institutions described in this book present in the symbolism of tall trees and young growing trees of Middleton's Lugbara informant, in the priest-king and the clan elders on one side and the young men's age groups of Chinua Achebe's Arrow of God, in the gods and the hunters of Amadi's Great Ponds, in the Oba and his son allied with the women's cult in Soyinka's Kongi's Harvest. In the visual art (when it is visible) we see the rigidity of form of the Fang ancestor figure guarding his ancestral relics and the open face of the mask of the young man. It is comparable to the rigidity of the Dan ancestor figure and the Dan mask of the young man. The ancestor figure has lived the over-all patterns given him by his destiny, but the young man's mask is still open to change. It is possible for the other members of the age group to look at it and project into it their hopes and aspirations. So the ancestor figure guarding the relics stands stiff and upright, undeviating from all the responsibilities that he has acquired in his path through life. He guards the knowledge of past conflicts and the accommodations brought about to overcome them hiding them from the impetuous gaze of youth. But the young men look at all the possibilities proposed by the mask and would not hesitate to lead it in the direction of conflict if they thought this would give more room for their own clan group or village group to grow unrestricted by the shadow of the elders and the pattern they have fixed. In order to lead their groups in new directions they may nurse secret ambitions and aspirations.

Therefore, the ideographic language of the adult societies during their initiation ceremonies is particularly concerned with the investi-

6. Himmelheber, 1958.

gation of the bush and the animals in the bush, with the under-
standing of the dark and secret world which has to be explored away
from the social order of the town and the village. We might propose
that this ideographic language is also particularly characteristic of
an expanding and moving society. The Bantu-speaking societies we
are describing may have originated in the middle of the Sahara about
8000 B.C., when it was teeming with animals and covered with rivers
full of fish. They may have moved out of the Sahara between 5000
and 3000 B.C., when the Sahara began to dry up, may have acquired
the use of iron in 1500 B.C. and may have started to move through
the equatorial forest of Central Africa at about the same time, form-
ing small centralised societies led by priests until well into our era
or about A.D. 1000. In the seventeenth century it was still moving
southwards when it confronted Dutch invaders.

We might propose that hunters' cults are still predominant in so-
cieties which are still expanding into unoccupied areas or in societies
which were still expanding until very recently. That is why the cult
of the hunter emphasises the virtues of the dark and secret side of
human nature.

The hunter is the man who can lead his social group into the un-
known and help to find a new environment when the old one can no
longer support it. Many societies which are no longer expanding have
memories of hunter-heroes who brought them into the territory they
now occupy or alternatively have memories of groups led by hunters
by whom they were conquered. Societies to the south of the equa-
torial forest have memories of a pygmy race of aboriginal inhabitants,
the "red men" who led them through the forests or once occupied
the land they now live on. In the founding myth of the Baluba,
Kalala Ilunga is the son of a hunter from the east who married the
daughters of the king he found in the country of the Baluba,
Nkongolo. When Kalala Ilunga kills Nkongolo and cuts his head off,
the head is eaten by red ants.

Evolutionary theories of the hunters have overemphasised the
role played by the aboriginal inhabitants in forming the symbolism
of more recent societies. In these theories the symbol of the hunter
is uniquely associated with societies that rely purely on hunting and
gathering for their means of livelihood. However, the symbolism of
hunters in Africa was of primary significance in migrating societies
who did not rely purely on an economy of hunting and gathering. It
does appear as if Bantu-speaking peoples made their way through the

equatorial forest with the assistance of the pygmy or bushmanoid hunting populations by slashing and burning in order to make farms but were led farther and farther through the forest by their own hunters or by fishermen, who had the same role as hunters, piloting them along the rivers, which must have been wider and deeper in 1000 B.C. They evolved this migrating economy, their unique mixture of farming and cultivating themselves, and did not look back to a time when they themselves were of a different physiological or ethnic type. Turner tells us that the Ndembu of Zambia have preserved a society in which they give preeminence to hunting, although its contribution to their food supply is intermittent and unreliable. The Kwahu hunter's ritual in Ghana demonstrates that the hunter is supposed to eschew contact with his social group while he is away hunting elephants and must learn habits of self-reliance and independence which lead him to explore far afield, but the Kwahu no longer rely on the yield from his hunting for their survival.[7] In both cases the cult of hunters emphasises features in the society which contrast with their staying in one place and indicates a history of constant movement in previous centuries.

Many African societies, therefore, seem to trace their history to their common origin as a hunting economy in the Sahara in which the women introduced techniques of pastoralisation in the village while the men went off hunting, organised in patrilineally based societies or cults. It is these societies which seem to have been the ancestors of such widely separated people as the Akan-speaking Fanti of Ghana, the Yoruba of Nigeria and the Lunda group of peoples in Angola, Zambia, Mozambique and Zaire. We might suggest that the hunters' cults have expressed their ambivalent attitude to the matrilineal authority in the homestead by using masks which the hunters wore to camouflage themselves when they stalked animals and that their symbolism has become merged with that of the young people's age-group societies. In some of those societies, since they have settled for a long period in one place, jural authority has become patrilineal, but they still retain a myth of a hunter who came from farther away and provided a ruling clan, as in the case of the Yoruba, the Fon, the Ewe, the Igala and the Baluba.

Many of these societies also see the personalities of their original clans as expressed by the personalities of particular animals, and we might conjecture that these animals were the camouflage adopted

7. Fraser, 1928, page 159.

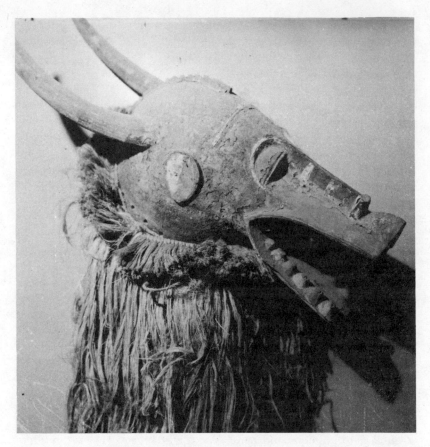

PLATE 16. Many African masks create feelings of disorientation by their cylindrical form, in which a circle viewed head-on appears as an animal when suddenly seen in profile. (Senufo, Ivory Coast)

by hunters who were founding ancestors in their efforts to understand the forest by taking on the characteristics of its inhabitants.

The use of animals as clan totems to stand for the personalities of particular clans, which goes with the theory that a man with a particular configuration of ancestors will have a certain kind of personality which produces behaviour which can be compared to that of a particular kind of animal, also seems characteristic of many societies with hunter ancestors right across Saharan Africa. In the mythopoeic

descriptions of such societies the cults of clan ancestors are often associated with the transformations of hunters' souls into animals' souls, and the unalterable features of the terrain in which the animals live are often associated with cults of spirits which express the idea of these unalterable features causing a limitation on the movement or behaviour of the members of the social group in the same way that they limit the movement of animals.

We might suggest, therefore, that African societies are proposing theories about the nature of man and his world which are radically different from that proposed by L. S. Senghor with his theories of negritude.[8] Senghor's theories seem to derive from the neo-Platonist Christian philosophers of the Renaissance, according to whom man can discern rhythms in the universe. Races of African origin, according to Senghor, are able to discern these rhythms by virtue of their immediate understanding of rhythm and in contrast to European discursive methods of reasoning about it. Instead it appears as if the theory of the universe underlying the African art and literature we have described here is one in which man is seen to move in certain configurations of space with the repetitive patterns of a movement imposed by those configurations of space. The limitations created by particular kinds of affliction, or by having particular groups of ancestors, are seen as similar in kind to the limitations imposed by the obstructions. We might also propose that a relationship between the autonomous definition by separate lineages and the ambiguity of adults' societies can be expressed by an analysis of movement in space carried out in the theatre of ritual as a form of ratiocinative analysis by human societies continuously migrating and exploring, impelled onwards by the Saharan "pump," the constant movement away from the centre of the Sahara over eight thousand years. It might also be conjectured that the Orphic theories of the individual defining himself in relation to his destiny derived from the same source as the visual art of Africa, as well as providing the mythopoeic source for Platonic philosophy, uniquely different, however, from the Christian neo-Platonism that we find in Senghor.

8. Senghor, 1964, page 202.

9 Satire and the Adults' Age Societies

If we accept the conclusion that Bantu-speaking African society was continually on the move from the time when it left its original home in the central Sahara (between 4000 and 3000 B.C.) and made its way through the rain forests at about the beginning of our era, reaching the southern tip of Africa in the seventeenth century, the problem of definition in new social circumstances and new environments can be seen to have been the most pressing consideration for every individual. It is not surprising, therefore, that its art depended on the emergence of definition from ambiguity, especially as its leaders were hunters whose particular concern was the identification of animals which camouflaged themselves in the savannah by using protective colouring. It is also not surprising that the social structure of this society should depend on emphasising the divergence of elders' and young adults' associations, and the art of the masquerade should be the province of the latter. The fact that the age-group association is peculiarly the institution in which new configurations of social groups or changes are accepted in society means that it is also the institution which produces satirical plays. The ambivalence of an individual's role as a member of a social group carrying out duties and obligations on behalf of that group and as a separate personality attempting to express egotistical desires apart from the group is expressed repeatedly in African art and literature. We can look at an example of an entertainment sub-group of an Afikpo Igbo male

adults' society in eastern Nigeria, described by Simon Ottenberg.[1]

Their plays are performed by a special group, the younger men within the male secret society, and the group of players has its own authority structure which is separate from that of the age sets which determine seniority within the secret society itself. In general there is a rigid system of age sets through which a man graduates every three years and membership of which entails deference to a system of authority in which all the age sets are junior and subordinate to the members of the age sets above theirs until they join the elders at the top. However, the Okumpka plays enable the younger men to criticise the elders when they are wearing the masks, and they usually perform the plays once a year during the dry season after the harvesting of the farms. About a hundred may assemble wearing the masks in the "common" area—in the middle of the village. Ottenberg writes that "The masked players as a group symbolize a totality of history, man, and nature at Afikpo." Some of the masks are in the styles of neighbouring areas with whom the Afikpo Igbo have historical connections, and some are indigenous to the Cross River area in general in which Afikpo is located. Some represent animals and some humanlike spirits, but most represent the elders or women; and so there are two main kinds—ugly masks for elders and white-painted masks with delicate features and designs for the women.

Plays criticise elders who subdue themselves in disagreements between other people in order to collect bribes, those who take the side of the party to a dispute which will give them the most money, those who engage in disputes which are very expensive for the community to continue and those who become Christians and followers of Islam because they will think it will gain more wealth for them. The plays, then, are a means of equalisation in the society, attempting to ensure that no one becomes more powerful or richer than anyone else. The young and mature adults who take part in them can therefore make criticisms wearing the masks which they would not be allowed to make without them because of their junior positions in the age-set system, and they wear some very ugly and distorted masks to demean the elders and refer to them explicitly by name. It might be suggested that the distortions of the masks are carved in deliberate contrast with the vertical and horizontal planes which represent the dignity of the ancestor figures' and the elders' place

1. Ottenberg, "Humorous Masks and Serious Politics Among Afikpo Igbo," in Fraser and Cole, 1972, page 99.

in a society generally ordered for the common good. Ottenberg has pointed out that plays seem to perform the same function as the witchcraft accusations of the Tiv in Nigeria, directed at individuals who have become too powerful, as described by Bohannan.

Bohannan describes a modern witch-hunting movement, called *Nyambua*, which was directed at all the officials who had achieved too much power after they had been chosen to exercise power by the government. There were no officially chosen office-holders among the Tiv before the British colonial administration, and those that were chosen by the administration therefore became suspect. They were alleged to be acquiring *tsav*, or power, by eating human flesh. Bohannan quotes Akiga, a Tiv whose autobiography has been published—*Akiga's Story*[2]—who said that the witch-hunting movements "have taken place over a period extending from the days of the ancestors into modern times." Bohannan says in his article that "these so-called 'anti-witchcraft' movements begin every few years, whenever the power system becomes too rigid."[3] In one, called *Ijôv*, which took place in 1912, an *Ijôv* was a sort of being of the forest which was impersonated by a masquerader responsible for finding who had too much *tsav*.[4] Another movement, *Hoyo*, was conducted by age associations against their elders.

In these movements, then, we find examples of young adults defining selfish behaviour in elders and elders accused of witchcraft when they have upset the balance of power by gaining too much of it, and yet in Chapter 6 we saw many examples of selfishness being characterised as witchcraft but also excused as valuable to the social group. Witchcraft then becomes a process by which an individual defines his position in the society, and the diviner helps him to emerge from a position of ambiguity. The elder who has an established position in his lineage is discouraged from pursuing a path which cuts him off from his lineage and its interests. The emergent leader of a dissident group is encouraged to move it away to pursue its destiny elsewhere.

Peter Morton-Williams describes a Yoruba society of mature adults whose purpose it is to make lineage elders keep to their defined roles.[5] The men in this cult wear the masks called *egungun*; on the

2. Akiga, 1939.
3. Bohannan, 1958, page 8.
4. In the mythopoeic language of the Yorubas, this parallels Ogun's hunt for Oro described in Soyinka's *Dance of the Forests*, v., page 127.
5. Morton-Williams, 1956, page 92.

first day the *egunla*, or big *egungun*, appear. These are the masks of the most famous ancestors of the lineage groups. On the second day come the *egun onidan*, the miracle workers, in the masks which specialise in various kinds of ambiguity, such as those who transform themselves into three different shapes during the dance. These masqueraders also perform satirical morality plays.

One example of an *onidan* masquerade carries a child on its back like a mother, but it is the equivalent of the *abiku* child, who keeps dying and coming back reborn. Thus it appears as if the living mother who keeps bearing children who will not grow up has her counterpart among the ghosts; one of which carries a child who keeps returning to her in the land of the dead and refuses to grow to maturity in the land of the living. The *egungun* masquerade, then, is particularly concerned with contrasting those who carried out their full destinies and became revered ancestors and those who have refused to accept the responsibilities which are a necessary counterpart of living a complete life. When the young boy or girl joins the *egungun* cult they indicate that they are willing to oppose the elders if necessary, and the boy who is initiated to the wearing of a mask is asked in the shrine, "Are you prepared to go even against your brother?" "Are you prepared to go even against your father?" "Are you prepared to go even against your mother?" The answer to all these questions is "Yes." Thus he indicates that as an *egungun* masquerader he is prepared to help define the lineage by criticising the roles of those who oppose it and by applying the society's sanctions to those who are neglecting their social responsibilities.

Wole Soyinka's play *The Dance of the Forests* contains graphic representations of some *egungun* roles, because it is a play which is particularly concerned with the part played by the dead in Soyinka's Yoruba society, describing a festival which Soyinka calls "the gathering of the tribes" but which has obvious resemblances to the *egungun* festival. Obviously the play refers to the myth-making capacity of West African states to invent an epic past. The elders in the play have asked the chief spirit of the forests to provide them with the ghosts of heroes from the past. Soyinka invents the seventeenth-century monarch of a Central African kingdom, Mata Kharibu (a name which has associations with Mata Yamvo, the seventeenth-century Lunda monarch and an actual historical figure). Therefore, there are references to African history outside the particular context of the Yorubas and their gods who are the principal characters of the play,

126

and there are references to Troy and the Homeric heroes as the counterpart of Mata Kharibu. The historian of his court, reincarnated as Adenebi (see below), taunts a warrior who refuses to fight another fruitless war with the words "I have here the whole history of Troy. If you were not the swillage of pigs and could read the writings of wise men, I would show you the magnificence of the destruction of a beautiful city. I would reveal to you the attainment of men which lifted mankind to the ranks of gods and demi-gods."[6] The enactment of the story of Mata Kharibu's court in Soyinka's play tells how the soldier who refuses to fight is sold as a slave and emasculated for use as a eunuch and how his wife kills herself while bearing an unborn child. These are the ghosts which Forest Head brings to "the gathering of the tribes" instead of the expected heroes, and the characters of Mata Kharibu's court are reincarnated as the people who live today and summon the past they wish to glorify—a vain endeavour when they are faced with its reality. The historian of Mata Kharibu's court becomes Adenebi the modern council orator who preserves the illusions of the past even at the present day and who is still making a clarion call of his request for heroes:

Find them. Find the scattered sons of our proud ancestors. The builders of empires. The descendants of our great nobility. Find them. Bring them here. If they are half-way across the world, trace them. If they are in hell, ransom them. Let them symbolise all that is noble in our nation.

But the old man replies to Adenebi:

The ghosts we were sent are slaves and lackeys. They have only come to undermine our strength. To preach to us how ignoble we are. They are disgruntled creatures who have come to accuse their tormentors as if this were a court of law.

The ghosts' principal complaint is that they were not properly buried. The half-child's complaint is that it was not allowed to be born in order to live its life and be buried, and the ghost-mother's complaint is that she has to carry the unborn child around with her and look after it even in the grave. She is the onidan in the egungun play described by Peter Morton-Williams, previously referred to. The man wearing the mask carries a rag doll which he beats soundly before he wears it and after he takes it off, "so that it will not choose to come to live with him."[7]

6. Soyinka, 1973, page 51.
7. Morton-Williams, 1956, page 96.

The Dance of the Forests includes all the ambiguity of the egungun. The town elders ask for reminders of their glorious past but instead are sent their skeletons in the cupboard. In the same way the egunla egungun of the first day of the masquerade are accompanied by alabala, the praise-singing egungun, and their role warns the towns-people of the inherent dangers in daring to mourn the dead, because as praise-singers the adulation they produce can turn their would-be patron to his disadvantage. The praises themselves can contain a sting if carried to the point of exaggeration, and in Soyinka's play Adenebi, the council orator, makes fools of the elders by his unctuous ennobling of the past. Demoke, the carver, chooses the tallest tree in the dangerous grove of Oro,[8] but he lops its head off and carves the history of the tribe with a kind of leering obscenity. Demoke is impelled in this exploit by his cult-god, Ogun, who uses the carver, his devotee, in his own quarrel with Oro, whose particular cult-object is the kapok or silk-cotton, the tallest tree in the forest, which is the tree Demoke purposely elects to carve. Demoke is afraid of heights and pulls his apprentice to his death when the apprentice climbs above him to carve the parts of the tree he dare not reach. Thus, Ogun, god of iron, of carvers, and the drummers who accompany praise-singers or beat praise-songs on their talking-drums, is keen to belittle Oro, the god who exults in his power to bring death; but his struggle with Oro is paralleled in his devotee's destruction of his overambitious apprentice, in the unburied ghosts' contemptuous defiance of the glories of the past and the carver's diminution of the tall tree of Oro, not only by cutting off its top to make it shorter but in the pawky humour with which he uses it to represent Madam Tortoise, the queen of prostitutes.

Adenebi describes Demoke's totem carved from the tree of Oro as bestial. "Bestial it was. Utterly bestial." But Obaneji reminds Adenebi that he had heard him say earlier that "the work was quite remarkable."

The council elders try to destroy the ghosts in the forest by fumi-gating the forest with petrol from a wrecked lorry. In doing so they incur the wrath of the ants, and we are reminded of the role played by the ants in eating the figures of the ancestors and thus assisting the earth in its re-creative and revivifying role. The ants are the agents of change, the destroyers of dead wood, who make sure that the full

8. See page 105 for the significance of Oro's association with tall trees and the King's power to carry out death sentences.

cycle of life is carried out for each individual who is born and lives a complete life and that he returns to the earth. Men are frightened to incur their wrath.

ANT-LEADER: We take our colour from the fertile loam
 Our numbers from the hair-roots of the earth
 And terror binds them. They know
 We are the children of earth. They
 Break our skin upon the ground, fearful
 That we guard the wisdom of Earth,
 Our mother.[9]

The ants also have a role in *This Earth, My Brother*, a novel by the Ghanaian writer Kofi Awoonor, but in that novel their role is a more despairing one. For Amamu, the lawyer, there is no respite from the wreckage that has been made of the past by the post-colonial governments of his country, and he goes mad and dies pursuing a dream of the past on the beach of his birthplace. "The shrines are falling now, the fences have been eaten by termites" is his lament.[10] *This Earth, My Brother* seems to use the form of the novel to revive the funeral dirge of Awoonor's people, the Ewe, and in Amamu's laments, which precede every chapter, he castigates the orators who glorify Africa's past in a satirical manner, echoing Soyinka in *The Dance of the Forests*:

The ancient termagant shall tell tales of ancient heroes of mighty Africa, of Chaka, of the conquering clansmen of the legendary Soundiata, the prince of the Malinke. Old scrolls shall be read in gilded halls proclaiming the glory of Koumbi Saleh, the wisdom of the scholars of Sankure, of mighty African rulers who bargained their subjects for heads of tobacco, kegs of gunpowder and a few yards of cloth that could scarcely cover the nakedness of their wives.[11]

The novels and plays of Soyinka and the novels and poetry of Awoonor are revivals of the forms of African oral literature by modern, university-educated writers, but the satirical forms of complaint and criticism have also survived in some forms of expression in the modern popular theatre. The most notable of these is the high-life play of Ghana, which gave rise to the high-life songs whose message is ambiguous. In an interview with the author, Kofi Awoonor de-

9. Soyinka, 1973, *Collected Plays*, page 67.
10. Awoonor, 1971, *This Earth My Brother*, page 166.
11. *Ibid.*, page 133.

scribed a high-life song sung by Bob Cole when Kwame Nkrumah was president of Ghana:

I remember very well Bob Cole, who is perhaps the most famous Ghanaian comedian, dramatising on the stage, during the last days of Nkrumah's rule, the whole business of arresting people, detention camps and so on, with his famous song "Aban Kaba," which means "the government's chains." The song goes like this: "When you and I were there, and you saw a policeman following me, did you not know that there was a government chain on my hands? Now you ask me all kinds of questions, you want to do this to me, you want to do that to me, but you must see that there is a government chain on my hands!" And Bob Cole got away with it because nobody really in the political setup at the time actually felt that Bob Cole was taking a jibe at the whole Nkrumah structure.[12]

Kofi Awoonor went on to explain how the traditional source of the high-life play was the Asafo company, the age associations of the young Akan-speaking adults, also to be found among the northern Ewe-speakers. The rival Asafo companies met and hurled abuse at one another or were used to destool chiefs who had carried out unpopular measures by going to their houses and singing insulting songs, thereby informing them that it was time to give up their office. The companies who performed high-life plays were formed by the young adults who had migrated to the towns in search of work and were very often made up of clerks from government offices. They held annual competitions to see who could perform the best high-life plays and then performing in night clubs in their spare time might rise to becoming full-time professionals through the popularity of their songs, which might be played on the radio and sold on discs in vast quantities. The professional companies would tour the country in lorries, performing their plays in every town and large village. The author witnessed a high-life play which had highly charged satirical implications in Accra in 1962. The performance was by E. K. Nyame, the most popular company at the time, and took place in the Plaza, a local cinema in Accra. A small stage was erected below the screen and was lit by two electric light bulbs strung on a wire from two poles and across the stage just above the height of a man's head. The band was sitting to the right of the stage, and the actors ran some distance from a door on the left where they changed into their cos-

12. Duerden and Pieterse, 1972, page 39.

tumes. All the actors were members of the band, including "E. K." himself. The theatre was packed, the audience having paid three or four shillings to come and sit on very hard wooden benches with rather uncomfortable strips of wood for back support.

The parts of women in the play were played by men who sang in falsetto voices, familiar to everyone who knows high-life records. The play was called *The Story of a Man Married to an Illiterate Woman* and was performed in the Tsui language. The play was unscripted, and so what was said would be described as what occurred to the performers spontaneously. It had a formal introduction, carried out by all bands performing "concerts." First "E. K." himself came onto the stage dressed as a woman jazz singer and did a caricature of a woman singing in the American style and in English. This was unrelated to the play, and so was the "duet" which came next. Here two men came onto the stage one after the other and told jokes to amuse the audience. Their faces were painted with a jet-black substance, and on top of it the outline of their features had been exaggerated in white so that when their faces took on any expression it was greatly exaggerated. Every so often they would stay still with a single expression fixed on their faces like a mask so that they looked exactly like figures returned from some unearthly region, just like Yoruba *egungun*, in fact. One of them had a tail.

And then the play was announced and began. The husband, whose face was painted in the same masklike way as the comedians who had introduced the play, appeared with his wife and her two sisters, so well costumed and made up that it was difficult to believe that they were men dressed as women and even more difficult to believe they were men when they danced. They danced provocatively in a scene in which the illiterate wife's two sisters flirted with her husband.

The three men dressed as women went off and another appeared, the literate woman. She asked the husband if he was a bachelor. "Well," he said, "I sleep in my house during the day and someone else sleeps there at night"—as if that explained the situation. His servant, a Lagosian with three broad white tribal marks painted on his face and with all the characteristic movements of a Yoruba, implored his master not to divorce his illiterate wife to marry the literate woman. "You find this woman everywhere," he said. "If you go to Kumasi, you find her there." And so he went on through innumerable towns, and every time he said, "You find her there" the

audience joined in. But the husband did not take his advice; the illiterate woman was driven away and the literate one moved in. Trouble came when the man fell ill. The literate woman just sat in a corner, read a newspaper and said, "Go to a doctor." When the doctor came the man collapsed on his bed with his legs and arms in the air, stiffened into the position in which he had held them in his chair. In a final triumphant dance his Lagos servant drove the literate woman away, and in this dance he pranced and jumped with malevolent contempt and triumph until she finally rushed terrified from the house. The whole play was full of comment on the contemporary Ghanaian scene and especially on the rising prices which had just begun to take effect at that time, and whenever a well-known high-life tune was played to suit the action the audience started to come forward, first in a trickle and then in a flood, to shower the platform with pennies and shillings. One girl took off her headband and gave it to "E. K."

Perhaps the most popular song in this performance was one that could have many levels of meaning. The husband said to his illiterate wife after he met the literate woman in the town, "You can go back home now; I have got to where I want to be." One interpretation of this song was that those were the words that Krobo Edusei, a Ghanaian minister at that time, spoke to his Ashanti supporters who had elected him to the National Assembly as soon as he was elected. However, the paradox was that his supporters were proud of him for being able to say it, because they had helped him to achieve the position where he could say it. They had enabled him to define himself.

We see, then, that the exploration of ambiguity in which leaders define their roles is a feature of the modern popular theatre just as the presentation of attitudes of ambiguity is a means by which the masquerader helps to define the leaders in the older kind of society— the kings, the hunters, the elders, the witches—and by a process of theatrical exploration determine their precise roles. It may be that the masks themselves are so ambiguous that they contain empty spaces into which the observers project or "dream" their own definition. The best examples of such masks are the Dan masks (see Plate 15, page 116). Alternatively, the masks make a contrast with the role which needs to be defined, and an example is the way in which the Afikpo Okumpka masks defined the elders. The forms displayed by

the masks and their uses in the masquerade have precisely these intentions.

Many of the masks are said to represent animals. Masquerade plays have been witnessed in Africa in which huge casts of performers playing animal roles were taking part. The animal also plays an important part in stories told by storytellers who themselves are outstanding theatrical performers. A description of a storyteller which has been widely quoted[13] is that written by Smith and Dale in their book published in 1920. They write that a storyteller with whom they were acquainted, Mungolo of the Baila people of what is now Zambia, gave a performance in which "every muscle of face and body spoke, a swift gesture often supplying the place of a whole sentence. He would have made a future as a raconteur upon the English stage. The animals spoke, each in its own tone, the deep rumbling voice of Momba, the ground hornbill, for example, contrasting vividly with the piping accents of Sulwe, the hare. . . ."[14]

The onomatopoeic features of many African languages makes storytelling as a performance produce a kind of unity between language and gesture. For example, in the Hausa luage, duck is agwa-agwa and turkey is talo-talo.

In a recorded interview with the author in 1970, Robert Serumaga described the kind of stories which would be told by the professional storytellers of his people, the Baganda, at weddings, at traditional ceremonies or at beer parties. He said that there were individual roles for the various animals and that if the storyteller said things that a leopard was not supposed to say when he was acting a leopard, or if he put the words of a leopard into the mouth of a hare, the audience would express its disapproval by booing. It is this conventional role played by each animal which enables the storyteller to criticise the behaviour of unpopular figures—chiefs, elders and politicians, for example—by giving them the names of animals. Because of the parallels between their behaviour and the characteristic behaviour of the animal used to identify them, the audience would immediately understand the reference and enjoy the discomfort of the chosen target of the storyteller's satire. Meanwhile, the victim, however powerful, would not be able to disclose that he suspected that he

13. E.g., by Finnegan, 1970.
14. Smith and Dale, 1920, page 336.

had become the target because he would thereby admit to identifying himself with the animal whose role the storyteller had assumed.[15]

The Kenyan writer Khadambi Asalache has written a short novel using animals as characters in the style of the traditional African storyteller.[16] Unfortunately, this brilliant evocation of the satirical art of the storyteller with its social and political implications still remains unpublished.

Asalache's plot concerns an assembly of animals and the political maneuvering which goes on in order to decide who should be secretary general. The carnivorous animals have made a peace pact with the others, and this destroys the balance of power and encourages the smaller animals to overreach themselves.

Many of the minor characters are interesting in themselves. Hippo is a builder who is pleased with himself and the extension he has made to the conference hall. Blackbuck is a businessman who sees politics and elections merely as a means of making money.

"You will soon become a tycoon," sitatunga said to blackbuck, as a way of keeping the conversation going.

"I am already a tycoon, as a matter of fact, if you didn't know."

"How exciting."

"It's merely a question of setting your eyes to it, and you become one."

"I remember that you have a flair for working methodically. At one time you wouldn't pass a tree without digging below it to examine something about it."

"To examine the roots."

"What was the purpose?"

"To find their molecular composition."

15. [The stories] are directed against particular individuals or groups. They are meant to expose certain undesirable traits in the character of one or more of, or someone connected with, the listeners. The story-teller is up to a point licensed to expose the weakness of a brother, a husband, a wife, the chief's wife or husband's mother, etc., his greed, deceit, cruelty, meanness, stupidity, her jealousy, looseness and so on, in a thinly-veiled story.

No names are mentioned. The story speaks of elephants, hares, lions, hyenas, "a certain man," etc., and all incidents happened in the past: long, long ago; and in a certain country far, far away. But of course, this is especially true of the witty stories told by adults, they refer to specific individuals and groups. Thus when the audience laughs they are often laughing at somebody present.—Okot p'Bitek, unpublished B. Litt. thesis, Oxford University, writing about the oral literature of his own people, the Acholi of Uganda.

16. Asalache, The Latecomer.

134

Sitatunga thought about this, and then said, "I suppose one can engage in any activity as long as one has the bent for it."

"The bent alone is not enough. You engage in some activity because you are after something. And then you need brains to get what you are after."

"I suppose you are right," sitatunga answered, getting alienated by blackbuck's pomposity. "I see a bag round your neck," he then commented, "what's in it?"

"Well, I haven't yet told you what my line of business is. I am a vendor of medicines, and my bag contains different kinds of medicines."

"Medicines taken from roots?"

"Of course."

"And they really cure illnesses?"

"What else do you think medicines cure? Stupidity?"

"Why not," sitatunga retorted, and when blackbuck didn't reply he asked, "I expect you will be displaying your wares at the congress?"

"I wouldn't attend the congress for any other purpose, I am afraid, for I have better things to do at home rather than spending days in one small crammed hall passing resolutions all day long."[17]

The main protagonists are Bush-baby, who has an intellectual and reflective cast of mind, an idealist with a naïve trust in the pacific interaction of the other animals, and Lynx, who changes from a lowly and unassuming member of the cat family into a bully who is prepared to use any means to win the election. He makes a speech to his supporters.

Those who knew lynx started to observe a change in his character. Being by nature an unassuming individual, he had suddenly gained in confidence. This wasn't in itself a bad thing, except that a note of pride could now be detected in some of the words he said.[18]

Bush-baby is at first very successful in playing all the bigger animals off against one another but finally is defeated by the low cunning of Lynx, who composes a fake election address over Bush-baby's signature and pins it to a tree. It read:

Dear voter,

The hour has now struck, like a sickle in the ribs. I know that some adventurer has been putting his views across to you. Beware of his influence. Where will he take you?

If these were ordinary times, then it wouldn't matter as to who gets

17. Asalache, page 54.
18. Asalache, page 74.

elected. But there has never been any ordinary time in this kingdom. The majority of us are good clean animals who would do each other no harm. But consider the qualifications of my opponent. He is a member of the cat family. And you know the motto of the cat family: no change. Members of the cat family believe that they were ordained to run us. There is already one of them running my campaign. I don't wish to comment on that. Open your eyes, dear voter. A vote for me is a vote for change, a vote for lynx is a vote for dictatorship. Choose now.

<div style="text-align: center">Your own candidate,
Bush-baby</div>

P.S.: My slogan is, vote for BB.[19]

Next Lynx offers to fight Bush-baby and thus force him to confess that he in fact wrote the election address. Bush-baby gets tired of having to make repeated denials and is killed in an absurd, quixotic fight with Lynx. The fight antagonises the other animals, however, and Wart Hog is elected secretary general in place of Lynx. Asalache's short novel manages to convey, more than any other piece of modern African fiction, the power of the animal story to emphasise the absurd and dangerous behaviour of human beings. He describes Lynx as working himself up into a temper to obtain the courage to fight Bush-baby, while the other animals cannot understand why Bush-baby has agreed to the fight. His campaign organiser, Leopard, stands in one corner with tears in his eyes. Lion keeps well away from what is happening. Because of the peace pact the carnivorous animals have made with the other animals, the smaller animals are left to fight it out on their own, and this situation upsets the balance and causes those like Lynx, near the bottom of the normal hierarchy, to turn into bullies in order to assert themselves while they are being manipulated by the larger and more cynical animals, such as Wart Hog. Bush-baby is afflicted with the disease of all intellectuals in politics. He wishes he hadn't got mixed up with dangerous and ambitious opponents like Lynx when he could be enjoying the delights and curiosities of the world away from the political arena. "Bush-baby's thoughts went back into the past," Asalache writes, "and the happy moments he spent sitting up in the trees to listen to the birds singing. He thought of the moments of silence he spent alone in the countryside, looking into the landscape and trying to distinguish flowers by their scents. That world now seemed so far away. He then remembered how he had accepted his name to be put forward

19. *Ibid.*, pages 78–79.

and how he had believed that in doing so he was helping the cause of the new system which many animals desired. But all that was now in the past."[20] Many of us can think of friends of ours who have been caught in this painful dilemma. Asalache's novel is so full of these insights into situations and characters that we are able to say to ourselves that the description of a character fits a particular acquaintance of our own. In his writing, therefore, Asalache is able to re-create all the characteristics of the African story which Okot p'Bitek has described being told by the Acholi in Uganda.

However, Asalache also points out how characters change according to the circumstances and therefore how ambiguous their behaviour may turn out to be. Leopard, in his story, is able to come to a meeting unawares and is detected by Bush-baby listening to the conversation when he is thought to be a long way off.

There was silence for about a quarter of an hour, after which bush-baby saw the branch of a tree he had been staring at jerk; and a moment later heard a creak. He made a sustained stare, after which he saw leopard jump down from the branch, and begin walking towards them. Bush-baby knew that leopard had been on that tree all the while they had been discussing him. Bush-baby did not wish to feel offended by this, arguing with himself that leopard had every right to take his own time.

Leopard's ingenuity showed itself in the way he had chosen the path he used to walk towards them. He was visible to the three of them all at once. He came along, walking with a kind of slow gait that came of habitual exercise of confidence.[21]

Leopard, therefore, is an enigmatic character whose approach is never seen, and in this he has a striking resemblance to the masks used in many African adults' associations. In fact, in many adults' associations, such as the Ekpo of the Edo in Benin, the leopard is used as a model for the masquerades.

It is the use of animal masks concerned with ambiguity which can account for many of the abstract features of African art. The masks create two important kinds of visual effects. They emerge from backgrounds against which they are camouflaged, and they create the impression that the spirit which enters the mask is never in one place. Hence its capacity to appear suddenly.

20. Asalache, page 88.
21. Asalache, page 17.

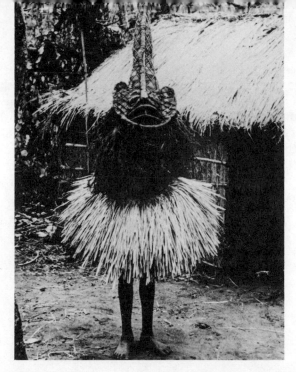

PLATE 17. Tchokwe masks are covered with a network of white lines, which are either woven into the mask or painted. Their "broken" appearance causes the mask to merge into its background. *Photothèque Musée de l'Homme, Palais de Chaillot (Paris)*

PLATE 18. A Bafum mask from Cameroon in which the convex form creates a dark shadow at the top which assists the mask in its camouflage before it emerges into sight.

The two most important optical effects used by the masks are the concave surface, which creates a shadow over the top of the face and has the same camouflaging effect as the dark colouring on the top of an animal's body,[22] and the network of lines which break up the shape of the mask and cause it to merge into its background.

Many other examples of the ambiguous use of form in the African mask can be analysed in this way. The author is at present preparing another book on this subject.

22. See Cott, 1940.

10 Conclusions

In this book we have suggested a paradigmatic model for reconstructing the African society of the past based on the ideographic representations of ritual and belief to be found in the modern written literature supplemented by accounts given by social anthropologists. We have also attempted to show how the visual art can be interpreted by using the paradigm. The metaphor with a forest of trees, which is used by Middleton's Lugbara informant, is seen to be more helpful than Claude Lévi-Strauss's opposition between society and nature, and we can elaborate the metaphor.[1] Groups which may be separate kin groups, lineages living in close proximity or lineages scattered but organised in clans, are seen to establish themselves similarly to seedling trees in a forest. As they establish themselves and grow taller they draw on the nutriment from soil fertilised by elders who have died. They hope that they will grow again in forms created by the dead elders because these were the forms which were able to survive and push their way up to the light through the surrounding forest. However, as they grow upwards the possibilities of form are gradually limited for them, and this limitation of form is expressed in the art of the ancestor figures, which begin to imitate the trunks of the trees from which they are carved, usually from soft wood so that they can be eaten by ants and fertilise new generations. After a tall tree has produced a restricting form in its place, parts of the tree seek to

1. See page 87.

establish themselves away from its shade. These are the segments of the lineages who are off taking some of the dead elders with them as ancestral figures to fertilise a new growth but to return in a form similar to the original form.

We could imagine, then, that twigs from trees could move away from that part of the forest, taking root elsewhere, and one of the symbols of manhood among the Igbo is the *ofo* twig, which has dropped from a particular kind of tree, *Deutarium Senegalese*. "Its twigs are somewhat phallic in shape and fall naturally away from the branches of their parental tree just as, it is said, human sons grow as dependents of their fathers but in time become separate from them."[2]

Meanwhile, it is necessary for some trees to grow taller than all the rest in order to be able to survey the surrounding forest from a situation in the sky to propose the kinds of form which best flourish there. These are kings. If they propose a variation of form which does not flourish in a particular forest, then they may be pulled down by the ancestors, who use the birds to fly even higher than the trees of kings and report to the ancestors whether the kings have chosen the best pattern of growth. (It might be suggested, for example, that the collected ancestors in the earth sent Yoruba kings a calabash of pigeon eggs to inform them that they should commit suicide because the pigeon was the bird known to perch on top of the highest trees.)

However, we also have to consider a situation in which the trees in the forest can turn into animals and how the form of each tree is related to the form of a particular animal. Thus the Bambara *ci wara* mask can be related to the form of the tree from which it is made, and the tree from which it is made requires that a particular rhythm be used when carved to form the animal. In other words, each tree form and each animal corresponding to it has its unique rhythm.

Members of a society whose special occupation it is to understand these rhythms are the hunters, and they are able to understand the rhythmic patterns because they themselves can transform themselves into the animals with which members of their clans are interchangeable. The hunters are the members of the society who use their individual personalities to explore new territories. When a boy becomes an adult there is a period in which he can use the features of his individual personality to succeed in hunting, and his ability to do this is a sign that he has reached maturity.

2. Henderson, 1972, page 118.

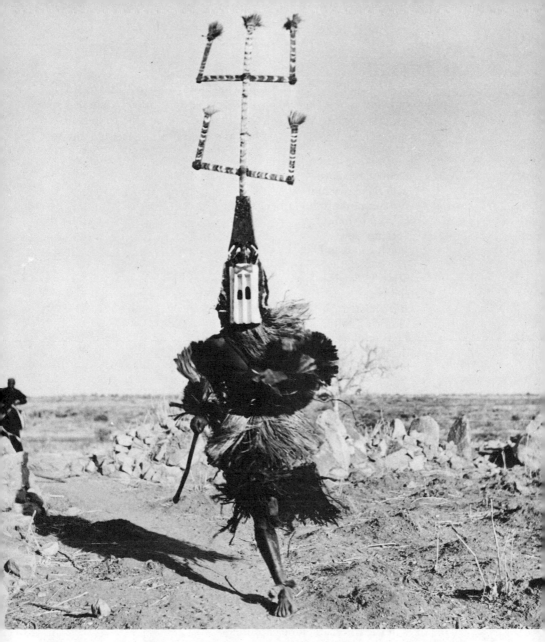

PLATE 19. The Dogon "Kanaga" emerges from the rocks and trees, which it closely resembles in appearance. (Mali) *Agence Hoa-Qui (Paris)*

Goody, commenting on the following lines from the Bagre myth, points out that when the son in LoDagaa society proves that he can shoot animals, he proves to his father that he will be able to look after him in old age and that he has become a man and accepted his responsibilities.

> He took the dove
> with the arrow in it
> and went over to his father's side.
> He said to him,
> "See my dove
> which I shot and killed."
> The boy's father
> began to laugh
> and beat his chest
> and declared
> "I begat a child,
> a powerful child,
> the day to come
> he'll give me help."[3]

The young adult, therefore, is in the process of defining himself, and defining himself involves accepting responsibilities. The more defined he becomes (and we have seen that this involves his responsibility for sacrificing at more and more ancestral shrines for Fortes' Tallensi) the more he is able to take on the responsibilities passed on to him by the elders. He expresses his capacity to take on these responsibilities by his prowess as a hunter. That means, therefore, that his determination as a self-reliant individual is placed at the disposal of his social group. It follows that the metaphors used to express the individual self-reliance of adults are those of the hunters and their cults and that they contrast with the metaphors applied to the elders who put down roots and produce stability and continuity in the society. At the same time, however, the young adults are in an ambiguous position. The hunter can turn into a tree in the same way that the animal he pursues can take on the appearance of the trees in the forest to elude capture.

In forming a paradigmatic model for the society corresponding to this metaphor we should therefore think of ancestors and elders as members of an association of adults, which in turn are often separated for men and women, but the association of elders and the as-

3. Goody, 1972, page 248.

sociation of adults are integral parts of the same group, while the royal clans from which the kings are chosen are peripheral to that group. Thus we can imagine a state of affairs in which all Bantu-speaking societies were once acephalous, consisting of lineage groups led by elders. With the introduction of technical inventions which unified sections of these acephalous societies the kings became necessary, and so certain clans were chosen to perform the function of a reservoir of individuals on whom kingship should be conferred. This was not an office they readily accepted, because it entailed that the holder kept himself separate from the rest of his society. It has already been made clear that the rituals and symbols of kingship stand for the need to enforce a specific and unique pattern on a society at a particular time and place in its history. It has been fashionable to associate the rituals of kingship in Africa with the requirements of imposing order in general on society and to overlook the fact that the rituals emphasise the need for a particular order in a particular set of circumstances. A good example is the interpretation of the origin myth of the Baluba constructed by Luc de Heusch.[4] He presents the various versions of myths collected by different observers, but they are all agreed that a hunter from the east married the daughters of the aboriginal king, Nkongolo, and one of them gave birth to a son, Kalala Ilunga. Kalala Ilunga accused Nkongolo of eating in public and laughing immoderately. Luc de Heusch interprets this to mean that Kalala Ilunga regarded Nkongolo's habits as boorish and uncivilised. Therefore, Kalala Ilunga was representative of controlled habits of behaviour and of orderly patterns of life in the society, and according to Luc de Heusch, Kalala Ilunga's new habits of eating compared with Nkongolo's uncouth ones, exemplify Claude Lévi-Strauss's analysis of the raw and the cooked. Therefore, the ruler is associated with the clans and their ancestors with order, the banished ruler with the original inhabitants and with disorder on which the new order was imposed. It appears from our paradigm, however, that such an interpretation is unlikely to be true. (At the same time it does not fit the society of the Baluba because most observers admit that the rulers are not in a strong position in that society, that their power is in fact extremely limited.) The society of the Baluba looks, in fact, much more like Henderson's Onitsha Igbo society, which is maintained by a constantly adjusted equilibrium between the king, the clan heads and their ancestors and the initiation cults. The ruler

4. Heusch, 1972.

stands for the inevitable and ultimate order that must be imposed for the whole group to survive in their immediate social and environmental context, the clan heads stand for the historically asserted pattern and the adults' initiation cults for the society's adaptability and sensitivity to change. Therefore, the ruler is concerned with the seasonal pattern of rain and drought, with the alternation of night and day and with the calendar; the clan heads and elders are associated with the methods that were adopted in the past by the economy for survival and became permanent features of the economy, and the initiation cults with new inventions and with the introduction of foreign habits that they decided were necessary for the survival of the community. The king had the burden of enforcing new but necessary laws, the ancestors maintained established social customs, and the young men and women explored new territories and fought wars and discussed their secret resentments against the conservative behaviour of the elders. Therefore, the young adults were the king's allies against the elders. We have seen this to be true especially in Bradbury's Edo society in Nigeria.

John Boston has pointed out that the king is associated with the hunter in the origin myth of the Igala in Nigeria because the myth describes "the emergence of a leader outside the established framework of authority,"[5] not an actual migration or an actual hunter. We might suggest as well that Bradbury's Edo-speaking Oba in Benin does not celebrate his *Ihiexu*, or cult of the hand, publicly because he is allowed to preserve his own individual character. He does not have to justify his private decisions publicly while Edo society is prospering.

Bradbury quotes the excuse given by the Oba Eware who achieved his high office by his own efforts from humble beginnings. He said that his hand had done so much for him that to do it justice in a public ceremony he would have to dissipate all he had gained.[6] The hunter who has killed three elephants in Kwahu society in Ghana is excused for not distributing the meat fairly. A song sung in the celebrations of his success states that "the hunter is stingy: he does not distribute his meat free because the elephant is a terror to face."[7]

The alliance between the king and the societies and young adults therefore contains a paradox. The satirical plays of the young adults

5. Boston, 1964, page 125.
6. Bradbury, 1973, page 265.
7. Fraser, 1928, page 167.

criticise the elders for their selfishness, but the young adults' associations justify the selfishness of their own members and that of the king.[8] The elders are not allowed to be selfishly secretive, but the king and the young adults are allowed secrets which assist their own selfish intentions.

The oral literature and the visual art express this paradox by the ideographic language of the hunter's symbol. The hunter is the man who hides behind the anthill and uses a disguise, the masks which, in the theatrical ceremonies, are said to emerge from the anthills. The ants are the agents of change which act on behalf of the young adults to dispose of the ancestors when they have remained for too long.

On the second day of the egungun ceremonies of the Yorubas the satirical masks emerge in contrast to the first day, when the elaborate and ornate masks of the revered ancestors were brought out. Thus the young adults' society creates the masks of the revered ancestors but also creates the masks for countering their influence.

The king's predecessors, on the other hand, are kept permanently in the society. The Bakongo Ndop figures are made of hard and durable wood and have been preserved for two or three hundred years. The Onitsha king sleeps beside an anthill during his installation ceremonies to be close to his predecessors. It is important to insist that the word "predecessors," not "ancestors," is used here because the collected groups of kings who have ruled the society in historical time are not related to one another as ancestors. Rather, they constitute a group of separate individuals who have passed on their name from one to another.

We are therefore led to distinguish between that kind of behaviour in individuals which is different from that of their immediate social group but which is licensed and that kind of behaviour which is unlicensed and demands banishment. Some kinds of behaviour are restricted to those individuals who have the misfortune to be born into royal clans. We have seen on page 29 that killing is one of the kinds of behaviour usually restricted to kings (except in times of war). Sometimes the awful responsibility that kings have when they are allowed to kill is emphasised in their installation ceremonies by terrifying and arbitrarily cruel acts.

It is said, for example, that the newly installed king of the Baluba

8. As they did in the Ghanaian high-life song praising the selfishness of a minister, referred to on page 131.

people would attack and massacre a whole village without warning. The Onitsha king executed a slave who had been tethered at the front of his compound during the installation ceremony.

Kings, therefore, are said to be descended from hunters because hunters are outside of the structure of the kin groups, and hunters can perform inexplicable acts. In the same way, the young adult men who found the similarities of their age groups showed knowledge of the terrains in which they hunted and so would provide knowledge to one another of alien terrains.

Thus it became clear why the king would impose laws derived from the sky gods' because he could obtain knowledge from them of laws which were alien to the kin groups, which transcended their subjective knowledge, and it also becomes clear at the same time why he himself would be regarded as imposing his own subjective personality.

The adult grows up in defining his own personality, and he discovers what that personality is, particularly in his activities as a hunter. When the Kwahu hunter asks the diviner which animal he may kill the diviner tells him of the animal represented by his own soul, which he must avoid killing. The king is regarded as a hunter because he is particularly responsible for the definition of his group of subjects, representing to them what kind of personality their group creates. Thus we have seen that it is more meaningful to regard the prohibitions and restrictions of a king turning him into a cult-slave as a means of preserving his defined personality than merely to regard the prohibitions and restrictions as a means of preserving the well-being and fertility of the society and that all the rituals associated with kingship are best understood as concerned with his precise definition. We have also seen that he must be defined in such a way that he does not interfere with the definitions of the separate clans or the separate lineages in the society. It is this need to allow every individual and every separate group of individuals to define themselves in their own unique way that produces the invisibility of the art, the need to avoid an over-all definition of the present. However, some patterns of behaviour in the society must be made visible, in the same way that the king's drums must be beaten at dawn before the day can begin, but this visibility must be restricted and therefore limited to kings, in the same way that the right to kill is limited to kings.

Once installed, the ruler's right to kill, however, had to be used

with discretion.[9] It was not to be used in such a way that it burned up the society. The ruler was associated with the society's fertility and not with its periods of drought.

In the Luba myth the vanquished original ruler, Nkongolo, is associated with the sun, which causes holes in the earth; Kalala Ilunga the hunter, who comes from another territory, is associated with fertility. However, he is also associated with silence and therefore with quiet discretion in his behaviour. Nkongolo is associated with thunder, with drinking and with excessive cruelty. Kalala Ilunga is a sky god but not a sun god because he brings rain, not drought. Therefore, his symbol is the moon. This raises the question whether African rulers are generally associated with the sun, as has sometimes been claimed.[10] They shade their societies from the sun with their umbrellalike panoplies and in their symbol of tall trees accompanied by rain clouds; and in their bisexuality they are close to the earth, and as bulls their horns represent the moon, the sign of the deity belonging to the queen mother.[11] In other words, the crescent formed by the bull's horns can turn into the moon because the king's origins in the earth make him bisexual. Thus he is differentiated from the ancestors, the phallic trees, and belongs to a set of individuals whose ambiguous role is that of being kings, of discovering separate personalities for the distinct societies they rule at differing periods of historical time. This gives us the reasons why the king's art is "scenic," why it is concerned with the description of the particular events which involve a particular king. The sojourn of a particular king in the society was a historical event and became a record of a particular set of circumstances in the past. The ancestors, however, go and come back and therefore can be regarded in a peculiar sense as timeless. Therefore, their art is very generalised. Its horizontal and vertical planes state ideographically that the ancestors represent the survival of the kin group without reference to time and place, while the art of the kings and young adults' societies which support them affirms the need for adaptation to the specific circumstances of par-

9. We can see how strongly the prohibition against killing acted on ordinary people in Amadi's novel The Concubine. Madume fights Ekueme at the beginning of the novel and throws him onto a projecting stump of a tree so that he is badly injured, but the "possibilities of killing a man filled him with fear. The costs of the rites of purification were prohibitive and even after that he would still be a hunted man."

10. E.g., by Hocart, 1936; see page 28.

11. The bull's horns may represent the life force; v. Cook.

ticular times and places. Returning to the metaphor of the forest, the ancestors keep growing in the same place and repeating the same form of tree, the kings produce distinctive forms which outgrow the rest to be able to survey the trees of the ancestors, and the young adults move off to the periphery of the forest to discover new possibilities of growth which may eventually become the repetitive and established pattern of new kin groups related to the original clans in the older forest. However, because of his place in the sky, with a general purvey of everything, the king is in danger of trying to impose his individual pattern for too long a period and may harm the ancestors and their kin groups. Therefore the ultimate power lies with the clans or the kin groups who have power over the king. The king is the agent of the mature adults' societies to ensure that the necessary changes and innovations are possible, but the elders are a testimony to the persistence and vigour of the society and are assisted by the king, who is answerable to the queen mother, or the earth, to become flourishing trees. They in turn must give way to the new growth of the maturing young adults and are eventually eaten by the ants. The balance is different in acephalous societies which may consist of groups of clans without kings and where senior elders in those clans are chosen to lead them and to guard the secrets of the ancestors. They often keep the secrets in a box or basket, which is guarded by the representation of the founding ancestor of the clan. In such societies the senior elder providing the clan's box of secrets may appear to have the same position as the king. The adult societies are his opponents if he becomes too powerful. The opposition between the senior elders and the mature adults is expressed in the art by the stiff and hieratic rigidity of the figures guarding the ancestral box of secrets and the fluidity and openness to innovation of the masks. The elders' societies themselves are the upholders of rigid conformity to the patterns established in the past by their immediate ancestors, and they keep the record of those patterns in the relics in the box to be handed on to their legitimate successors. The mature adults' societies are institutions in which everyone can avoid rigidity and can work out new patterns when they become necessary.

It is not surprising, therefore, that, particularly in acephalous societies, the diviners' and the young adults' cults should form an unspoken alliance. When diviners' cults have formed associations they have recruited the young, those who are impatient for change, to assist them in their maintenance of power. The association of

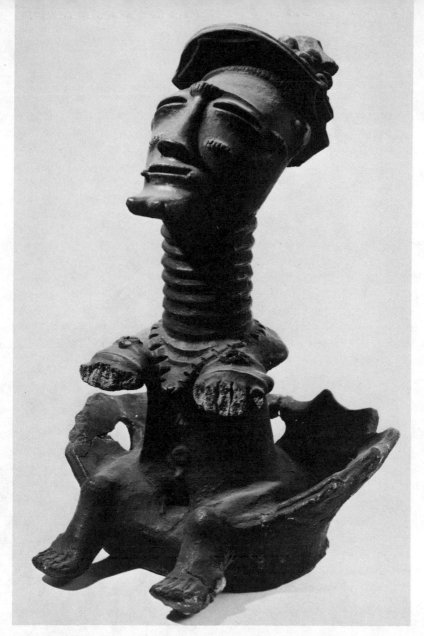

PLATE 20. This funerary figure of the Anyi people in the Ivory Coast, made in terra-cotta, emphasises the vertical and horizontal rigidity of the elder, although terra-cotta is not a material which normally lends itself to straight planes. *Photothèque Musée de l'Homme, Palais de Chaillot (Paris)*

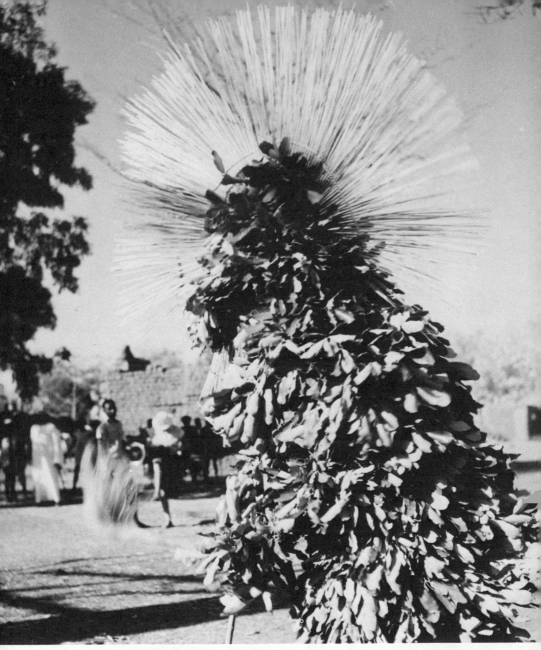

PLATE 21. Among the Bwa people of Upper Volta, the masks made of leaves and fibres worn by the young men appear from the bush to vanquish the elders' masks (which are made of carved wood) in a mock battle. *Agence Hoa-Qui (Paris)*

diviners of the Igbo at Arochukwu maintained its power through a spy system which recruited individuals who would be useful. The secret societies of the Baluba people are said to have used press-gang methods to recruit the most intelligent, successful and good-looking individuals to their ranks. It seems, then, that the adult initiation cults recruited new blood in order to keep ahead of the times. They recruited outstanding individuals who introduced needed innovations in the same way that the group of kings added to their numbers over a historical period of time and each new king introduced a new order of society.

If, however, kings preserve their individuality and the accumulated expressions of their ancestors' individuality, the members of the young adults' societies are not supposed to preserve theirs. They must eventually be ready to give up their right to individual expression in order to become elders.

We have said that hunters, kings and mature adults are those individuals in the society who are allowed to define themselves with the help of the diviners. We have also pointed out that fission can take part in expanding and exploring societies with the help of witches who express their need to define themselves by their ambiguous behaviour and for that reason are characterised as witches. Therefore, hunters, kings, mature adults and witches have similar characteristics which enable them to understand all the other individuals belonging to this category of those seeking to define themselves. In some societies, such as the Edo of Benin,[12] kings and mature adults' secret societies may form an alliance against the elders. In others, such as the Azande of the Sudanese Republic, the kings and the elders may be allied against the secret societies. In all cases their ability to identify their opponents arises because they themselves are similar in character to their opponents and they understand their opponents in exactly the same way that the hunter understands the animals through adopting their habits of concealment in the forest, the diviner understands the witches by using his own powers as a sorcerer, or mature adults understand the elders because they themselves hope to replace the elders. Therefore, the ability of the masquerader to satirise those who are selected in his role as a social critic derives from his own ability to identify with the figures he satirises, his ability to act out his role and thus to define it. When the mature adults' society opposes the burial of the deceased elder and parallels

12. See page 63.

his encounter with the unburied ghosts in his path to the land of the dead, they are opposing his definition.

One way of defining oneself is to take an oath. An oath means that a man stands by a declaration or a decision. He intends to carry it out come what may. On page 21 we referred to the fact that Olumba took such an oath in Amadi's *The Great Ponds*.

Taking an oath is thus equivalent to being prepared for an expensive outlay in order to define oneself, in the way in which the priest of Umuaro would have been required to pay all debts of the village in order to become a king[13] or the Edo Oba Eware of Benin, who would not hold a public ceremony for his hand because "to do it justice in a public ceremony he would have to dissipate all he had gained."[14]

Being allowed to define oneself is therefore equivalent in the visual art to being allowed to make oneself visible. Self-definition is a process of becoming visible, but being visible must not last too long if it produces rigidity. Therefore, the visibility of the king defining his society must be carefully restricted. He must be confined to his palace except on the occasion when his public appearances are controlled by exact rituals. The visibility of the deceased elder who has become an ancestor must be confined to the lineage group's ancestral shrine and must be allowed for exhibition to his successor only when he performs sacrifices and summons the assistance of the ancestor. The elder has completed his destiny when he has been given a second burial and has been defined despite the attempts of the mature adults' society and the unburied ghosts to prevent his accomplishing it and becoming defined for the benefit of the eldest son, who thus begins the process of his own definition and the fulfillment of his own destiny. Their opposition to the father's ghost reaching its final destination and definition of "planting," however, is a dialectical enactment of the limitations imposed on the father as an ancestor so that he should not stay so long that he interferes with the son's completion of his destiny, the son's definition of his role as the new elder guarding the group-soul of his family group, with its new configuration of ancestors. By exhibiting the characteristics of the unburied dead, the mature adults' society who are losing one of their own members to the elders are demonstrating the consequences of remaining unburied and being left to wander in the

13. See page 90.
14. Bradbury, 1973, page 265.

underworld. They are contrasting the world of darkness with the world of light and definition. However, they also say that it is a world fertile with new possibilities. They tell the eldest son who is leaving them in order to bury his father that he is leaving the world of expressing himself as an individual in order to take on the burden of responsibilities for his kin group. He himself is abandoning the present which it is their job to keep invisible in order to take on a temporary visibility, the visibility of a transient historical myth, soon to be revised and readjusted when he in his turn makes way for his eldest son, one more member of the society of mature adults, who hopes to renounce the status of an unburied ghost. Their temporary visibility is expressed in a very general way, however, when the figure is carved which represents them in the ancestral shrine or on top of the basket of ancestral relics. It is only the king who makes his historical present visible so that it will remain visible in all the limitations of its temporary individuality; and in order to obtain visibility he takes up a position close to the sky and in direct communication with the god of the sky, but he himself may not become the sun or sky god, or the particular pattern that he imposes would be too persistent. Therefore, he is subordinate to the principle of fertility, the queen mother, whose symbol is the moon. The mature adults may make the actuality of their present visible for fleeting moments in the masks of their theatre of satire, but the masks must be hidden away for the rest of the year and must be continually replaced. Thus the art of each group in the society is seeking continuously to keep the present from becoming static or fixed so that the principle of life and change can be kept alive by each generation. The art of the ancestors remains very general, but it must be hidden away; the art of the kings can be displayed openly and permanently but must remain fixed in its particular individuality and avoid any expression which is so static and general that it would be imposed on the society if it were allowed the kind of permanent display reserved for the king's temporally limited individuality; and the art of the young adults must appear for very fleeting moments and must constantly be reviewed. Thus in all forms of nonindustrial African art the present is kept invisible.

Bibliography and References

The date refers to the original publication date and the publisher to the edition to which reference is made.

ABRAHAM, WILLIAM E., *The Mind of Africa*. Chicago: University of Chicago Press, 1962.

ACHEBE, CHINUA, *Things Fall Apart*. Greenwich, Connecticut: Fawcett Publications, 1959.

———, *Arrow of God*. Greenwich, Connecticut: Fawcett Publications, 1964.

ADAMS, RICHARD N., *Power Correlates of Changes in Symbols*. Paper presented to American Anthropological Association, Toronto, December 1972.

AIDOO, AMA ATA, *Anowa*. London: Longmans, 1970.

AKIGA, B. A. S. (trans. R. East), *Akiga's Story*. Oxford University Press for International African Institute, 1939.

AMADI, ELECHI, *The Concubine*. London: Heinemann, 1966. *The Great Ponds*. London: Heinemann, 1969.

ARMSTRONG, ROBERT, *Prolegomena to the Idoma Idea of God*. *African Notes*. University of Nigeria: Institute of African Studies, Vol. 4, No. 1, October 1960.

ASALACHE, KHADAMBI, *The Latecomer*. Unpublished manuscript.

———, *Night of My Blood*. Poems, with an introduction by E. Mphahlele. New York: Doubleday, 1971.

156

Awoonor, Kofi, *This Earth, My Brother.* New York: Doubleday, 1971.

Bachofen, J. J. (trans. Manheim, 1967), *Das Mutterrecht. Myth, Religion and Mother Right* (Selected Writings). London: Routledge, Kegan Paul.

Barry, Sir James, *Works.* London: Cadell and Davies, 1809.

Bascom, William R., *Social Status, Wealth and Individual Differences Among the Yoruba. American Anthropologist,* Vol. 53, No. 4, 1951.

———, *Ifa Divination.* Bloomington: Indiana University Press, 1969.

Beier, Ulli, *Contemporary Art in Africa.* New York: Praeger, 1968.

Bohannan, Paul, *Extra-Processial Events in Tiv Political Institutions. American Anthropologist,* Vol. 60, No. 1, pages 1–12, 1958.

Boston, John S., *The Hunter in Igala Legends of Origin. Africa, JIAI,* Vol. 34, No. 2, 1964.

———, *The Igala Kingdom.* Ibadan: Oxford University Press for the Nigerian Institute of Social and Economic Research, 1968.

Bowdich, T. E., *An Essay in the Superstitions, Customs, and Arts Common to the Ancient Egyptians, Abyssinians and Ashantees.* Printed by J. Smith, London, 1821.

Bowen, Eleanor S., *Return to Laughter.* New York: Doubleday, 1954.

Bradbury, R. E., *Benin Studies* (edited and with introduction by P. Morton-Williams). Oxford University Press for International African Institute, 1973.

Brain, R., and Pollock, A., *Bangwa Funerary Sculpture.* London: Duckworth, 1971.

Brosses, Charles de, *Du Culte des Dieux-Fetiches ou Parallèle de l'ancienne Religion de l'Egypte avec le Religion actuelle de Nigritié.* Geneva, 1760.

Busia, Kofia A., "The Ashanti" (in *African Worlds,* edited and with introduction by D. Forde). Oxford University Press for the International African Institute, 1954.

Caesar, Julius (trans. Edwards, 1917), *De Bello Gallico.* Loeb Classical Library, Harvard University.

Christensen, J. B., *Double Descent Among the Fanti.* New Haven: Human Area Files, 1954.

Cook, A. A., *Zeus, a Study in Ancient Religion.* Vol. 1. Cambridge University Press, 1914.

DOUGLAS, MARY, *Purity and Danger.* London: Routledge, Kegan Paul, 1966.

———, *Witch Beliefs in Central Africa. Africa, JIAI,* Vol. 37, No. 1, page 72, 1967.

———, *Natural Symbols.* London: Pelican Books, 1970.

DUERDEN, DENNIS G., *Art and Technical Progress. Transition,* No. 45, pages 27–37. Accra, Ghana.

DUERDEN, DENNIS G., AND PIETERSE, COSMO, *African Writers Talking.* London: Heinemann, 1972.

ELIADE, MIRCEA, *Cosmos and History: The Myth of the Eternal Return.* New York: Harper Torchbooks, 1954.

———, *Myths, Dreams and Mysteries.* London: Fontana Library, Collins, 1957.

EURIPIDES (trans. Arrowsmith, W., 1969), *The Bacchae* (in *Greek Tragedies,* Vol. 3, editors D. Grene and R. Lattimore). University of Chicago Press.

EVANS-PRITCHARD, E. E., *Witchcraft, Oracles and Magic Among the Azande.* Oxford University Press, 1937.

FINNEGAN, RUTH, *Oral Literature in Africa.* Oxford: Clarendon Press, 1970.

FORTES, MEYER, *Oedipus and Job in West African Religion.* Cambridge University Press, 1959.

FRASER, A. G., *The Cult of the Kwahu Hunter. (The Gold Coast Review),* Vol. 4, No. 2, 1928.

FRASER, DOUGLAS AND COLE, H. M. (eds.), *African Art and Leadership.* Madison: University of Wisconsin Press, 1972.

GABRE-MEDHIN, TSEGAYE, *Africa as the Origin of the Early Greek Theatre Culture.* Paper submitted to the International Congress of Africanists, third session, Addis Ababa, December 1973.

GOLDIE, SIR WILLIAM, *Calabar and Its Mission.* Edinburgh: Oliphant, Anderson & Ferrier, 1890.

GOLDWATER, ROBERT, *Primitivism in Modern Art* (revised edition). New York: Vintage Books, 1966.

GOMBRICH, ERNST, *Art and Illusion.* London: Phaedon Press, 1960.

GOODY, JACK, *Death, Property and the Ancestors.* London: Tavistock Publications, 1962.

———, *The Myth of the Bagre.* Oxford University Press, 1972.

GRIAULE, MARCEL, *Conversations with Ogotommêli.* International African Institute and Oxford University Press, 1965.

158

GROENEWEGEN-FRANKFURT, H. A., *Arrest and Movement*. London: Faber, 1951.

HARRIS, J. R. (ed.), *The Legacy of Egypt*. Oxford University Press, 1971.

HENDERSON, R. N., *The King in Everyman*. University of Chicago Press, 1972.

HERSKOVITS, MELVILLE J. AND FRANCES S., *Dahomean Narrative*. Evanston: Northwestern University Press, 1958.

HEUSCH, LUC DE, *Le Roi Ivre ou l'origine de l'état*. Paris: Gallimard, 1972.

HIMMELHEBER, HANS, *Die Dan; ein Bauernvolk in Westafrikanischen Urwald*. Kohlhammer, 1958.

HOCART, ARTHUR M., *Kings and Councillors* (edited and with an introduction by R. Needham). University of Chicago Press, 1936.

HORTON, ROBIN, *The Kalabari World View, An Outline and an Interpretation*. Africa, *JIAI*, Vol. 32, No. 3, July 1962.

———, *The Ekine Society, Borderland of Religion and Art*. Africa, *JIAI*, Vol. 33, No. 2, April 1965.

———, *Kalabari Sculpture*. Department of Antiquities, Nigeria, 1965.

HURAULT, J., *La Structure Sociale des Bamiléké*. Paris: Mouton, 1962.

JAHN, JANHEINZ (trans. M. Grene), *Muntu*. London: Faber and Faber, 1961.

JEFFREYS, M. D. W., *The Divine Umundri King*. Africa, *JIAI*, 8, pages 346–53, 1935.

KIRK, G. S. (ed.), *The Language and Background of Homer*. Cambridge: Heffer; New York: Barnes and Nobel, 1964.

KIRK, G. S., *Myth, Its Meanings and Functions in Ancient and Other Cultures*. University of California Press, 1970.

KUBIK, GERHARD, *Masks of the Mbwela*. Geographica, Vol. 5, No. 20, Lisbon, October 1969.

LEACH, EDMUND R., *Rethinking Anthropology*. London School of Economics Monographs on Social Anthropology, No. 22, University of London Press, 1961.

LEGGE, F., *Forerunners and Rivals of Christianity*. Cambridge University Press; reprinted Peter Smith, New York, 1950.

LEWIS, I. M., *Ecstatic Religion*. London: Penguin Books, 1971.

LLOYD, PETER C., *Sacred Kingship and Government Among the Yoruba*. Africa, *JIAI*, Vol. 30, No. 3, 1960.

LORD, A. B., *Homer's Originality and Dictated Texts*. Transactions

Index

Page numbers in italics refer to illustrations.